RENÉ MAGRITTE

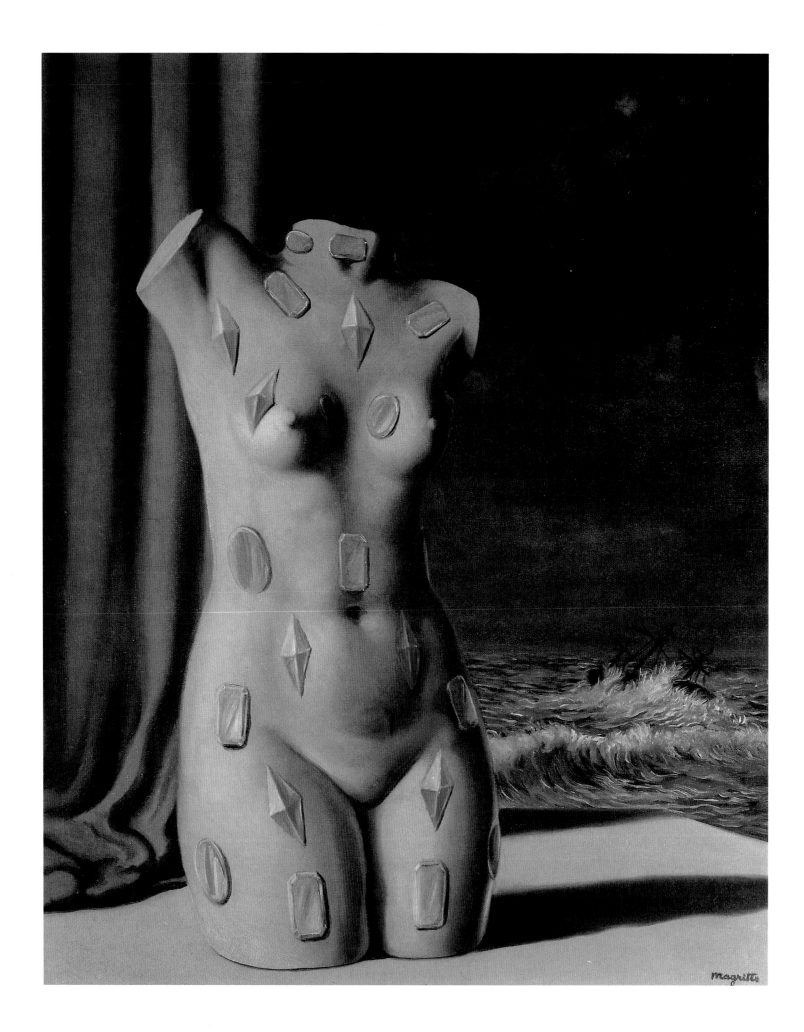

Jacques Meuris

RENÉ MAGRITTE

1898–1967

TASCHEN

HONG KONG KÖLN LONDON LOS ANGELES MADRID PARIS TOKYO

To stay informed about upcoming TASCHEN titles, please request our magazine
at www.taschen.com/magazine or write to TASCHEN America, 6671 Sunset Boulevard,
Suite 1508, USA–Los Angeles, CA 90028, contact-us@taschen.com, Fax: +1-323-463.4442.
We will be happy to send you a free copy of our magazine which is filled with information
about all of our books.

© 2007 TASCHEN GmbH
Hohenzollernring 53, D–50672 Köln
www.taschen.com

Original edition: © 1991 Benedikt Taschen Verlag GmbH
© 2007 VG Bild-Kunst, Bonn, for the illustrations
English translation: Michael Scuffil, Leverkusen
Cover design: Sense/Net, Andy Disl and Birgit Reber, Cologne

Printed in China
ISBN 978–3–8228–3686–6

Contents

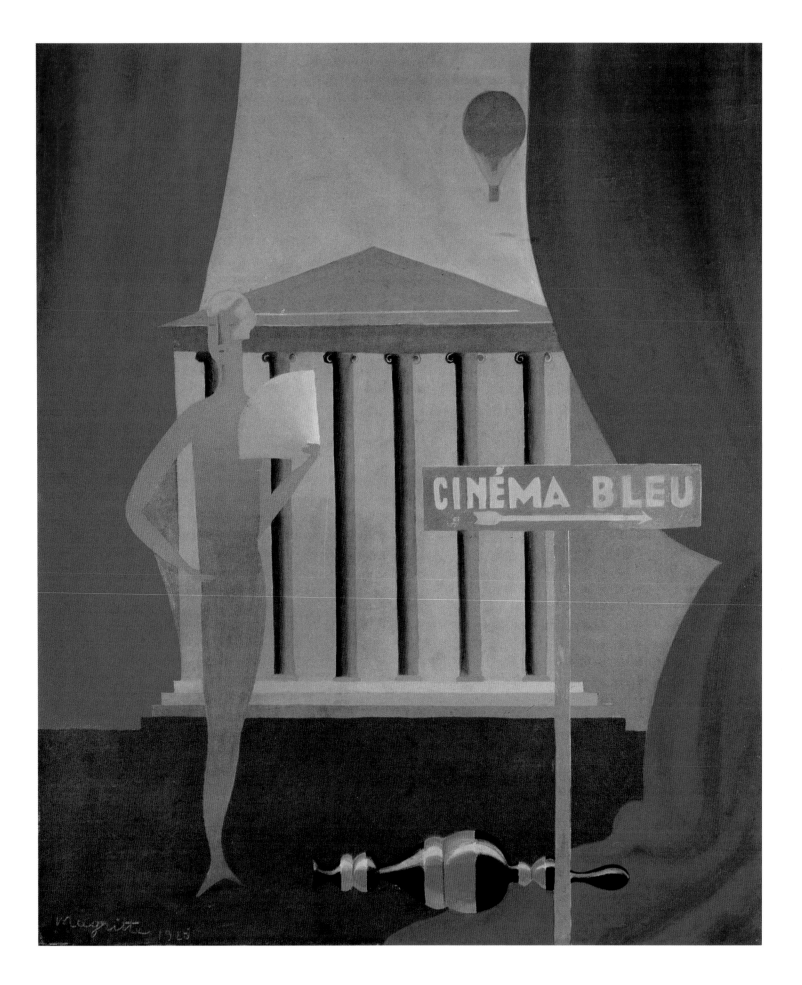

How does one become a Magritte?

How does one become an artist? How does one become a painter? And how does one become a painter who is not an artist?

How does one, in the case of René Magritte, become a painter like this, so individual, so far outside all the norms which characterize the nature of art and which, until the beginning of the 20th century at least, were accepted by common sense and long tradition alike?

When Magritte was born on 21 November 1898 in a little town in the Belgian province of Hainault, where everyone earned his living from the local quarry, the visual arts in Europe had already undergone several revolutions. They had gone from the kind of sculpture and painting which concentrates on nature and the real world to an art which was conceptually very much more strongly directed towards inner feelings. The traces of this transitional phase can be recognized most clearly in Impressionism and its fringe phenomena. In Impressionism were concentrated very many of the ideas which had inspired the already "modernistic" artists of the later 19th century. In short, this period was witnessing the end of a realism which restricted itself to a reproduction of the real. Colours now took on the function of reflecting impressions rather than reflecting a reality which henceforth was no longer considered reproducible. There appeared on the scene theories in which emotivity and scientism were intermingled.

In 1898 Vincent van Gogh, the pre-Expressionist, had already been dead for ten years; and Paul Cézanne, the pre-Cubist, had already discovered that every natural form was capable of being re-drawn in geometric shapes. Other developments were also emerging, which, though only temporary, were nonetheless not without influence on the ambience from which fine arts took their inspiration. The fin-de-siècle and its ideas stirred up no little turbulence in an atmosphere characterized by the final triumphant victory of the first industrial revolution, which was now a hundred years old. During this period, Magritte's native country, Belgium, was experiencing the appearance, in a manner less clandestine – though still not "popular" – of an aesthetic Modernism, manifested most notably through the works of James Ensor and such groups as "Les Vingt", who invited many of the new generation of European artists to the exhibitions they organized.

Among the cultural events of the late 19th century, two are worthy of being singled out for special mention here, since they can be seen as symptomatic, both in respect of the cultural milieu in which the Belgian intelligentsia was luxuriating, and of certain influences which were later to make their mark on Magritte, if only marginally. For when he took over these ideas for his own use, then it was often in order to achieve the exact opposite.

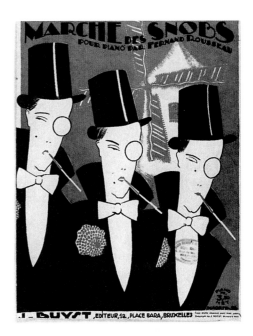

Marche des Snobs, 1924
Title page for a score

The Blue Cinema, 1925
Le cinéma bleu
Oil on canvas, 65 x 54 cm
Geneva, private collection

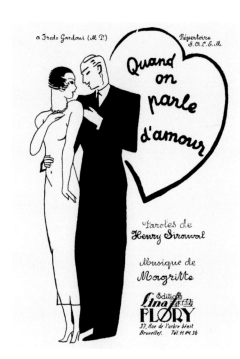

Quand on parle d'amour, n. d.
Title page for a score

Primrose, 1926
Primevère
Lithograph, 125 x 86 cm
Courtesy Galerie Isy Brachot, Brussels–Paris

Between 1880 and 1910 the spirit of Romanticism was revived in the Symbolist movement, which in Belgium was represented by such well-known writers as Maurice Maeterlinck and Émile Verhaeren, as well as a number of visual artists, of whom Fernand Khnopff and William Degouve de Nuncques are the most noteworthy from today's standpoint. What is it that distinguishes these two artists as forerunners of Magritte? Of the former, it is said that he was "documentary in outlook" and "obsessed with the truth", while the latter is chiefly interesting on account of his picture *The House of Mysteries*, dating from 1892 (illus. p. 100), which greatly resembles Magritte's *The Empire of Light* (1954; illus. p. 101).

The end of the 19th century also witnessed another aesthetic phenomenon in the appearance of Jugendstil or Art Nouveau, to which both Belgium and imperial Germany made important contributions through a number of well-known artists. Although this movement differed considerably from the aforementioned, their ideas on occasion even being mutually contradictory, nevertheless they shared a common sensitivity of approach to the two worlds by which human beings are moved: the inner world and the outer, the world of reverie and the world of vitally essential activity. There is, moreover, a link between the symbolist scrolls as used by, for example, Gustave Moreau or the English Pre-Raphaelites on the one hand, and the "style nouille" of Art Nouveau, so evident in the works of Victor Horta, on the other. This link found its expression in the need, strongly felt at that time in Jugendstil, for technological progress to be humanized and for this process to be reflected in an "artistic" signature in the fashion of the age – a "symbolistic" fashion, in other words, although the Symbolists for their part wished to withdraw from a reality which had thrown up many existential questions. By contrast, Art Nouveau sought to shake this reality to its foundations, in order to impose a human dimension on progress, taking full responsibility for an epoch which in several respects was in the grip of a thoroughgoing transformation.

We shall be looking with particular attention at these movements which were making their appearance in the art world while Magritte was growing up; it was in the context of these trends that ideas on painting and its purpose were developing, ideas which were having a decisive influence on a process which was deriving from the visual arts concepts relevant in the post-Renaissance period, but were by now totally exhausted. During the 1920s Magritte reinforced this development in his own peculiar way, turning on its head the principle that feeling took precedence over the actual. In this return to the real, which he initiated, he was swimming against the tide represented by the current idea that painting should be concerned with emotion rather than reflexion. For this reason, Magritte always rejected the suggestion that any kind of symbolism underlay his pictures.

It has been stated, and rightly so, that Symbolism occupies a place, historically speaking, between the Romanticism of the first half of the 19th century and the Surrealism of 1924. Symbolism took over much of the one to pass it on to the other, but only ever in part. José Pierre has remarked, quite rightly, that practically no field of aesthetic creative activity was left untouched by Symbolism during the period from 1880 to 1910, no matter how fleeting this influence may have been. Indeed the movement itself was short-lived; its much-debated influence and poetic impulses melted away under the pressure of contemporary events. But this does not alter the fact that the general framework, within which was formed the taste of the society in which Magritte spent his early life,

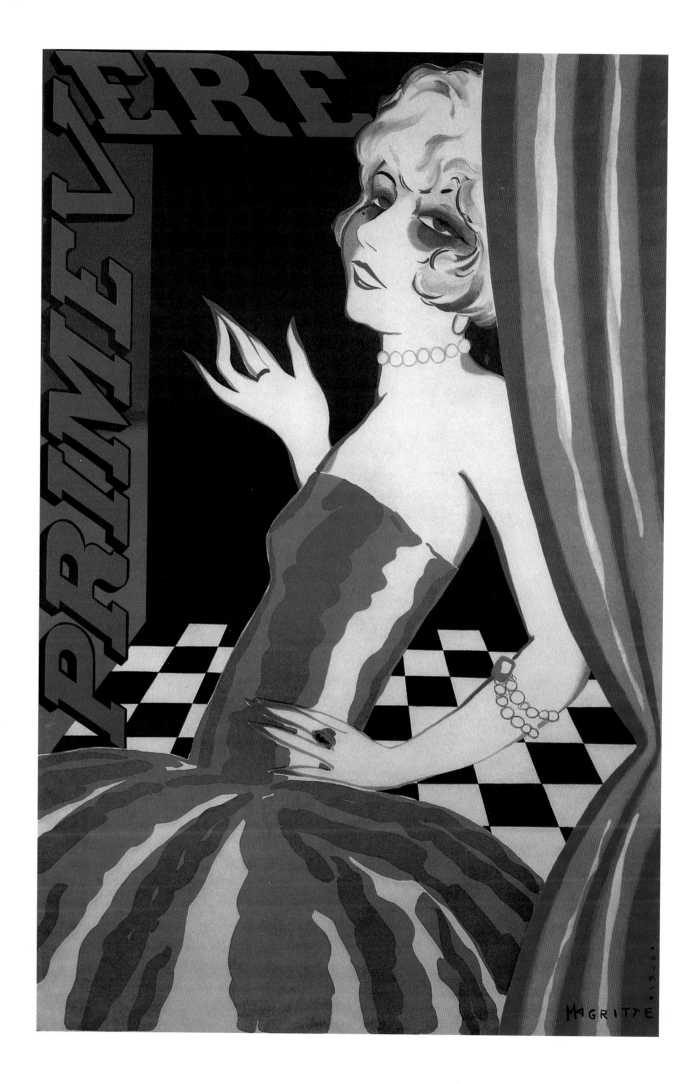

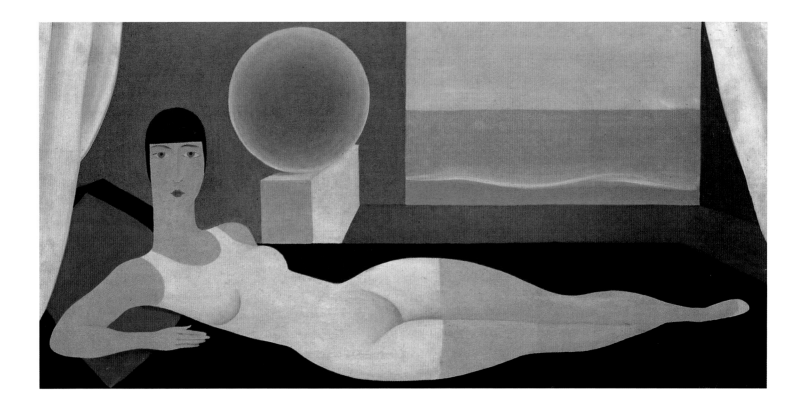

was one marked by a collision between old and new, between sentimental tradition and technological renewal.

Was it, then, the circumstances of Magritte's adolescence that made him decide to become a painter and to find a highly individual means of personal expression?

From 1898, when he was born, until about 1919, the year in which his first known works appeared – incidentally Post-Impressionistic in character – Magritte experienced a childhood and youth typical of all petit-bourgeois households whose source of income was craft or trade. A childhood in simple circumstances, even, when one considers the small southern Belgian towns where the Magrittes lived: what they must have looked like and what sort of life went on there. It is by no means devoid of interest to dwell on this aspect for a moment, in order to understand the social attitudes which accompanied the painter for practically the whole of his life, and the reactions which inspired him as an artist. The Magritte family moved house often between 1898 and 1910. They left Lessines when Magritte was no more than a year old, and went to live in Gilly, another small market town in the region. From there they moved to nearby Châtelet. The next move took them to Charleroi, the capital of Hainault, in the middle of the "pays noir". Not long after returning once more to Châtelet, the family finally settled in Brussels. All these places had one typical feature in common: the great majority of the working population were miners, steelworkers or glass-factory workers, and living conditions were characterized by unmistakable proletarian deprivation. Léopold Magritte, the artist's father, kept a tailor's shop, and his mother Adeline was a milliner. In both occupations, small-scale clothing manufacture was combined with the clothing and drapery trade. Their clientèle was a relatively well-off lower middle class whose social status was not greatly different from that of the Magrittes themselves, being made up for example of tradesmen and clerical staff. His parents were able, then, to maintain a certain degree of affluence,

Woman Bathing, 1925
La baigneuse
Oil on canvas, 50 x 100 cm
Charleroi, Musée des Beaux-Arts

The Model, 1922
Le modèle
Oil on canvas, 65 x 54 cm
Courtesy Galerie Isy Brachot, Brussels–Paris

11

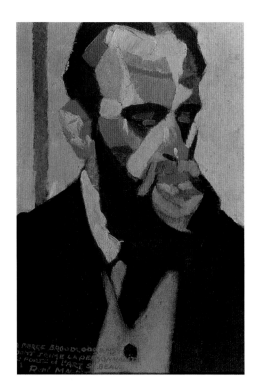

Portrait of Pierre Broodcorens, 1921
Portrait de Pierre Broodcorens
Oil on canvas, 59.5 x 37.5 cm
Brussels, Musées Royaux des Beaux-Arts

which allowed them to aspire to a relatively good education for their children, and to enable them to spend their youth not overburdened by worry or care. And yet this background was not really open to any particularly elevated level of culture; traditional patterns were more important than future perspectives; convention and decorum formed a permanent backcloth to their lives.

There was nothing in this background to point to any inclination on the part of the eldest of the three Magritte brothers to embark on a career in art. It was also the case, however, that René's brother Paul (1902–1975) spent his whole life endeavouring to make a name for himself as an artist, musician and composer, albeit with no great success. The third brother, Raymond (1900–1970), enjoyed a not unsuccessful career in commerce. The fact that from a milieu indifferent to art an artist should emerge is nothing extraordinary in itself. In the case of Magritte, however, things look in retrospect very different, because this was an artist who developed an amazingly creative muse, outside all the "modern" or "classical" rules, or indeed the very concept, of painting. At the same time his private life, insofar as it can be judged from the outside, remained closely tied up with the lifestyle customary in the circles from which he came. Thus Magritte's thinking – which was wide open to the future – was in contrast to a strangely petit-bourgeois way of life.

Perhaps, though, Magritte's psychological disposition, so different from that of the other young people of his milieu and generation, can be explained in part by his father's restlessness, which found its expression in the family's constant changes of address. There was a certain freedom of spirit vis-à-vis received notions, and a certain freedom of action arising out of this. There can be no doubt that the young Magritte was familiar with circumstances more simple than his own, which surely introduced him to a kind of dialectic of disorder: other reactions, other ways of speech, other traditions. It is quite possible, however, that the family's numerous moves were motivated by economic considerations; then again, perhaps the cause lay deeper in the father's subconscious, or perhaps there were conscious but secret motives present. Who knows? The biographers say nothing on the matter, and Magritte himself maintained an almost total silence on these peregrinations.

There are a few, albeit meagre, pointers which allow us to attempt a preliminary, cautious explanation of Magritte's character and the foundations of the thinking that dominates his work. We owe some of these clues to Louis Scutenaire, and they enjoy a fair degree of credibility in that he and his wife, Irène Hamoir, were among Magritte's closest and most long-standing friends. They met in 1927 and remained in constant contact thereafter. In one of his numerous writings on his friend, Scutenaire states that it was as a young child in Gilly that Magritte first experienced what he called the "sensation of mystery". The story ran as follows: When a tethered barrage balloon crashed on the shop were the family were living, it had to be got down from the roof, and this "long soft thing" that stern-faced men in leather clothes and helmets with earflaps had to drag downstairs seemed very extraordinary to him (Scutenaire, 1977).

There was another event of presumably greater importance for the future of the young Magritte: the suicide of his mother, who in 1912 drowned herself in the River Sambre not far from Châtelet. She was forty-one years old, Magritte at the time fourteen. The story is sometimes repeated that Magritte and his two brothers had gone to look for their mother and had found her body practically naked, but for a wet night-dress that had ridden up and was sticking to her skin. There is no likely confirmation of this story; according to Irène Hamoir,

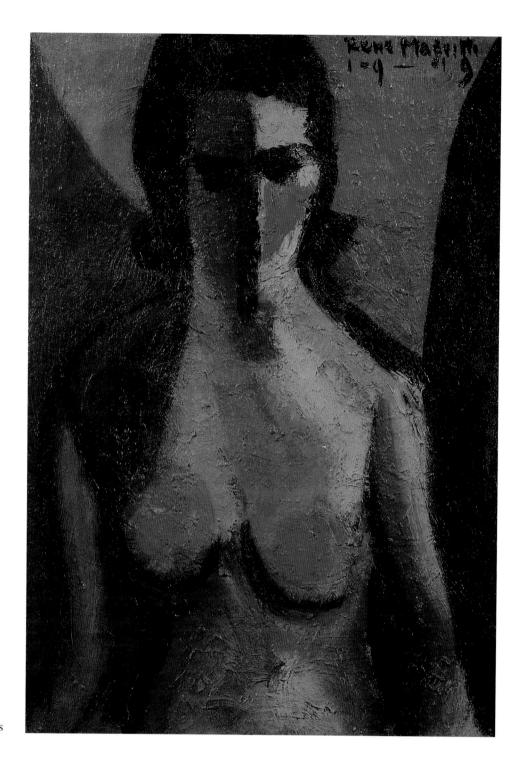

Nude, 1919
Nu
Oil on canvas, 40 x 29 cm
Courtesy Galerie Isy Brachot, Brussels–Paris

Magritte never mentioned it in the presence of his friends, and evaded the questions on the subject asked by Louis Scutenaire when the latter was writing his account. As he observes in his biography of the painter, this event was responsible for a further "sensation of mystery" experienced by Magritte, and at the same time – and for the first time – for giving him a sense of his own importance: he was, namely, "the son of the woman who drowned herself". He continued to live with his father, who did not remarry, and together with his brothers was entrusted to the care of nurses and governesses – evidence of the family's relative affluence. Perhaps the experience also enhanced the malice which he apparently exhibited in his outbursts of "childish tyranny", as well as his "already strongly marked sense of the bizarre" (Scutenaire, 1977).

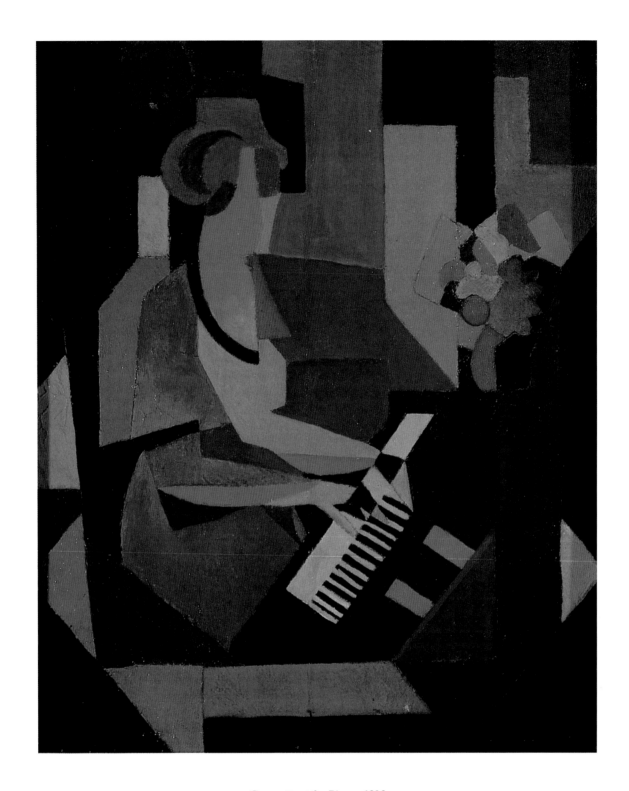

Georgette at the Piano, 1923
Georgette au piano
Oil on canvas, 44 x 36.5 cm
Courtesy Galerie Isy Brachot, Brussels–Paris

Self-Portrait, 1923
Autoportrait
Oil on canvas, 44 x 36.5 cm
Courtesy Galerie Isy Brachot, Brussels–Paris

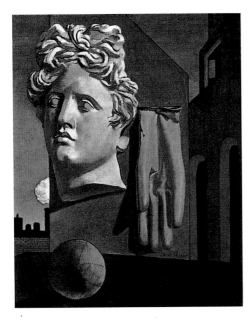

Giorgio de Chirico:
The Song of Love, 1914
Oil on canvas, 73 x 59.1 cm
New York, Collection The Museum of
Modern Art,
Nelson A. Rockefeller Bequest

Of course, Adeline Magritte's suicide raises many questions concerning the young man and future artist. Whether or not it is true that Magritte was present when his mother's body was discovered or that afterwards, as the eldest son, he felt a sense of importance vis-à-vis his brothers, or that the event gave rise within him to a "sensation of mystery" which he was to make the constant foundation of his doctrine; whether or not any of these things are true, it is obvious that the event cannot simply be put to one side when trying to illuminate the psychological facts which conditioned the deeper motives of the artist when he began to consider "what to paint" – to take just one of the phrases which open the many passages he himself composed in order to elucidate his intentions. The main question to be answered is this: did Magritte see his mother's suicide in Freudian terms as a total abandonment which triggered within him an endless questioning of the complex secret of all things, living and dead, which fills the existence of each and every one of us? Is this the event alluded to in a letter he wrote very much later, in 1956: "I, too, have a great many bitter memories, but I shall never understand what is meant by 'repentance'; I have feelings only of remorse" (letter to Maurice Rapin, dated 8 November 1956, quoted in: "Pure Art")? Was this experience, incidentally, certainly a traumatic one for Magritte, the source of those – the majority – of his works which play on the known and the hidden, the open and the secret, on sense and nonsense?

However that may be, psychoanalysis regards acknowledgement as the best therapy, if not in words, then at least through the medium of pictures. Magritte, however, showed little interest in psychoanalysis, above all when attempts were made to use it to interpret his paintings. "Our friend Freud . . ." he would say in jest. On this subject we do have some evidence in writing, namely a typewritten letter in English which he sent from London to Louis Scutenaire in March 1937. In it he tells of a visit to two South American psychoanalysts who had opened a practice in the British capital. The meeting had been arranged by Sébastian Matta. They talked about the meaning of Magritte's pictures, in particular the one entitled *The Red Model* (1937; illus. p. 35). It depicts two bare feet in the shape of ladies' boots, standing on stony ground against the background of a wooden fence. "So they see in my picture a case of castration. You see how simple that makes things, all at once. After several interpretations of this kind, I also did a real psychoanalytical drawing for them (you know what I mean): 'canon bibital' etc. Naturally they analyzed this picture with the same detachment. Between ourselves, it's terrible what one lays oneself open to when drawing an innocent picture" (Scutenaire, 1977).

In any case, throughout Magritte's œuvre there runs a whole series of pictures which suggest that the memory of his mother's body, reportedly found naked but for a piece of underwear clinging to her form, had never disappeared from his visual memory. In this connexion one could mention all the works in which pieces of cloth are depicted, in which human bodies appear, or which conceal situations in which such forms are hinted at. The most powerful pictures of this kind are undoubtedly *Homage to Mack Sennett* (1937; illus. p. 32) and *Philosophy in the Boudoir* (1947), which represents a variation on the same theme after a lapse of ten years: a ladies' night-dress, hanging in one case on a hook in a wardrobe and in the other on a coat-hanger, through which soft breasts are discernible. In a gouache (1966; illus. p. 33), likewise entitled *Philosophy in the Boudoir,* the sexual organs are depicted in the same way, but still more explicitly and with erotic vividness. The same penetrating eroticism

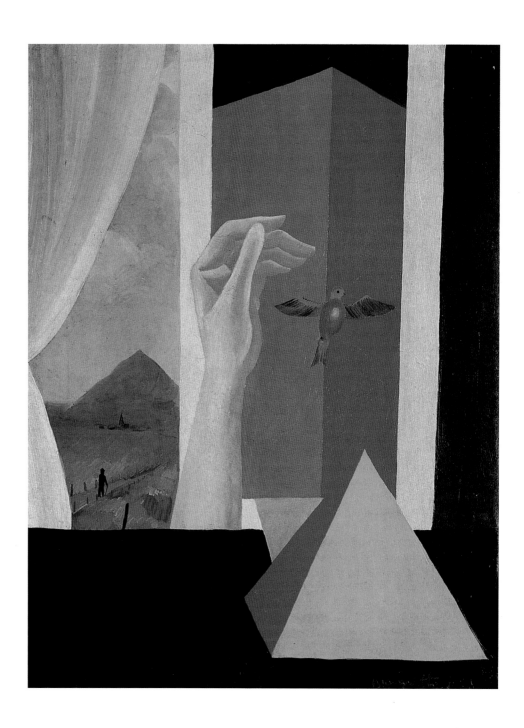

The Window, 1925
La fenêtre
Oil on canvas, 65 x 50 cm
Brussels, private collection

can be seen in the different variations of *The Rape* (illus. pp. 38–39; the first picture in the series dates from 1934).

In his writings and personal utterances, Magritte had little to say on the subject of eroticism. In his life, as in his pictures, it leads a concealed existence. The female nude, a central theme in many of his pictures, he obviously regarded mostly as a "thing" like any other motif, animate or inanimate. Treated sculpturally in many cases, the female body is just as much an object of desire as a visual display. Given that woman is, however, the symbol of a secret so actively pursued, perhaps Magritte was fascinated not so much by eroticism as such ("the pure and powerful sensation" he called it nonetheless) as by the latent invocation of complex mysteries. Look at the picture entitled *The Drop of Water* (1948; illus. p. 2), or imagine a classical bust, such as museums exhibit in the form of plaster casts: first one sees the object itself, then the reference to love. The attention of the observer is thus directed towards the sensuous,

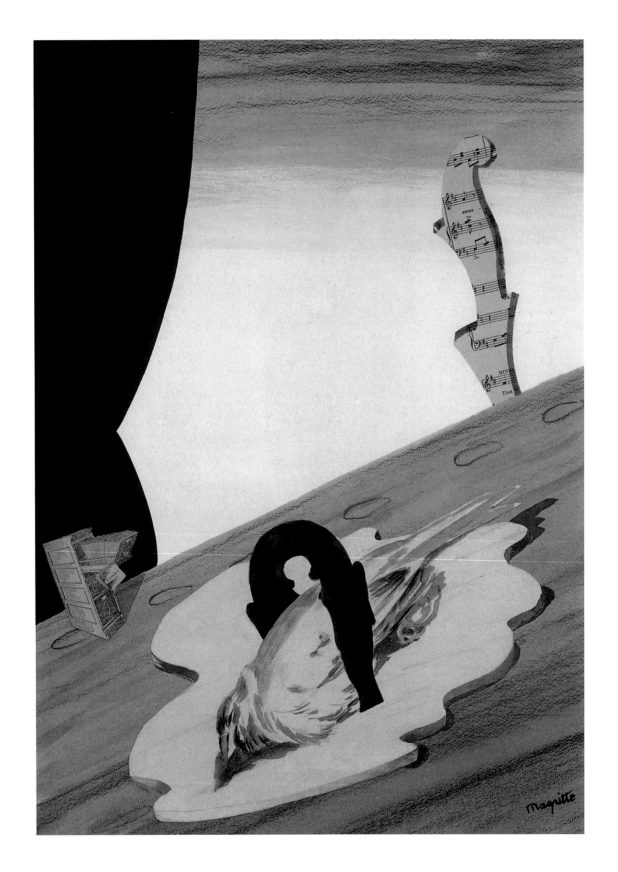

Untitled, 1926
Sans titre
Collage, 55 x 40 cm
Courtesy Galerie Isy Brachot, Brussels–Paris

Left Behind by the Shadow, 1926
Les épaves de l'ombre
Oil on canvas, 120 x 80 cm
Grenoble, Musée de Peinture et de Sculpture

allowing lust to take the path of poetic understanding. There is nothing crude in this whatsoever.

Incidentally, Magritte once recounted how, when he started, the idea of a totally new form of painting came to him, one which had no connexion whatever with existing movements such as Cubism and Futurism and the rest, but was, on the contrary, closely linked to sensitive magic, of which eroticism is generally a key element. In his case, however, it is supplied with accessories which cause it to shine out through childhood memories. This is not to say, however, that these memories have anything to do with the death of his mother. In actual fact, Magritte penetrated still further into his subconscious: he recounted how in an old cemetery he had once met a little girl who became the object of his dreams, and who found herself "translated to the lively atmospheres of stations, parties and towns which I created for her..." (Lifeline I). From here it was not very far to his highly individual *Alice in Wonderland* (illus. p. 166), even though Magritte was none too keen on Lewis Carroll's prose; he deplored Carroll's presenting his fables as though they were dreams.

What is concealed is more important than what is open to view: this was true both of his own fears and of his manner of depicting the mysterious. If he

The Threshold of the Forest, 1926
Le seuil de la forêt
Oil on canvas, 74 x 64 cm
Düsseldorf, private collection

wrapped a body in linen, if he spread curtains or wall-hangings, if he concealed heads under hoods, then it was not so much to hide as to achieve an effect of alienation. He employed this technique at a very early stage, for example in 1927 and 1928 with *The Invention of Life* (illus. p. 28) and *Symmetrical Cunning* (illus. p. 29), as well as in *The Lovers* (illus. p. 30) and *The Central Story* (illus. p. 31), certainly one of his major works. These veils are traps indeed!

But these decisions, which made Magritte what he was in the sphere of 20th century representational painting, can hardly have been clearly in his sights when he began his apprenticeship. Like all children, he drew and coloured. As an adolescent, he attended grammar schools specializing in the classics. In 1910, at the age of twelve, he was enrolled in a school in Châtelet where he was more or less introduced to painting. The story goes that on Sunday mornings there were lessons in pokerwork and "the decoration of umbrella stands". Contemporaries are said to have seen pictures by the young Magritte, who was regarded at the time as a sort of "prodigy". But can they be believed? These witnesses spoke of a picture dating from 1911 which depicted "horses stampeding in panic out of a burning stable". Ths painter's father is supposed to have destroyed it during the First World War. This motif would, indisputably, have been a harbinger of the themes he treated in later years (see, for example, the

Pleasure, 1927
Le plaisir
Oil on canvas, 73.5 x 97.5 cm
Düsseldorf, Kunstsammlung
Nordrhein-Westfalen

ILLUSTRATION PAGE 22:
The Forest, 1926
La forêt
Oil on canvas, 100 x 72 cm
Liège, Musée de l'art wallon

ILLUSTRATION PAGE 23:
The Man of the Sea, 1926
L'homme du large
Oil on canvas, 139 x 105 cm
Brussels, Musées Royaux des Beaux-Arts

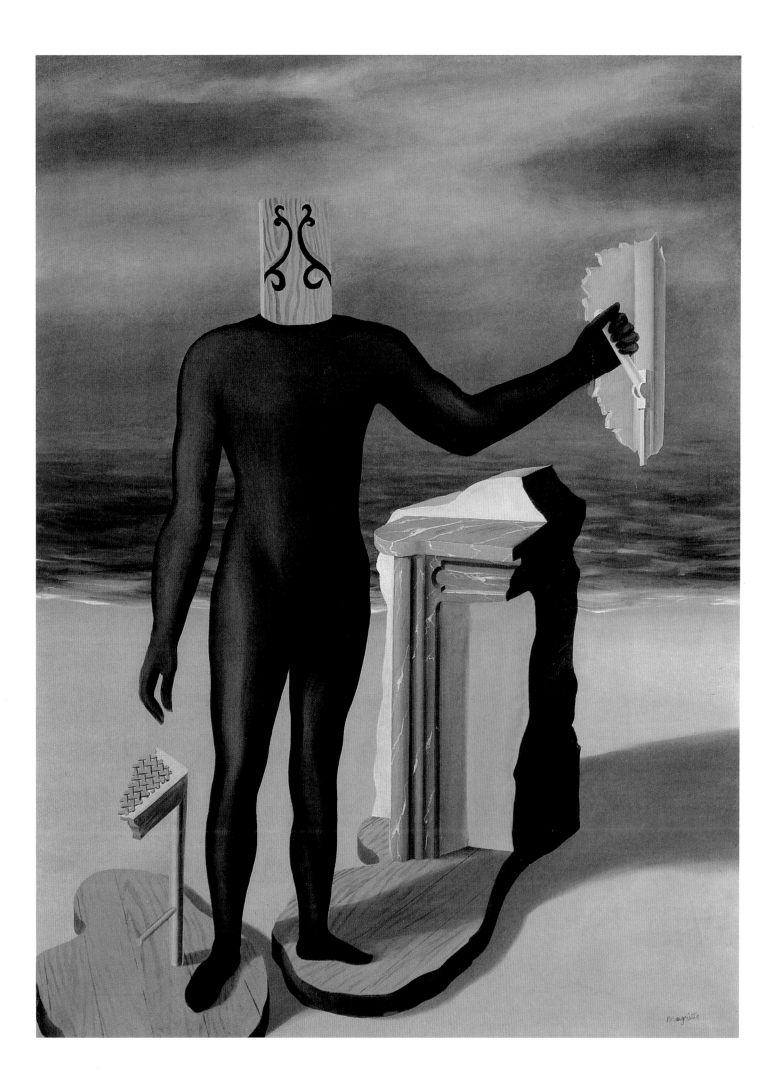

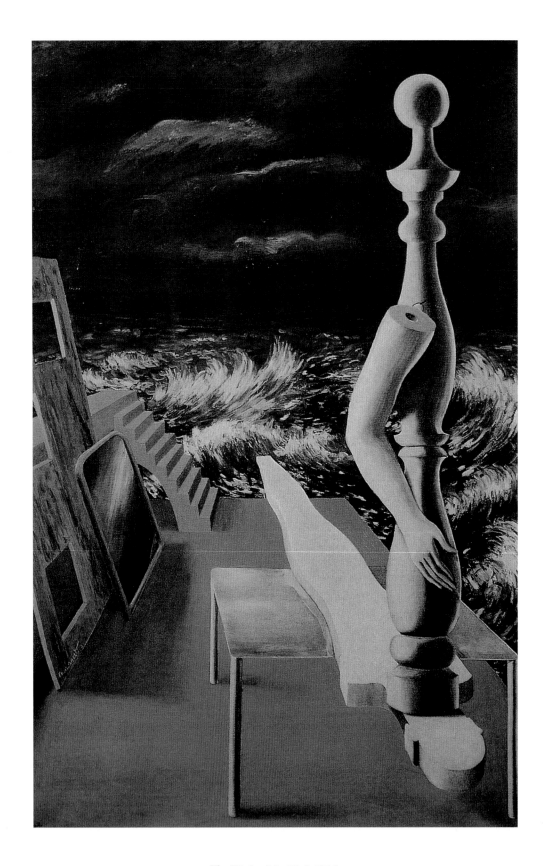

The Birth of the Idol, 1926
La naissance de l'idole
Oil on canvas, 120 x 80 cm
Private collection

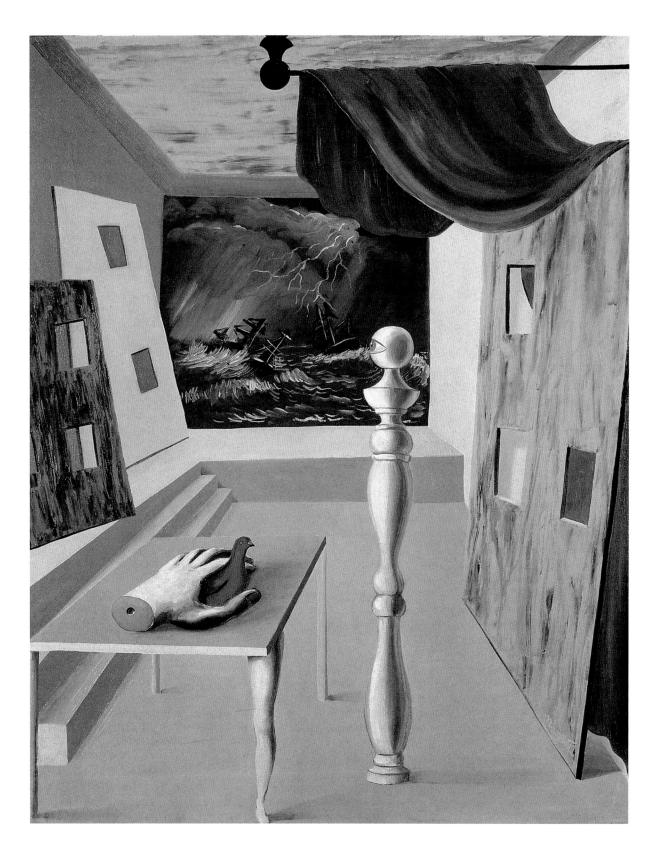

The Difficult Crossing, 1926
La traversée difficile
Oil on canvas, 80 x 65 cm
Brussels, Jean Krebs Collection

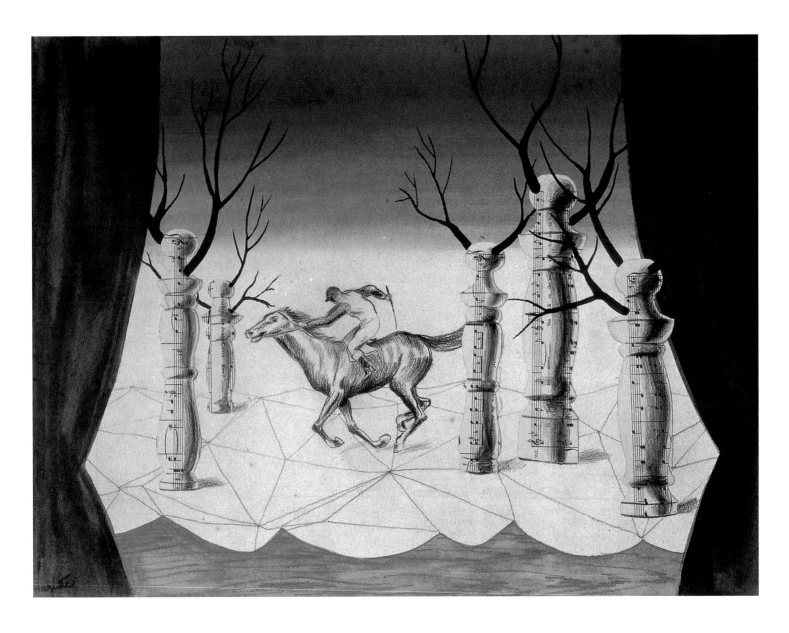

The Lost Jockey, 1926
Le jockey perdu
Collage, 39.5 x 54 cm
New York, private collection

unfinished picture, without a title, found on the easel at his death). However that may be, in 1916, at the age of eighteen, he entered the Académie Royale des Beaux-Arts in Brussels, thus underlying his resolve to become a professional artist. However, he only remained there for two years. "From the very outset of his time at the Académie, he displayed a youthful contempt for the institution, a contempt he now considers all the more presumptuous in that at the time he did not understand the aims being pursued there . . ." (Scutenaire, 1977).

Alongside the learning of technique, his short stay at the Académie also had certain effects on his early career, and perhaps on his later quest as well, besides on the ideas he was to hold for the whole of his life. His teachers in Brussels were the painters van Damme, Sylva, Gisbert Combaz and above all the Symbolist Constant Montald, whom several arstists of Magritte's generation have spoken of as a teacher, if not an artist, of interest. In all probability, Magritte's indisputable fascination with realism in the depiction of people and things, which he made into a fundamental principle of his whole endeavour, goes back to his time at the Académie. Then again, the Symbolism respresented by Montald, even though it was out of date by 1916 and totally lacked any clientèle, may well have given Magritte his own criteria for deciding "what to paint".

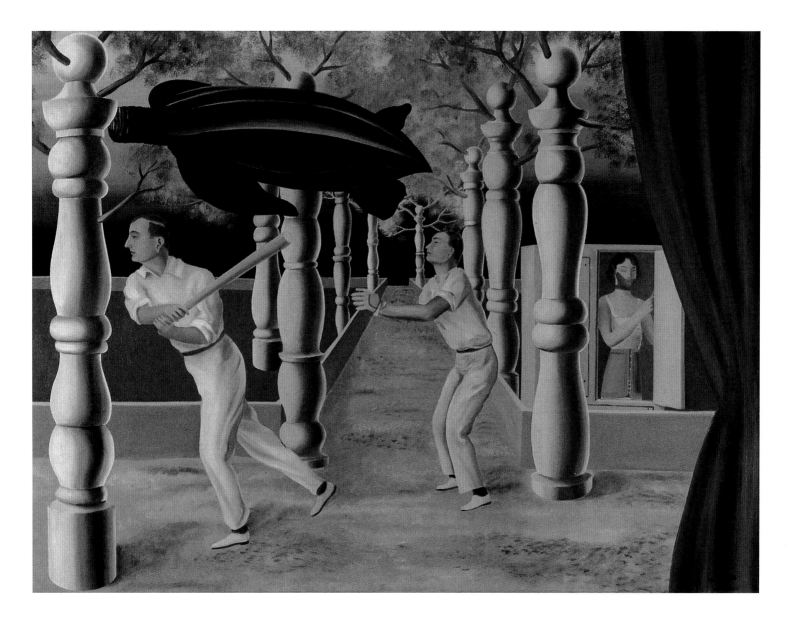

Magritte was never a friend of symbols in painting, though in poetry perhaps. In his mind, what was expressed by the one and by the other were fused. Thus the implicit contents of Symbolist ideology, utopian as they were, were not always as far removed as he thought from what he was striving for, accepted or rejected in his own endeavours. There was, to be sure, the slide of Symbolism into Art Nouveau and later into Art Deco, to which Magritte was by no means indifferent, if we are to judge by a pre-Surrealist canvas like *The Blue Cinema* (1925; illus. p. 6). And there was in Symbolism the striving for alienation as well as its appeal to the delirium of an imprecise way of thinking, a notion which in the present case is far more questionable.

It was from this direction too that a first modernistic collision occurred between the ineffable and the real, between the world of the dream and the world of the visible, between the things of the spirit and the concrete image. True, Magritte did not dream while painting – he saw himself as a "realist painter", dominated by the inspiration which emanated from his thoughts – but the fact remains that he saw the pictorial likeness as a means of "objectifying the subjective", which a Symbolist like Arnold Böcklin also reckoned as part of the artist's mission.

All in all, though, there are certainly more differences than similarities between Magritte's approach and that of the Symbolists, even if they were pre-

The Secret Player, 1927
Le joueur secret
Oil on canvas, 152 x 195 cm
Private collection

The Invention of Life, 1927
L'invention de la vie
Oil on canvas, 80 x 116 cm
Brussels, private collection

Surrealists. This may be demonstrated by a particular case. One has only to compare the picture by Fernand Khnopff, successively entitled *The Sphinx, Art,* and *The Caresses* (1896), which is regarded as one of the masterpieces of Belgian Symbolism, with the two versions of *The Choir of the Sphinxes* (oil, gouache, 1963 and 1964; both illus. p. 143). These are typical of Magritte's way of using a picture to burst open reality and to confuse the observer by giving a picture a title whose connexion with the object depicted can only be understood via unexpected – and relative – associations. This choice of title can only be justified by poetic caprice and intellectual game-playing. While Khnopff's picture depicts a Graeco-Roman background with an ephebus resting his head against a nonchalant and delighted being, half woman and half leopard, Magritte's picture has nothing to do with classical mythology. It depicts a forest firmly rooted in the ground above which, in a sky with well broken cloud, there hover difficult-to-identify objects: flat sections of the foliage of the trees above which they are flying. The only sphinxes on this picture are those one wants to see, for example the choir of primordially silent trees whose sudden soughing swells up until it dissipates in the sky.

But that is not important. Magritte's intention was different. In fact the heart of the major difference between Magritte and the Symbolists lies in the concept of "symbol" itself. Magritte always made it quite clear what he meant in this context. His ideas on the subject were summarized in a short introduction which appeared in the catalogue to the exhibition entitled "Le sens propre",

which was organized by Alexandre Iolas in Paris in November 1964. This includes the following passage: "One would have to be ignorant of what I paint in order to associate it with a naive or learned symbolism. On the other hand, what I paint implies no superiority of the invisible over the visible; the latter is sufficiently rich to form the poetic language which evokes the mystery of the invisible and the visible." Also in 1964, on the occasion of an exhibition entitled "La part du rêve" held in the Musées Royaux des Beaux-Arts de Belgique in Brussels, in which he took part, Magritte restated his attitude in particularly vivid fashion. A glass case had been set up, containing a number of objects specially made for the purpose. An accompanying notice referred to them as "symbols". The painter wrote to the Chief Curator of the museums in the following terms: "I consider it desirable to avoid any misunderstanding in this regard . . . these are objects (bells, skies, trees etc.), not 'symbols'" (letter to Philippe Roberts-Jones dated 26th April 1964).

However, this object-centred – or objective – realism did not appear in all its ramifications immediately and Magritte gave up his academic studies to embark on his own quest. His first recorded works were post-Impressionist, and later para-Expressionist in character (for example, a *Nude* dating from 1919; illus. p. 13). But these were not the paths he was seeking.

The Académie in Brussels was responsible for one event which more than anything else was to bring him into contact with the fashionable tendencies of the period, namely his meeting with fellow-student Victor Servranckx. They even co-authored a short essay entitled "Pure Art" and subtitled "A Defence of the Aesthetic". Dating from 1922 or 1923, this unpublished essay was signed by both, and it is difficult to tell who wrote which parts of it. It is no less difficult to discern what it was that perhaps even then set Magritte apart from his temporary fellow-travellers. It was around this time – 1919 or 1920 – that he met the Bourgeois brothers – Pierre, the poet, and Victor, the architect – and the Parisian-born painter Pierre Louis Flouquet, who was then living in Brussels and for a short time shared a studio with Magritte. They were joint

Symmetrical Cunning, 1928
La ruse symétrique
Oil on canvas, 54 x 73 cm
Courtesy Galerie Isy Brachot, Brussels–Paris

The Lovers, 1928
Les amants
Oil on canvas, 54.2 x 73 cm
Brussels, private collection

ILLUSTRATION OPPOSITE:
The Central Story, 1928
L'histoire centrale
Oil on canvas, 117 x 80 cm
Courtesy Galerie Isy Brachot, Brussels–Paris

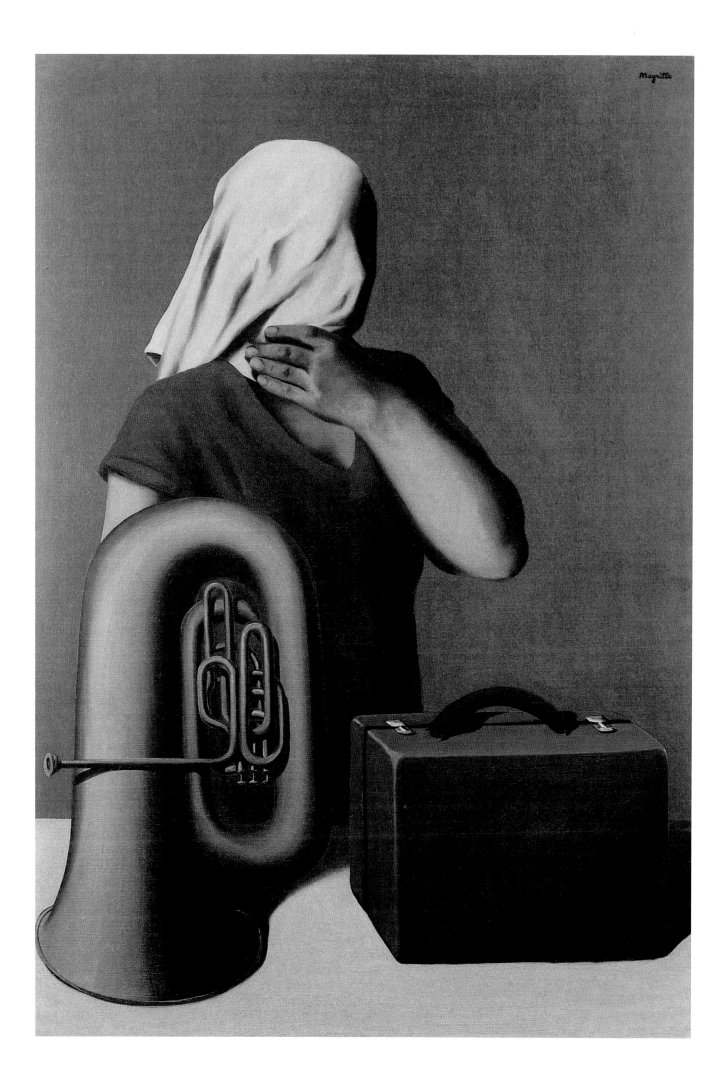

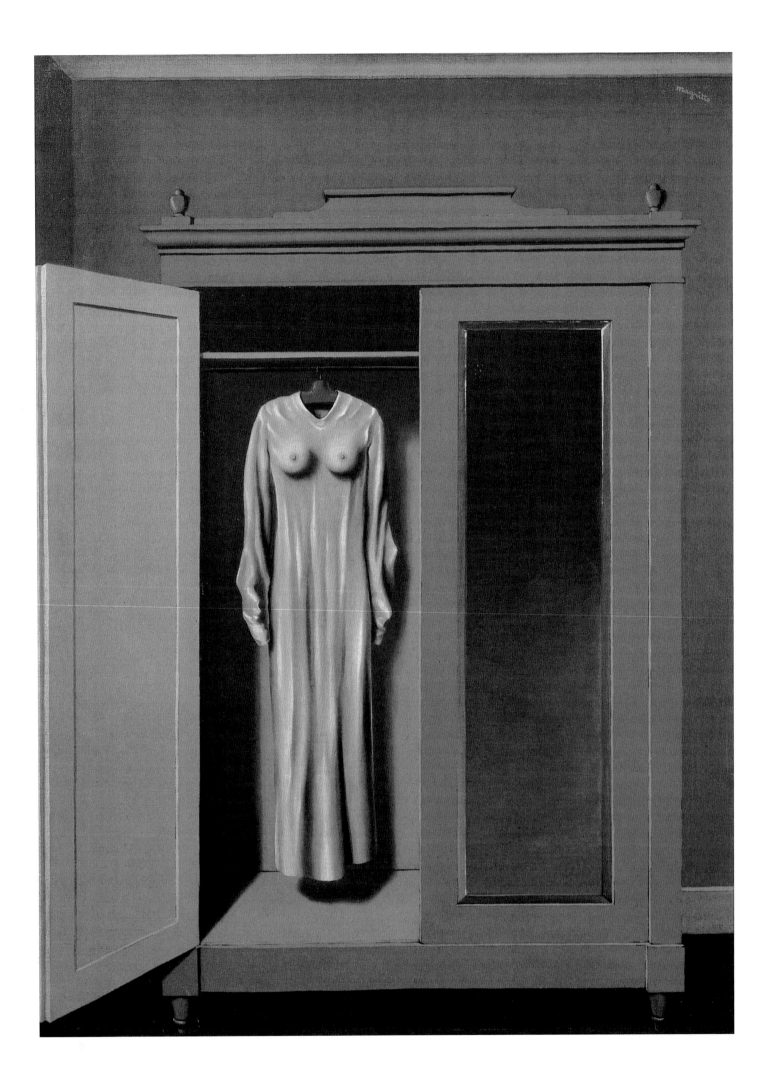

publishers of a short-lived periodical entitled "Au volant" and together, or else in concert with other artists, they held exhibitions of their work, including posters as well as one picture by Magritte which shows the influence of Cubism: *Three Women* (1922). These artists were close to what were at the time the most up-to-date trends in aesthetic purism, whose source was the Dutch group "De Stijl", the founders of Constructivism. Magritte did not feel at ease in this company; but from the publications which he and his friends passed around he discovered Futurism, in which he took great interest. This can be clearly sensed in his pictures dating from this period, which hover between Cubism and Futurism. In 1959, writing to André Bosmans, he said that these were the two directions between which he would have hesitated "if I were really an artist-painter".

The attractive thing about Futurism was that it attempted for the first time, where the painted picture was concerned, to achieve a pictorial synthesis between technical effectiveness and the art of painting, while at the same time proposing forms of composition and colouration which managed without recourse to the traditional effects of the representational painting of the 19th

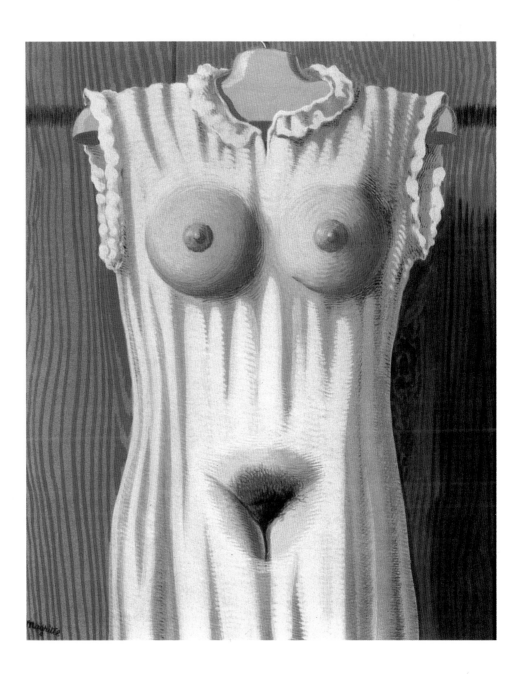

Philosophy in the Boudoir, 1966
La philosophie dans le boudoir
Gouache, 74 x 65 cm
Private collection

ILLUSTRATION OPPOSITE:
Homage to Mack Sennett, 1937
En hommage à Mack Sennett
Oil on canvas, 73 x 54 cm
La Louvière, Municipal collection

century. But in Magritte's eyes it had the disadvantage of remaining true to an aestheticizing interpretation of the real. He had therefore to wait until 1925 for the true revelation; this came in the form of Giorgio de Chirico's "metaphysical" picture *The Song of Love* (illus. p. 16), a reproduction of which had been shown to him by the poet Marcel Lecomte. Magritte was seized with enthusiasm.

In 1925 the first Surrealist Manifesto by André Breton was just one year old. Magritte's closest friends were no longer those of the previous years, a development helped on its way by the incipient Surrealist movement.

Nonetheless it is instructive to dwell for a moment on the period during which he and Servranckx were together. Servranckx himself was developing into an abstract painter, but one who was not indifferent to Surrealism. He introduced Magritte to a carpet-manufacturer as a pattern designer. This episode is noteworthy in that it introduced our subject to various possibilities of earning a living on the fringe of artistic activity without having to surrender the freedom essential for all creative endeavour. Magritte worked for two years in the studios of the Peeters-Lacroix carpet factory on the outskirts of Brussels, and thus grew accustomed to bread-and-butter commission work. During the same period he was designing advertising posters, another activity which enabled him to "keep the pot boiling" and, in particular, a few years later (1931–36), together with his brother Paul, to open the "Dongo" advertising studio. These bread-and-butter jobs also gave him the chance to familiarize himself with techniques and materials which he could use in his artistic capacity: collage, and the science of creating an eye-catching picture. They also taught him that on the ethical plane the line separating the so-called applied arts from "great art" – or what passes for such – is a narrow one indeed. This is presumably the source of Magritte's indifference – in total agreement with Marcel Duchamp and his ready-mades – to commission work, whether portraiture or advertising, or anything in between, which he nonetheless reluctantly undertook. Above all he maintained a consistent detachment towards the fantasy of the "unique piece", so beloved of collectors. His attitude was quite explicit: he would produce paintings with similar subjects, he would, on demand, produce copies of the same subject with slight variations, he would make recurrent use of a formal vocabulary and its pictorial elements, and so on. For the same reason, finally, he was indifferent to riches and renown.

Magritte's friends in the years subsequent to 1924 – the members, in effect, of the original Brussels Surrealist group – were to remain close to him for many years. As early as 1920, he had met Édouard L. T. Mesens, who had been engaged as piano teacher to his brother Paul. Mesens was something of a jack-of-all-trades and, contrary to proverbial wisdom, a master of all: he was a talent-spotter, a gallery-owner, an exhibition organizer, a bon vivant, a gourmet, critic, poet, collagist, and "most potent at potting". He ran or founded art galleries in Brussels, Paris and London, where he was indefatigable in supporting the work of his friend. Like Magritte, he seized on the Surrealist idea as a longed-for and providential opportunity for young artists to combine head and heart in their activities: in other words, to scandalize. One of them (Paul Nougé, c. 1925) said that they chose Surrealism "for ease of conversation". With respect to the Paris group, in particular, this could be taken as a declaration of independence; it could also be seen in a confused political context, in which the mutual contradictions of communism and anarchism were jumbled together.

"The problem of the shoes shows how easily the most frightful things can appear quite harmless as a result of the power of carelessness. Thanks to 'The Red Model' one can feel that the unification of the human foot with a shoe in reality goes back to a monstrous custom."

The Red Model, 1937
Le modèle rouge
Oil on canvas, 183 x 136 cm
Rotterdam, Museum Boymans-van
Beuningen

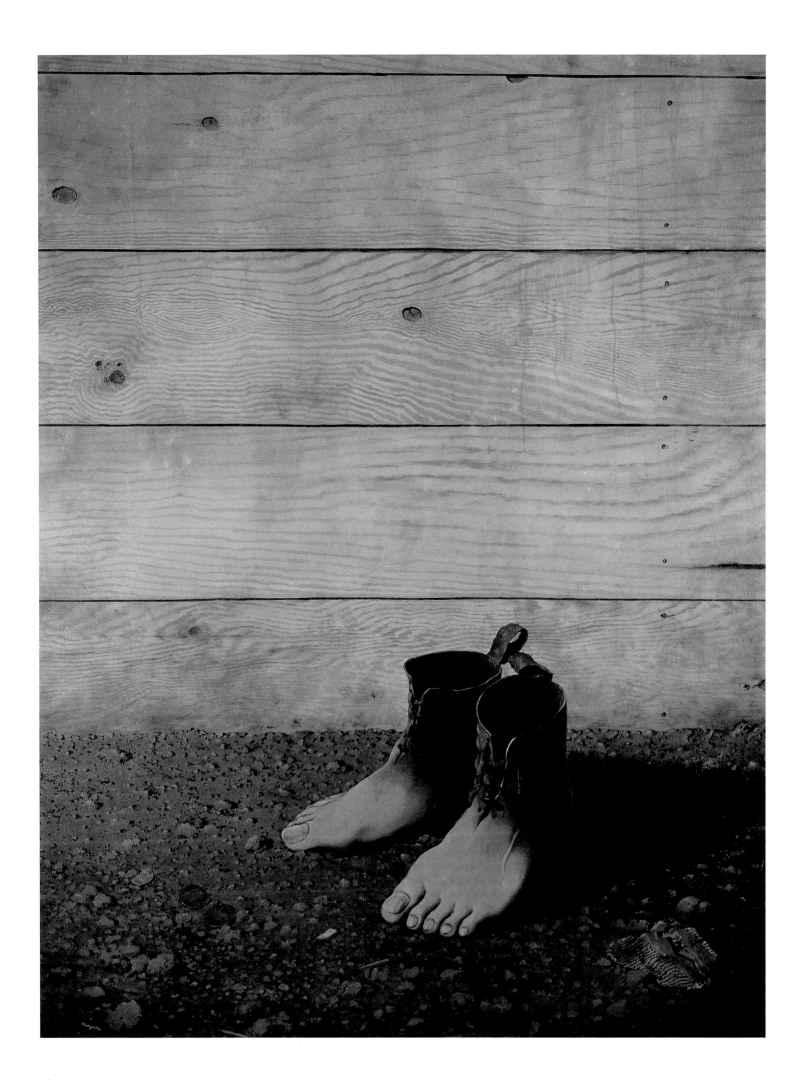

The passing years saw an enlargement of the circle of friends around Magritte and his wife Georgette Berger, whom he had married in 1922. The closest companions-in-surrealism (in the order in which he met them) were: Camille Goemans, who married the gallery-owner Lou Cosyn, Marcel Lecomte, Paul Nougé, André Souris, Louis Scutenaire and Irène Hamoir, Paul Colinet and Marcel Mariën. To these may be added others whose membership of the circle was more sporadic or only came later, including Gérard Van Bruaene, Achille Chavée, Marcel Havrenne, the Hainault Surrealists and, after 1945, Jacques Wergifosse and André Bosmans. A noteworthy feature of this list, both in respect of the exchanges which inspired and, in part at least, upheld the artist's lively imagination, and in respect of the definition is that, of the people closest to him, not one is or was a visual artist, except by accident. Magritte's friends were all writers, poets above all, occasionally thinkers, in general, intellectuals. Although by and large they all displayed markedly independent minds, they clustered around Magritte like courtiers around the painter-king. They constituted a group in themselves, albeit an informal one, which liked to become active periodically as such, in order to exercise the "collective inventiveness" which provided the title for one of the magazines published by the painter and his friends in 1940.

While they were in the course of preparing this publicaction, the members of the group could see the clouds of war, which had already engulfed Germany, France and Great Britain, approaching dangerously close to the Belgian frontier. It is thus not surprising that their poetic views became mingled with, and almost overshadowed by, their largely left-wing political opinions. René Magritte, a sporadic member of the Belgian Communist Party, had prepared an introduction to the first number of the periodical. It is brief. We can quote it here in full, in that it reveals the scope of a strand of artistic and ethical thinking not only in the face of imminent events, but also in view of the fact that this way of thinking was now challenged by the reaction of the masses, of a humanity, in fact, caught up in an ecstasy of power. The tone of this 1939 text provides an insight into the (not always so transparent) personality of a man who was a man of his time, a Magritte who tended towards anarchism. It is moreover an example of his attempts on the moral plane to harmonize the meaning he gave to his work as a painter with that of his life. "Man's will is fashioned in such a way that he does all in his power to accomplish a Utopian task. The consent of those who carry out the task is obtained by the use of threats and words which appear to designate indispensable realities. The world is blinded by this blackmail, and yet it shows a legitimate disquiet, albeit one which is quickly appeased by the somewhat vague hope that wishes are going to be fulfilled somehow or other. As long as our means last, we Surrealists cannot put an end to this campaign of ours, which puts us in absolute opposition to the myths, ideas, feelings and behaviour of this ambiguous world" ("For 'L'invention collective'", p. 99).

This brief text contains some hard words, which point the way to a better understanding of the Magritte problem. Some appeal to the emotions: Utopia, disquiet, hope, wishes; others to existential constraints: blackmail, consent, carry out. The word "ambiguous" and the expression "we Surrealists" go beyond what appear to be the concerns of painting and art, in the eyes of those who believed art was justifiably a form of escape. For Magritte it was above all a form of thought, comprehending everything, the world and what it has to offer. Painting was chance. When he said: "If I were really an artist-

"... I put an as yet unknown mermaid on the beach, whose head and top half were those of a fish, while her bottom half was that of a woman."

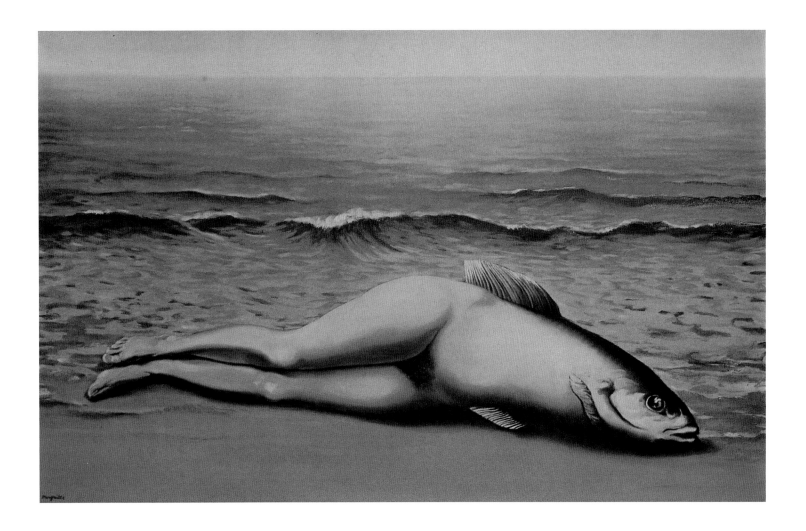

Collective Invention, 1934
L'invention collective
Oil on canvas, 75 x 116 cm
Private collection

painter . . .", he must have meant that in reality he was not. But then what was he? A scandalous malcontent, constantly stoking up our fears with sinister pictures and with the riddles that confront us all? Absolutely! For this unique man there was no such thing as common sense; all the convictions in which one trusts are false. It was not a matter of chance that he quoted the following passage from "The League of the Frightened Men" by Rex Stout: "Written or printed words mean nothing, unless they are intended for people's entertainment" ("Amentalist Manifesto"). Accordingly, what was needed was the introduction of a new logic, perhaps through the medium of the picture as a corrective to language.

In short: formal training, individual searching, family events, changing companions, the road from abstraction to Cubism, to Futurism and to Expressionism – all these were stations along the winding path which Magritte travelled between 1910 and 1925, between the ages of twelve and twenty-seven, in the process of gathering his first serious experiences as a painter, a painter who did not want to be an "artist-painter". In 1925 this development came to an end; from now on, he was concerned "only to paint objects with their evident details" ("Lifeline I"). This was the moment, then, which marked the taking of a definitive decision. A Surrealist just one year after the publication of Breton's "Manifesto", Magritte chose to become a "realistic painter", one for whom reality – in other words, what we see all the time – is the privileged medium for turning convention on its head and transforming it into an enigma and, at the same time, revealing to the greatest degree possible the

The Rape, 1948
Le viol
Gouache on paper, 18 x 15 cm
Private collection

The Natural Acquaintanceship, n. d.
La connaissance naturelle
Drawing on beer-mat, 9.5 x 9.5 cm
Courtesy Galerie Isy Brachot, Brussels–Paris

The Rape, 1934
Le viol
Oil on canvas, 25 x 18 cm
Courtesy Galerie Isy Brachot, Brussels–Paris

mystery that it contains within it. We shall be returning later to this unexpected approach to a totally novel form of Surrealism.

As Magritte himself explained, the first picture to take account of this decision was *The Window* (1925; illus. p. 17). On the other hand, the first picture which he described as "Surrealist" and "successful" dates from 1926. It is *The Lost Jockey*. There are a number of versions of this motif, the first also dating from 1926, another dating from 1940, and yet another from 1942. One version was produced in 1940 as an oil-painting (a medium used by the painter throughout his life). It depicts a jockey pictured against the light, riding along a straight avenue lined by large chessmen resembling wooden skittles turned on a lathe. The background is formed by a pattern of branches, and the right hand edge of the picture is shut off by a tapestry curtain, as if the action were taking place on a theatrical stage. Another version (illus. p. 26) combines various techniques: collage, water-colour, Indian ink, chalk. It also depicts a scene bordered by heavy curtains, this time to the left as well as to the right, in the middle of which the mounted jockey is drawn in great detail. At the horizon the white ground gradually shades into the blue of the sky. The track is covered by a geometric network of fine lines. The trees are bare, and there are fewer of them; their trunks are drawn in the form of turned skittles, and covered with musical notes and staves.

A major part of Magritte's dictionary of objects and things is already there in the first pictures acknowledged by the painter as initiating the style he had chosen. These objects and things are primordially visual in character and require no a priori interpretation. A jockey is a jockey, a curtain is a curtain, the trees are trees, a skittle is a skittle and so on. But what are they doing juxtaposed like this? And what are these objects and things doing in another picture (dating from 1927, the same period in other words), which is even more complex, namely *The Secret Player* (illus. p. 27)? Like a mixture of the two preceding works, animate figures are depicted within a framework of trees, a rigorously defined ground and skittles; this time they are two pelota players. But above them there is not a ball, but a dark shape resembling a giant tortoise (or a duck-billed platypus, an anomalous mammal that seems to combine every stage of evolution within itself). On the right-hand side there is a cupboard containing a woman at her toilet, the lower half of her face concealed behind a "chador" or, more probably, by one of those nets used by men to tie up their beards when they were washing their faces. A bearded lady, then?

Within the space of hardly a year, between the 1926 version of *The Lost Jockey* and the 1927 version of *The Secret Player,* one has the impression that both the language and the presentation have grown considerably stronger: realism, now acknowledged, has allowed the possible to be transcended in order to achieve the unforeseen. This was the source, practically, of all the rest until 1967, when Magritte left this world in his turn. Did he really decide in favour of Surrealism "for ease of conversation" or, in other words, *faute de mieux?*

While it is fairly easy to trace Magritte's path back to the moment in which he made his crucial decisions, it is less easy to discern the sources which introduced into his vision, and into the arsenal of figures he employed, the things which are regonized today as forming an integral component of his world. Certainly, many of the "things" he depicted derive from our perfectly ordinary everyday surroundings. There are others, too, which have their origin in the cheap illustrated magazines and novels, the advertisements, detective fiction –

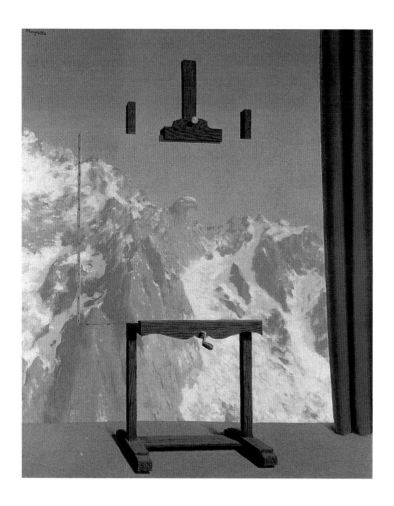

Arsène Lupin! – and popular scientific literature of the 19th century, or else in the cinema: Scutenaire has told of the great attention devoted by the painter to the film-comedies and war films of Sinoël and Erich von Stroheim (cf. illus. p. 197). There are however, in the background of Magritte's inspiration, other influences which perhaps drew on what he saw while thumbing through volumes of art history and remained in his visual memory, albeit in spite of himself. Perhaps. Who knows?

Thus, in the highly penetrating introduction he wrote for the Magritte Retrospective held at the Palais des Beaux-Arts in Brussels and the Centre Pompidou in Paris in 1978–1979, David Sylvester notes that while Magritte probably found his inspiration in popular, everyday sources, there might well have been other "unappreciated" but "exceptionally interesting" sources, to wit: Paolo Uccello himself. In particular, Sylvester compares Magritte's *The Lost Jockey* with Uccello's panel *The Hunt,* which shows men on horseback fighting animals in a wooded landscape. Sylvester advances the further hypothesis, "less certain but not at all unlikely", which would explain the recurrent use by Magritte of *bilboquets.* As he goes on to say, one could find similar pictorial elements in Uccello's *Profanation of the Host,* where he did indeed use twisted pillars to separate the scenes which together formed his picture. Are they really things in the form of *bilboquets*, or are they skittles turned on a lathe, or are they derivatives of chessmen, chess being a game in which Magritte excelled. Or are they simply "table-legs", as he maintained, thus giving short shrift to the Uccello hypothesis?

In his book published in 1974, Abraham M. Hammacher notes the existence in many of Magritte's compositions of traces that hark back to the metaphysics

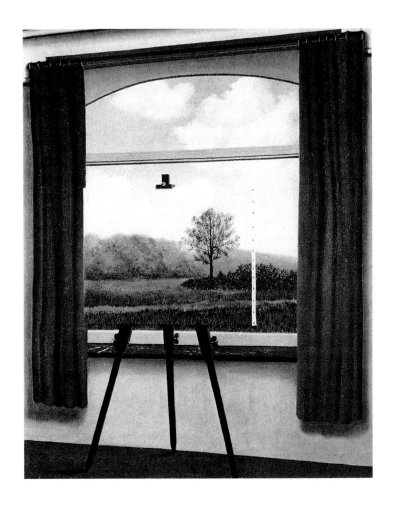 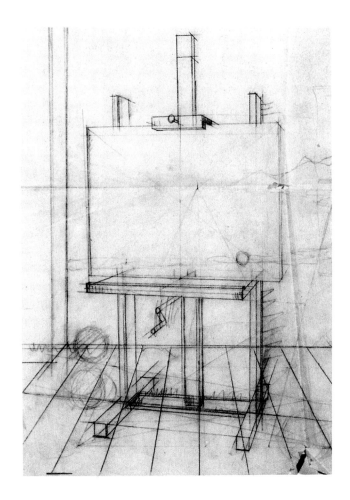

ILLUSTRATION LEFT:
The Human Condition, 1933
La condition humaine
Oil on canvas, 100 x 80 cm
Courtesy Galerie Isy Brachot, Brussels–Paris

ILLUSTRATION RIGHT:
The Human Condition (Study), 1935
Drawing, 56 x 55 cm
Courtesy Galerie Isy Brachot, Brussels–Paris

of Giorgio de Chirico. On the other hand, he is digging up too much art history when he sees similarities between the "hard light" of Caravaggio and that of Magritte, or when he notes the latter's use of "brilliant dark" greens for foliage as being comparable with the painting techniques of the 15th century. In the case of the picture *Personal Values* (1951/52; illus. p. 98), Hammacher is reminded of the Italian interiors of the 16th century, in particular with regard to the tricks with proportions which Magritte was also fond of. And as for *The Blank Cheque* (1965; illus. p. 65), he even makes a plausible comparison between the use of space by Magritte and by the painters of the pre-Renaissance, to "to oppose movement and modify depth", and thereby introducing the element of the imaginary.

Finally, in the same context, he mentions the German Romantics, in particular Caspar David Friedrich, singling out Magritte's pictures entitled *The Human Condition* (1933 and 1935; illus. pp. 41 and 43). These are "pictures within a picture". They depict a window, or some other opening to the outside, in front of which stands a canvas on an easel. On this canvas is depicted the same landscape as, theoretically, exists in reality as the view through the window. One can go even further. A recent work by Roland Recht on the invention of photography and the use of illusion by the German Romantics contains valuable clues to the antecedents to which Magritte could have had recourse ("La lettre de Humboldt", Paris 1989). Certain pictorial problems thrown up by the German Romantics are indeed reminiscent of those posed by Magritte, even though, in his case, Romanticism created no more than a "melancholy atmosphere".

Recht reports that Friedrich Schlegel, one of the founders of the Romantic

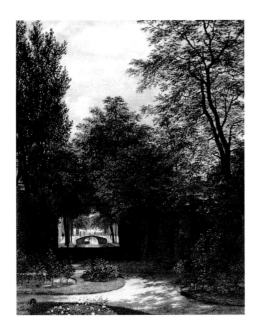

Bartholomeus Johannes van Hove:
Garden in The Hague, 1828
Oil on canvas, 83 x 67.5 cm
The Hague, Gemeentemuseum

The Human Condition, 1935
La condition humaine
Oil on canvas, 100 x 81 cm
Geneva, Simon Spierer Collection

School in Germany, commented on the problematic nature of windows as deriving from their situation between the landscape and the person regarding it. The same applies to *The Human Condition,* pictures in which Magritte sought to solve the same problem by means of his own. 150 years before his time the gardens of the landscape architects, with their painted panoramas, were pointing in the same direction. "In many gardens paintings were set up to be seen through an arch or the entrance to a cave, which produced a strong sense of illusion"(Kurt Breysig, quoted *ibid.*). Recht, for his part, adduces a reproduction of *Garden in The Hague* by the Dutch painter Bartholomeus Johannes van Hove (1828; illus. p. 42), which features in the distance, in the opening of an avenue lined by tall trees, a painted view of a bridge and of river-banks themselves tree-lined, the lower branches of the "real" trees covering the upper edge of this additional, artificial panorama and, indeed, continuing it further. Could one not associate this Romantic Dutch painting with that by Magritte entitled *The Waterfall* (1961), which depicts an easel on which is a picture of a wood, the whole ensemble being placed among leafy branches which encroach on the picture?

Natural nature, as domesticated by the gardeners, thus receives an addition in the form of painted nature. But does the fact of its being painted thereby render it factitious? Or is it not rather a matter of illustrating a "theology of light", as maintained by Recht, who had already noted the extent to which Romantic dioramas introduced the viewer into the frame formed by the cycle of hours and days? On this particular point we have a statement by Magritte himself. This is attested by the various versions of *The Empire of Light* (1954; illus. p. 101), and even by the unfinished, untitled picture of 1967. Both are characterized by the interplay between day and night, between opposites which are nevertheless complementary. For him light, and its absence, are at the very origin of the mechanisms of mystery. The power of day and night to "enchant us" (as he says, with justice, with reference to *The Empire of Light*) is none other than the power of poetry.

But to turn the clock back in the search for sources, plausible or implausible, recognized or unrecognized, is pointless, except for the purpose of ordering this œuvre, in its entirety, in some eternalistic history of art, which the painter for his part, incidentally, rejected. Magritte's painting was in many respects so innovative that it deserves a place of its own in the history of art. It is not enough to attempt to straitjacket it in movements such as Romanticism, Symbolism or Surrealism.

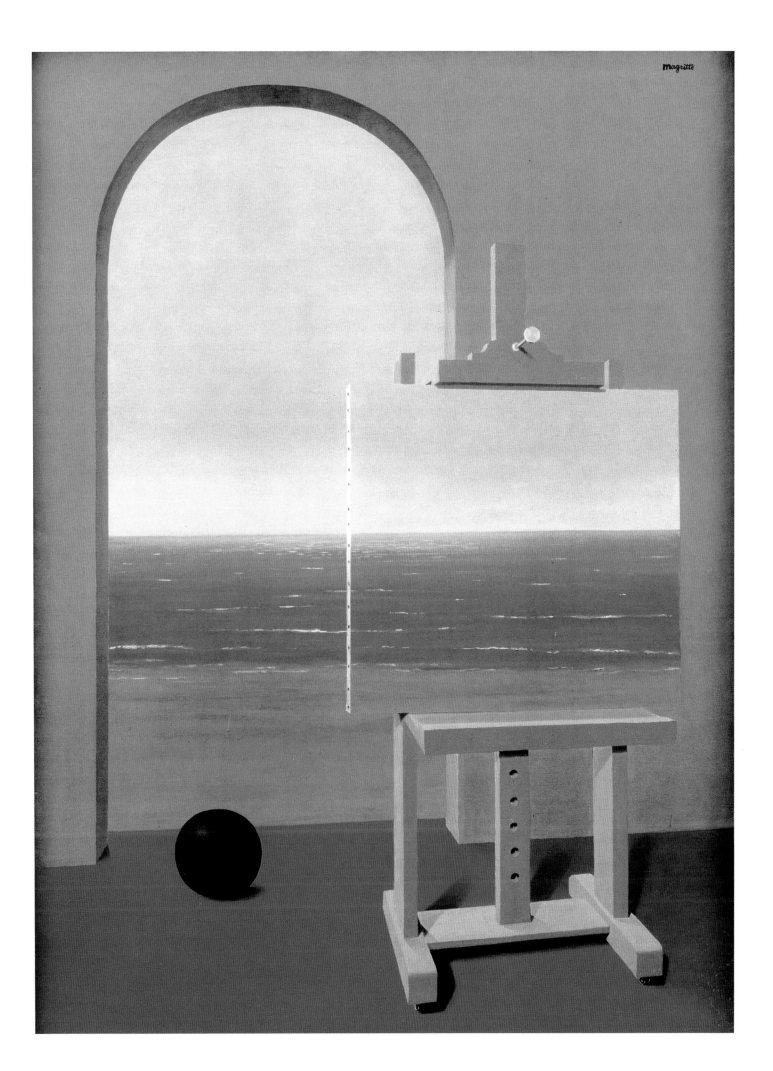

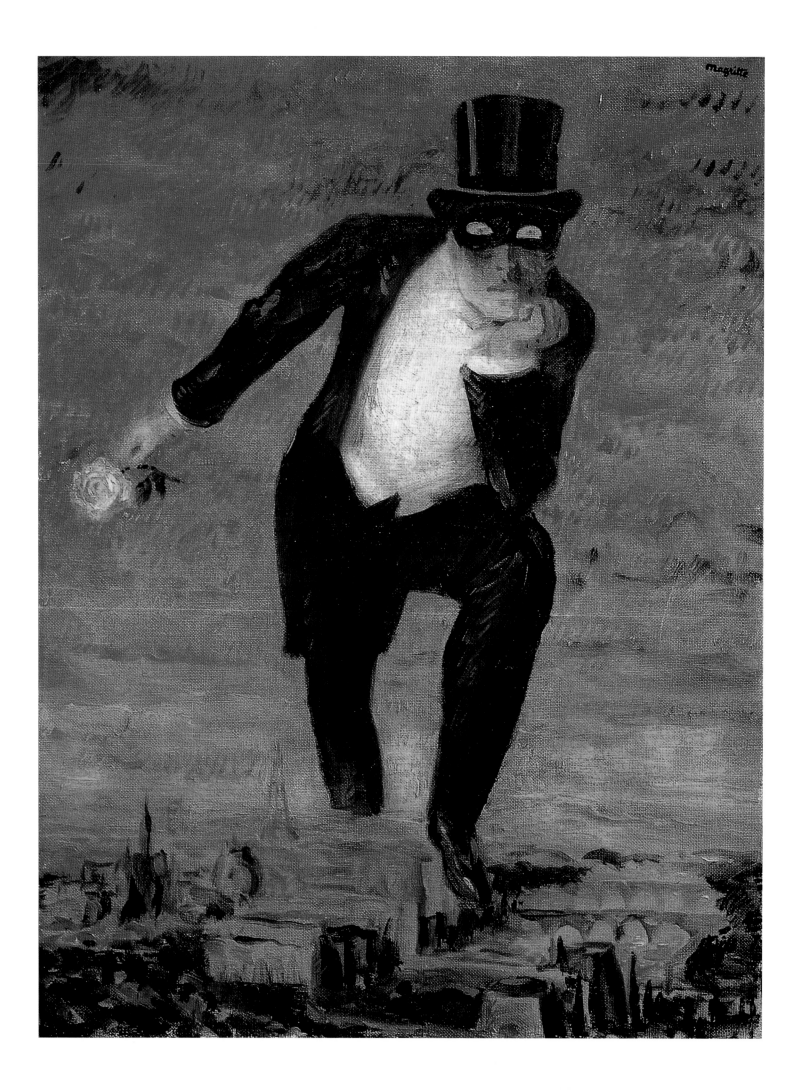

The Undogmatic Surrealist

Without fear of contradiction, it can be said of all the great Surrealist painters from Max Ernst to Salvador Dali, from Yves Tanguy to René Magritte, that they were original to the extent that they neither copied nor were copied, even though some of their successors may have tried. But Magritte's originality resides elsewhere too, in particular in his special relationship to Surrealism and to the Paris group which thought of itself as the movement's soul. Magritte's originality manifested itself primarily in his fundamental attachment to the world as it is, and on this basis proceeding always from the evidence of reality; all the rest derives from this. He mobilized the sub-conscious via the bias of the pre-conscious, and this in turn via the bias of the obvious. Thus he confirmed that truth is stranger than fiction and that the conscious thus takes precedence over the unconscious. He was practically the only Surrealist to proceed thus and to have placed himself deliberately outside an art of fiction founded on a para-Freudian appeal to neurotic forces.

René Magritte next to his picture 'The Barbarian' (destroyed during the Second World War)

Paul Nougé was thus able to assert with total justification that the activities of the Brussels group which formed around Magritte in the years after 1925 were called Surrealist simply "for ease of conversation". A number of conclusions can be drawn from this, supported by numerous facts dating from throughout the life of the movement. The first conclusion is that the Belgians knew from the very outset how to keep their distance, politically and intellectually, from other groupings, even including the one which had introduced the epithet "Surrealist", in other words the writers and visual artists who had gathered around the "Pope" of the movement, André Breton. Secondly, it should be borne in mind that the "Surrealist decision" on the part of the Belgian artists, whether from Brussels or from Hainault, was due as it were to chance, insofar as Breton's manifestos fell on fertile ground in southern Belgium. Magritte's more or less close companions in arms, who were active within the context of what was meant by "Surrealism", were engaged at the time in a search for a consensus on a new conception of artistic creativity and the freedom which it requires. One of Magritte's very first known writings (in collaboration with others, among them E. L. T. Mesens) may cast more revealing light on this question. It dates from the year 1925 and was intended as an introduction to the periodical "Oesophage" which, however, only ran to one number. Beneath the title "How Far the Development Might Lead", one can read as follows: "When the Will is no longer the slave of things, everything seems lost, and it becomes possible to produce pictures of a wonderful universe – creation – only to drop them again immediately – critique. One is so serious that nothing is taken seriously any longer except negation. And thus the development does not stop here, but rather begins. Often one will skim the

The Return of the Flame, 1943
Le retour de flamme
Oil on canvas, 65 x 50 cm
Private collection

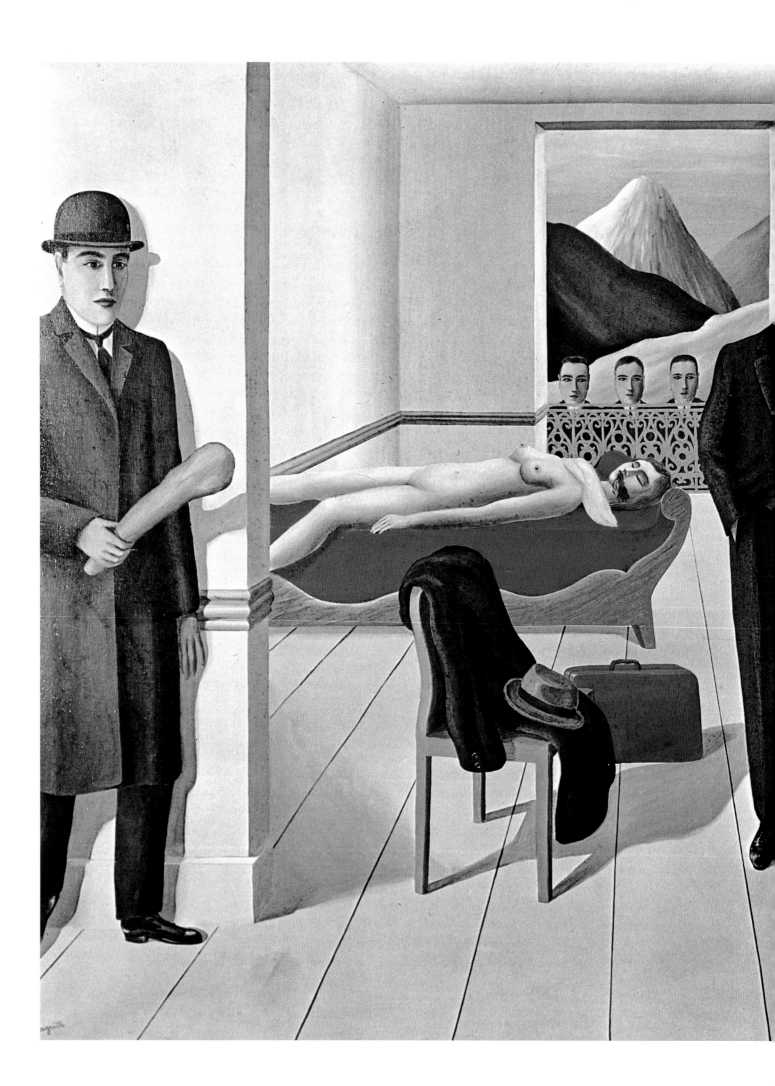

The Threatened Murderer, 1926
L'assasin menacé
Oil on canvas, 150 x 195.2 cm
New York, Collection The Museum of
Modern Art,
Kay Sage Tanguy Foundation

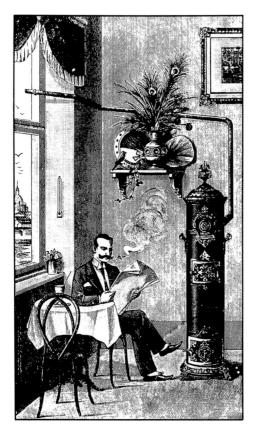

Illustration from:
F. E. Bilz: "La Nouvelle Médication
Naturelle" (1899), Vol. 2, p. 1445, ill. 392
Bougival, Pierre Alechinsky Archive

The Man with the Newspaper, 1927/28
L'homme au journal
Oil on canvas, 116 x 81 cm
London, Tate Gallery

fringes of idiocy, but no matter. It is agreeable to think how far it might lead"("Writings from 'Oesophage'").

In regard both to Magritte's aesthetic and ethical decisions and to his relationship to strictly orthodox Surrealism, these sentences are interesting insofar as they make it clear that the ideas of those Surrealists of the Magritte tendency were not always so very distant from the spirit of negation associated with Dada. At about the same time as this magazine appeared, Magritte first set eyes on the reproduction of Giorgio de Chirico's *Song of Love* (illus. p. 16) that so fascinated him. But what did he think of Dadaism? He hardly ever spoke of it, except to say that he regarded it as the origin of Pop Art. And yet there is a trace of Dadaist derision in many of his attitudes towards the external world, in many of his letters to his friends, in his periodic propensity to scandalize, in the many pamphlets he composed, in many of his earlier pictures, and even in some dating from later years (the so-called "Vache" period). He also appreciated Francis Picabia. But what was it that so attracted him to that involuntary recruit to pre-Surrealism, Giorgio de Chirico? The latter's picture *The Song of Love* depicts a soft glove pinned to a stretched canvas, to which the head of a classical scupture is also attached, while against the background of a nocturnal landscape there rears up a rectangular building. "This triumphant poetry has replaced the stereotype effect of traditional painting. It represents a total break with the mental habits typical of those artists who are prisoners of talent, of virtuosity and all the little aesthetic specialities. It is a new vision, in which the beholder retrieves his isolation and hears the silence of the world" ("Lifeline I").

With Chirico and Dada, Magritte's descent was traced back to the period prior to Surrealism. Following the same line of thought it could just as well have been traced back to Marcel Duchamp, no less a pre-Dadaist than a pre-Surrealist. "Anti-artistic" was what Magritte called him, and he appreciated his humour. In an interview with Jan Walravens in November 1962, he declared that "Marcel Duchamp was very important as a French Surrealist because he showed that quite banal objects could acquire, as a result of very slight modifications, a valuable charm" (Jan Walravens: "Encounter with Magritte" Yet there were considerable differences between Duchamp and Magritte, just as there were between Magritte and Dada. In Magritte's pictures we see no sign of the derision or the avowed nihilism characteristic of the Dadaists, although this was not always so where some of his campaigns were concerned: a series of pamphlets dating from 1946 is sufficient evidence of the spirit of contrariness and the contemptuous sarcasm displayed by Magritte's circle. The titles speak for themselves: "The Imbecile", "The Arsehole", "The Bugger" etc. On the other hand, while in the case of Duchamp the objects are taken out of their original utilitarian context, Magritte takes them as they are in reality but placed in poetic confrontation. As a reminder: "What one sees on one object is another, hidden, object." What the two have in common, however, is their opposition to aestheticism in its traditional sense of "the study of the beautiful", or "sense of beauty".

Whatever the differences between the two, there is not the slightest doubt that at least in one important point there is agreement between the Duchamp of the ready-mades and Magritte as a painter of objects. Both took pains to make their banal objects express something different from what they are. "I painted (pictures where the objects are depicted with the appearance they have in reality, in such an objective manner as to ensure that the bewildering effect

which they would show themselves, thanks to certain means, as capable of producing, might be re-encountered in the real world from which these objects were taken, and this by a perfectly natural exchange" (Lifeline II). Magritte was of the opinion that Duchamp achieved a delicate charm in his objects by means of slight modifications. He himself, on the other hand, transformed their relationship by means of a "perfectly natural exchange", in that he put the objects back in the inhabited world. There thus exists, through Magritte as intermediary, an intimate connexion between the domestic appearance of things or objects – in other words their appearance in the world as it is – and the suggestions provoked by their unaccustomed juxtaposition. Therein lay his Surrealist approach, then, his essential liberation, "for most people the realization of a real, albeit unconscious, desire" (ibid.).

This approach, as thus put into practice, was not quite the same as Breton was pursuing when he invoked a "convulsive beauty". Magritte neither held with the rejection of realism, as called for by the founding manifesto of the Surrealist movement, nor did he throw in his lot with a psychological conception of art. Even less did he believe in the principle of automatic writing, and he also had no confidence in the exploitation of dreams as a source of inspiration. Above all, Magritte took up the opposite position to André Breton's ideas on Surrealist painting as expressed thus: "The mistake that was made was to think that the model could be taken exclusively from the external world or, indeed, to think that it could be taken from the external world at all" (André Breton: "Surrealism and Painting", 1928). But through all the storms of slings and arrows, beyond the ruptures and antagonisms so beloved of the Surrealist groups, Breton almost never rejected Magritte's œuvre, even when they campaigned for opposite positions. Theory and practice are not the same. There were however two exceptions: the pictures dating from the so-called "Renoir" and "Vache" periods, of which more later.

As is generally known, Magritte wrote a great deal: letters, pamphlets, manifestos, explanatory texts on his intentions. Reluctant as he often seems to have been to do so, he was frequently asked to explain his paintings and to make them comprehensible. He had a great deal to say about the Surrealist ideology, and usually he attributed to Surrealism intrinsic qualities which he found in no other revolutionary movement of his time. It has to be conceded that the Surrealist ideology was the one which accorded best with his own thoughts and actions, these being born of a conviction that art is nothing if it does not reveal the unspoken implications of the human condition. In the manifesto "Pure Art", to which he put his signature jointly with that of Victor Servranckx in 1922, he had already had a foreboding of the importance which would result from the merger of intellectualism and sensibility in the development of art. The two authors quoted Cocteau in this connexion: "In art, every value susceptible of proof is vulgar." But they also made reference to Stendhal: "Beauty is nothing but the promise of happiness." Or again: "The painter does not paint in order to fill the canvas with colours, any more than a poet writes to fill a page with words."

The total rejection of the gratuitous was one of the constant features of Magritte's attitude. This applied in equal measure to pre-1940 Surrealism. One needs to remind oneself that it meant to present itself in no sense as an artistic movement, but as a philosophical reaction, as it were, on behalf of "the greatest possible freedom of spirit" and of "absolute non-conformity". This undoubtedly revolutionary attitude was aimed at transcending the Cartesian

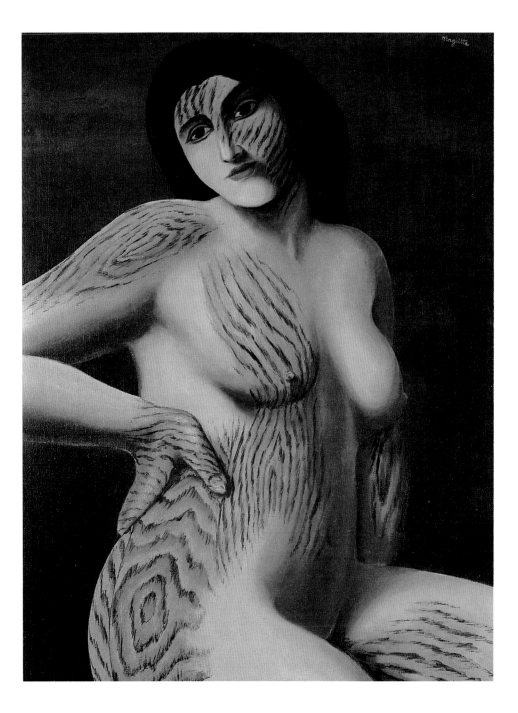

Discovery, 1927
Découverte
Oil on canvas, 65 x 50 cm
Brussels, private collection

injunctions and rationalist reactions by which French thought was dominated at the time. Dreams, rêveries, fantasy, the super-conscious and the para-normal were the preferred means of extricating individuals from their mental and social alienation. "Real" life, said Breton in his first Manifesto, is such that one loses the faith one has in it. So although the life of the movement was largely supported by literature and the so-called visual arts, these were merely means employed to arouse in people the ideas they had in regard to their own condition. In this regard, too, Magritte's thinking and work were unusual, since he combined both in his attitudes, his writings and his pictures. They were also unusual in that he repeatedly endeavoured to gain acceptance for a resourceful ideology just when the Surrealist movement could use one. In the same way as the Belgian-born poet Henri Michaux, who was able to draw "the emanations which flow among people", Magritte also appears, ultimately, as peculiarly representative of what Surrealism set out to be. For him, too, painting was purely a means, not an end in itself.

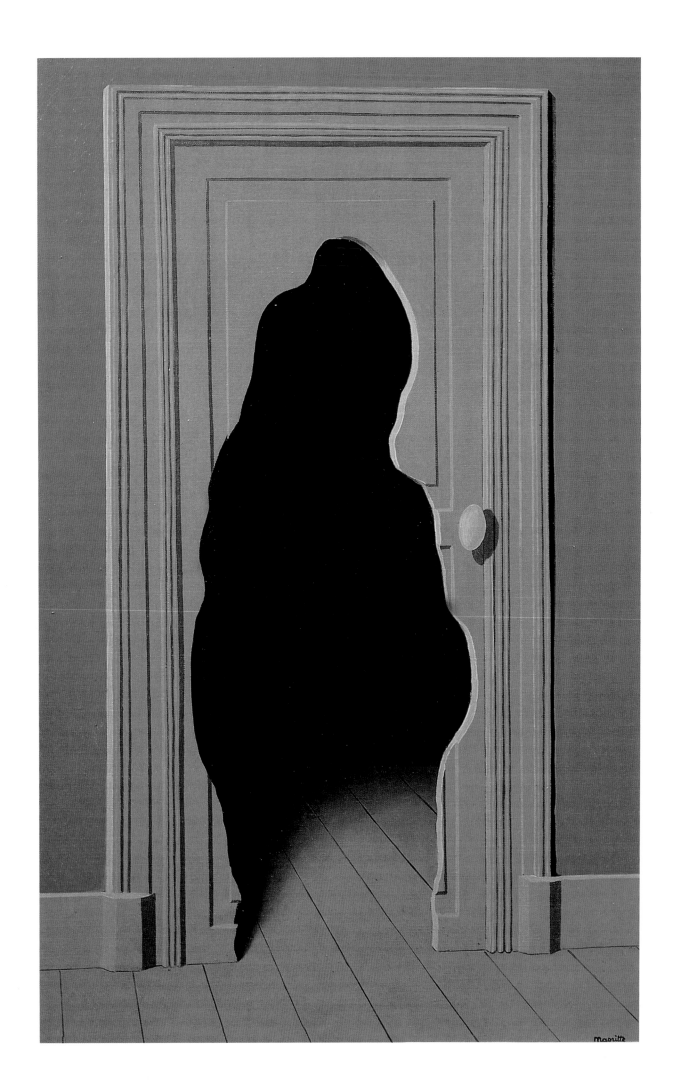

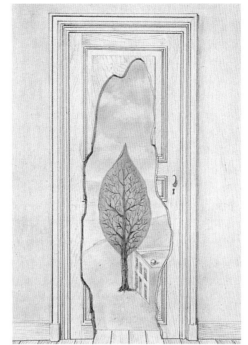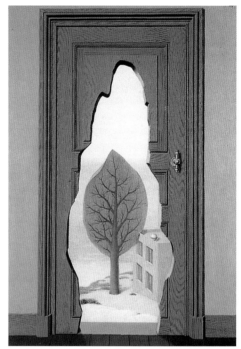

As we have seen, Magritte's comments on Surrealism were almost always positive, even though he did not necessarily – not by a long way – share all the opinions or follow all the decrees of the Paris group. And this is true even of those cases where his attitude changed from one of criticism to one of concurrence. When he was questioned in 1935 on the "crisis of painting" (not a new topic, then!) he explained that there are "gleams of light" and that "it is the Surrealists who deserve the credit for having shown them" ("Les Beaux-Arts" No. 164, Brussels 1935). And in 1938 he declared: "Surrealism . . . has given humanity a method and an intellectual orientation appropriate to the pursuit of investigations in the spheres which one would gladly have ignored or despised, but which are nevertheless of direct concern to mankind" ("Lifeline I"). Or again: "It has enabled many a painter to break free of old, more or less erroneous, formulas." And in 1955: "Surrealism is the point where there is no longer a contrast between top and bottom (between black and white)." ("Interview with Conrad Altenloh" To this response by Magritte to a question put by the interviewer, André Blavier notes that he was quoting freely from Breton at this point, and the quotation was "almost a caricature"(Blavier 1981, p. 345). In 1957 we have this: "'Surrealism', like 'Fantasy Art', says something extremely vague, indeed false, if one gives it any other sense than the very limited one to which it corresponds exactly"(*ibid.* p. 368). In an interview with Georges d'Amphoux, in 1958, he said: "Certainly it is simpler to apply a label to describe a school or a so-called school . . . but all the same I don't like people categorizing what I paint." Then in 1961: "For me Surrealism is the kind of painting which describes a thought which evokes a mystery; thus implying that this thought must resemble the figures which the world offers to thought . . . The way I combine objects evokes the Surrealist mystery. That is something which exists" ("Interview Jean Stévo III"). And finally, from 1962: "Surrealism mirrors the view that human life must be absolutely worth living." Or: Surrealism is "for an artist, to be conscious of himself as an artist". And: "My integration into the movement was inevitable, because my ideas at the time,

which incidentally are still my ideas today, were similar to those of the Surrealists" (Jan Walravens: "Encounter with Magritte").

Reading over these various utterances which span a considerable period of time, one will detect a constancy in Magritte's acknowledged affiliation to Surrealism as such, that is to say the Surrealism as was explicitly defined at the outset. He himself defined the term very narrowly, and yet he conceded that it touched on the totality of the human condition. But did he set limits to Surrealism, the artistic movement, rather than to Surrealism, the attitude of mind? Probably. One needs only to remember that the strictly anti-bourgeois line encouraged by the Surrealists found a ready supporter in Magritte, who rejected his background milieu, even though he continued to display the outward signs of it in his clothes and in his home. When he said "Surrealism is painting", he took it for granted that we were talking about *his* Surrealism, for immediately afterwards he explained his idea with a succinct description of his way of appealing to the "Surrealist mystery". As we have already mentioned in the course of quoting from the interview with Georges d'Amphoux, there were also occasions when he distanced himself from any attempt at labelling. He even went so far – at least on one occasion – to assert: "I have never thought of Surrealism as anything but a 'warmed-up joke'." That might look like a judgement on the basis of hindsight. He was probably referring more to what Surrealism later turned into than to what it was at the time when his affiliation was "inevitable".

Without a doubt, there is much to debate in these outbursts, serious or "scandalous" on Magritte's part, especially on this topic. There can be no doubt at all concerning his honesty in respect of himself, though.

In his opinion, this freedom paid off, especially in regard to the Surrealist world as it was ruled from Paris by its founder-chief. This freedom was manifest, without however continually displaying "Surrealist" features. The point is documented by the frequent and ongoing writings contributed by Magritte to the movement's publications when asked to do so. It is also documented by a number of close friendships, for example with Paul Éluard. The relationships of the Belgian Surrealists – Magritte and his Colleagues – to the life-giving heart of the movement in France were coloured by a certain number of events. The friendly relationship towards André Breton grew cooler as the Belgians began to take up a more independent position for themselves. It is clear that there were disagreements about fundamental ideas and essential concepts. In political matters, in particular, the left-wing commitment shared by the French and the Belgians gave way to splits which took the edge off their "revolutionary faith", besides affecting membership of the respective communist parties in the two countries. In Belgium, the surrealists were speaking, by 1925, of the Western communist parties as being in "a severe state of decay". As far as social affairs were concerned, in 1927, as Paul Nougé said, they held to "an ethic supported by a psychology coloured by mysticism" (A. Béchet and C. Béchet: "Surrealistes wallons", Brussels 1987, p. 11). Basically, the Belgians were suspicious of any political commitment. They placed their real subversive strength at the disposal of a poetics which they saw as a model weapon for deployment against bourgeois thought, while communism, in their eyes, represented in the final analysis a dialectical obstacle to artistic freedom and the revolution of which it was in the van.

These then were the relations which Magritte and his friends maintained towards orthodox Surrealism as led by André Breton in its capacity as the

"What we can see in a painted picture that fascinates us loses its charm when we meet in reality that which we see in the picture. And vice versa: what we like in reality is, when represented in a picture, a matter of indifference to us – if we do not confuse the Real and the Surreal, and the Surreal with the Sub-real."

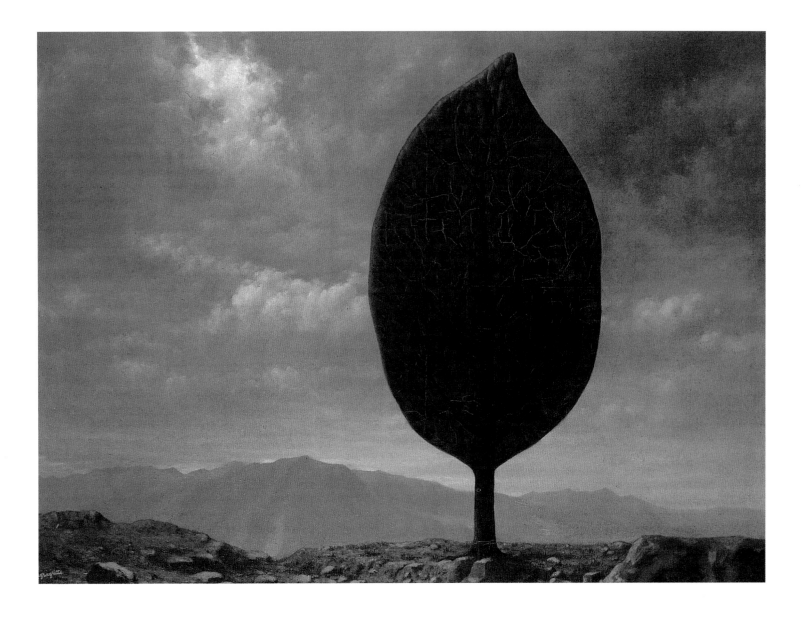

The Plain of Air, 1941
La plaine de l'air
Oil on canvas, 73.7 x 100 cm
Private collection

moving force behind an art which was different from what had been current hitherto. It is important to investigate these relationships, above all if one wishes to isolate the original features which characterized the work and the thought processes of the painter. There are a number of anecdotes – friendly and malicious – relating to this topic. They all show that the Belgian groups not only largely upheld their freedom in the face of the Parisian dictatorship, but that also, it was from them that the initiative for regeneration of the Surrealist ideology sometimes originated. Leaving the anecdotes aside, amusing as they are, let us turn to the most striking facts in order to illustrate the particular features of the group around Magritte.

There are a number of documents which reveal these particular features as manifested most especially in the attitudes taken up by the painter and his entourage. These documents refer both to campaigns in favour of new openings along the Surrealist path, and to specific situations thrown up by current, and thus transitory, events. Many of these positions arose as a result of decisive moments in which political considerations and artistic concepts were mingled, as exemplified by the major events of the Second World War. Thus it was that at the end of this conflict, in 1946 and 1947, Magritte composed and signed, along with his friends, a number of manifestos. In the dossier which Blavier

devotes to them, they are entitled respectively: "The Quarrel over the Sun", "Surrealism in Full Sunlight", "The Extramentalist Manifesto" and "The Amentalist Manifesto" (Blavier 1981, pp. 147–180). These mark the sequel and the preliminaries to two experiences which Magritte underwent in his painting, which represented a considerable – albeit temporary – break in his style, though not in his basic ideals. These experiences are what are known as his "Renoir period" (1943–44) and his "Vache period" (1948).

All in all, the manifestos on "Surrealism in Full Sunlight", on "Extramentalism" and on "Amentalism" express an optimistic view of Surrealism, and that at a time when the war might more easily have given rise to depression and, now that it was over, the atmosphere was one coloured by basic existential unease. Magritte's concerns, in these circumstances, once more went beyond the mere art of painting; with alacrity he set about working out effective ideas on "changing life" or, at least, casting it in a less melancholy light. Was it contrariness? Was it excorcism? Louis Scutenaire says of the "Renoir period": "What an enterprising show of bittersweet humour on the painter's part, to seek to impose on spirits crushed by the miseries of war these luminous pictures, and yet typical of his idiosyncrasy" (Scutenaire, 1977). The preparatory texts and the manifestos themselves contain in any case a number of clues which cast light on the efforts – generally attributed to this period – to regenerate the Surrealist ideal. This ideal was in a pretty poor state in those days: the war had scattered the Paris group to the four winds, the leading figures having fled to the south of France or to America. Here and there, some of them pursued their theoretical sallies, but attempted nothing new; in New York in 1942, Breton was wondering about the need for "prolegomena to a third manifesto". His text ends with a question on the necessity of a "new myth". And in the occupied territories, which of the genuine Surrealists were left, apart from most of the Brussels group?

What does one find in "The Quarrel over the Sun", for example? Strangely, an "impressionistic" idea of charm that could be gleaned from pictures contributing "the equivalent of the colours of a deliberately subjective, chance perception, allowing of no equivocation". It was not Impressionism in the historical sense. It was "the variable physical impression", not "an unchangeable sensation". What needed to be done was to clothe our mental universe in a "charm which gives life more value". Two pictures may serve as an example of this change: both are entitled *Desolate Region;* one dating from 1928, the other from 1946. The first depicts a "neutral landscape", while the other is bathed in "full sunlight" with "cheerful colours". In spite of the apparent difference in the intentions expressed by these two pictures, Magritte saw no contradiction in principle. Austerity was the dominant feature of both, in his opinion, and the difference between them he explained in terms of the differing contexts in which they appeared.

The same preoccupations appear in the introductory remarks to the "Extramentalist Manifesto", in which the author contrasts a life "which one came to value more highly as a result of discomfort, worry, pain and fear" with "a virgin, vivacious and beautiful today". With great verve, Magritte wrote that Extramentalism was "taking the place of Surrealism". He was taking liberties once more! He already foresaw, incidentally, the opposition which Breton duly expressed to these intentions. And he gave his own response in advance, too, in a letter to Paul Nougé in September 1946, in which he set his course in plain words: a proud independence from Paris. In his own words: "It is perhaps

"... I thought ... that the iron tackle, which hangs around the necks of our wonderful horses, grew like dangerous plants on the edge of the abyss."

The Voice of the Winds, 1928
La voix des vents
Oil on canvas, 73 x 54 cm
USA, private collection

rather late to claim this venerable expression ('Surrealism') for ourselves, and perhaps it would be too great an effort to get the public to change their ideas of the meaning of the word." Perhaps, therefore, it would be "simpler to use a new word and save our energy for a different cause". Extramentalism or Amentalism "will make people think of us first of all", since what was at stake was the succession to the old Surrealism, which after the war had fragmented itself in a discouraging race for its glorious past ("Extramentalist Manifesto", notes)

Those of Magritte's pictures which reflect his "Renoir" experience go back to the spring of 1943, for example *The First Day* (illus. p. 170) and *The Fire* (illus. p. 169). There are, though, pictures dating from as late as 1946 which still reflect the change, such as *The Crystal Bath* (illus. p. 167). André Breton regarded this sunny Surrealism as being totally incompatible with everything he stood for after his return from the United States. We do not have the verbatim text of the reactions of the Surrealist "Pope", but we do have the answers which Magritte gave in his turn. They are quite explicit concerning the

Natural Encounters, 1945
Les rencontres naturelles
Oil on canvas, 80 x 65 cm
Courtesy Galerie Isy Brachot, Brussels–Paris

disagreements between the two men on one important point: the efforts of the Belgian group to resuscitate the Surrealist ideology in a form that took account of post-war conditions. These certainly came to nothing. While Magritte returned after 1946 to his previous style (which he had, incidentally, never totally abandoned), he could at least claim the credit for having documented the changes which events had necessarily brought about in fashions and ideas, even if they had been revolutionary in principle before.

In a letter to Breton dating from June 1946, Magritte was quite ready to concede that his "sun period" pictures contradicted "many of the things we believed in before 1940". Herein he discerned the reason for the "resistance it has provoked". But, he said, "we are no longer living in order to prophesy," because the Nazi occupation had, "better than we could have done it, unleashed the panic that Surrealism wanted to arouse". Magritte insisted on "the need for a change" that would justify the "irruption of a new atmosphere". This last, in his eyes, would have to challenge the "prevailing pessimism" by means of a "quest for joy and for pleasure" which could open the way for those

The Cicerone, 1947
Le Cicérone
Oil on canvas, 54 x 65 cm
Courtesy Galerie Isy Brachot, Brussels–Paris

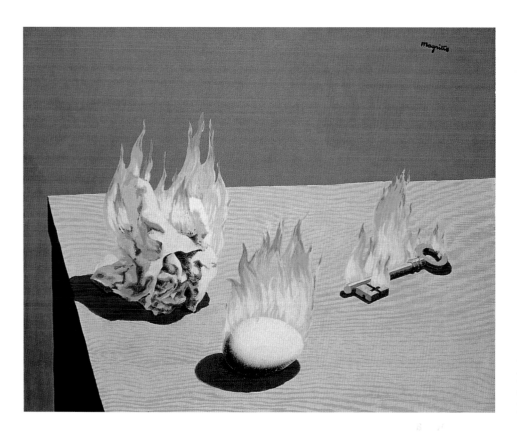

The Ladder of Fire, 1939
L'échelle de feu
Gouache, 27 x 34 cm
Private collection

who, "like us", know "how to invent feelings". It was however necessary to apply the "science of objects and feelings" which Surrealism had previously made its own "to other ends than before". Otherwise, "Surrealist galleries will be just as boring as all the rest". Magritte summarized Breton's reservations towards his new painting with the remark: "You do not feel the physical sensation of pleasure which I am trying to arouse". But, he commented, "if I am not succeeding, one cannot maintain, while keeping a straight face, that Matta, Ernst, Brauner etc. succeeded in their objectives". For "we know very well what they're after, all too well in my case" ("The Quarrel over the Sun").

In August 1946 there was a further exchange of letters with Breton, who had replied in "too conventional" a fashion for his taste, it would seem. In this letter, Magritte inserted most notably "a few lines, addressed perhaps to the winds", among them the following: "Surrealism must no longer be allowed to be a bridge between two wars." And: "It is necessary to reject its fixed formulas (like those of magic, too), in order to prevent the ancillary aspects becoming a means towards fossilization." In his opinion, what was needed was to "reconcile two contradictory elements: Surrealist poetry and sunlight". Referring to the "Second Surrealist Manifesto" of 1930, he declared that "using charm to provoke a 'grave crisis of consciousness' leaves the picturesque 'disconcerting' lighting effects so beloved of third-rate actors . . . far behind". At the end of the same month, the words which passed between them took on a more cutting edge. "It would perhaps be more entertaining if, when writing, we threw the balls at each other . . . I have the depressing feeling that life is slipping away through the cracks in 'fossilized Surrealism', and that we need to take energetic measures". Magritte emphasized that ". . . this light, which we're provisionally describing as 'sunlight' is, as I understand it, an appeal to the extramental world, to the real external world in which we live". Thus he made the connexion once more to Giorgio de Chirico, by whom he had been so

greatly impressed. But at the same time he expressed criticism of the style of painting which Chirico had come to prefer to that of his metaphysical painting. "If you compare this with Chirico's intentions, then there is agreement insofar as Chirico wanted to distance himself from an epoch which had outlived itself, and total contradiction, where he appealed to the joys abandoned by Italian painting, going back to school instead of playing truant" ("The Quarrel over the Sun").

At about the same time Magritte wrote to Nougé: "I for my part have buried Surrealism – my Surrealism – some time ago, and Breton's version all the more." No doubt this was somewhat of an exaggeration, and contradictory, too, insofar as he returned to his accustomed style after the illusions of a "Surrealism in full sunlight" had dissipated. There was, however, a further escapade, that of the brief "Vache period" of 1948 which, however, had quite different raisons d'être than those advanced to explain the "Renoir period". But this does nothing to alter the fact that Magritte's pictures, exhibitions and writings of those early post-war years nevertheless represented major declarations of independence vis-à-vis orthodox Surrealism as personified by Breton. They were also important evidence of the vitality of the Belgian group. They were – and this is even more important – precise documents to the populist deviations of Surrealism and to the use of the term not only by the general public, but also, and above all, by representatives of a particular kind of painting. Not the painting of Sébastian Matta, Max Ernst or Victor Brauner, which Magritte had attacked in a letter to Breton after previously praising it, but rather the painting of a whole army of copyists and "counterfeiters of Surrealism", who are still active even today among the excessively benevolent or credulous.

When one re-reads Magritte carefully, in particular the declarations he put out in the correspondence and manifestos quoted above, one cannot fail to

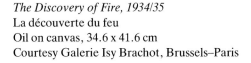

The Discovery of Fire, 1934/35
La découverte du feu
Oil on canvas, 34.6 x 41.6 cm
Courtesy Galerie Isy Brachot, Brussels–Paris

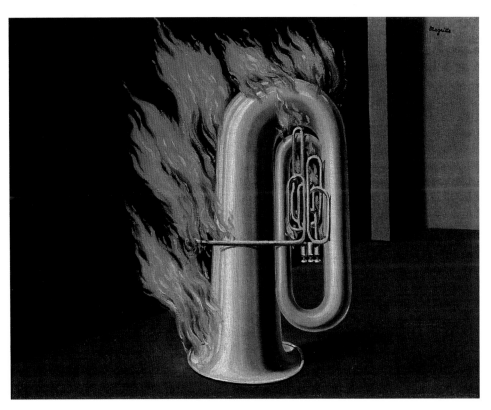

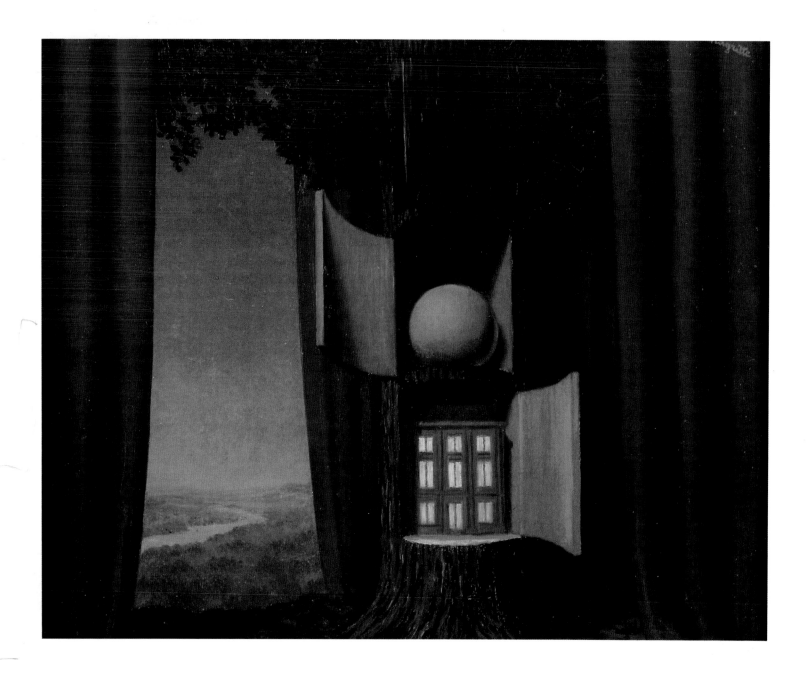

The Voice of Blood, 1948
La voix du sang
Oil on canvas, 50 x 65 cm
Private collection

notice a certain lack of consistency in his thought. On occasions, at least, he seems to have gladly damned what he had previously adored. Only in part, though: the problem of objects and things in their real form was never ignored; the relationship between reality and mystery was never lost sight of, even though the painter sought new forms of communication between them. And with regard to fundamental Surrealist ideas, he suddenly cut a figure as a guardian even sterner than Breton himself, a Breton whom in 1955 he found "depressing", reproaching him with no longer searching for "the philosopher's stone", doubting indeed whether he had "ever searched" for it.

On the other hand, Magritte's positions point to a feature of his character which was often misinterpreted, namely his attitude towards the prevailing atmosphere of the time, and towards the various – external – events to which in general he appeared to give little attention. The series of manifestos appeared, it must be remembered, while Belgium was under occupation by the forces of an invading army. It was a black period in history, and a tragic time for people everywhere; their very existence was threatened. This is what largely explains Magritte's reaction. He was unambiguous on the subject, as the quotations

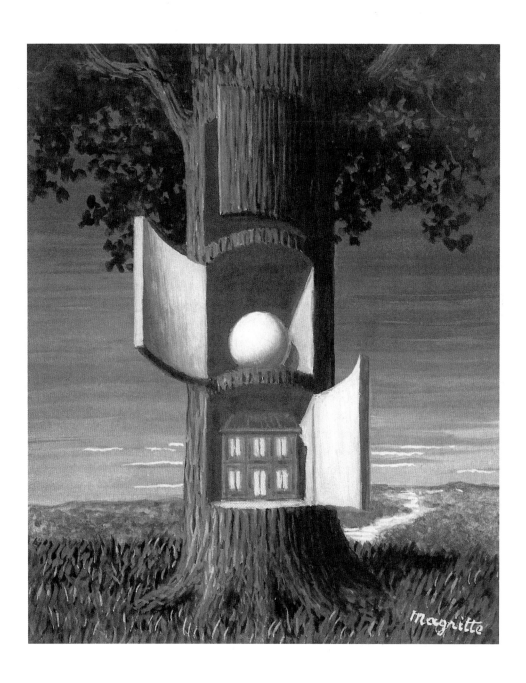

The Voice of Blood, 1948
La voix du sang
Gouache, 17 x 14 cm
Courtesy Galerie Isy Brachot, Brussels–Paris

given above will show. Replacing tragedy by joy could not, in the circumstances of the time, disguise the facts. There was then something rebellious, if not revolutionary, in this gesture of giving the sun precedence over night. And all the more so, because it was not a matter of denying reality, but rather of thwarting it, and somehow of exorcizing it, by taking up an opposite position. And among the most striking elements which Magritte contributed to painting was this valuable one: the image as reproduced implies a metaphysical message in the Heideggerian sense. For the German philosopher Martin Heidegger, mystery was inherent in the essence of truth; for the Belgian painter René Magritte, the picture was there to help make Man aware of his situation in the real world. This brings us to "Magritte the philosopher", whatever one may think of philosophy or its peculiarities, and whatever he himself may have had to say about philosophy at the time. Under the circumstances he was, certainly, an intuitive philosopher, feeling his way and occasionally confused, but not necessarily an amateur. "'Mental universe' is the name we give to everything which we can perceive by means of our senses, our feelings, our intellect, our instinct or any other medium" („Amentalist Manifesto").

This was the time of the joint celebrity of Sartre and Camus, of the existential and of the absurd, elevated into dogmas, with their differences and their variants. How could these theories, insofar as they reflected a particular consciousness of the age, be conciliated with a Surrealism which would abandon none, or at least not very many, of its pristine non-Cartesian, indeed, emotional qualities. As far as Magritte was concerned, these were qualities founded on an uninterrupted interrogation of the mental universe considered, according to what we have just quoted, as the receptacle of "everything we can know, feel, imagine etc." The notion of "mystery", so dear to him, underwent a strange transformation with regard to the central notion of the concept. When Magritte claimed Extramentalism as the successor to Surrealism, at the same time declaring that "we are not philosophers", he took mystery to be a secret that was being unveiled little by little, but never totally revealed. What other reason was there for painting, after all? This mystery lay between the mental and the extramental (or amental), between the real, and what the real arouses in us. "Since we are concerned with the mental universe, in other words, with the world that we perceive, what we have to do is to perceive it as intensely as possible, with the help of pleasure and of the strongest of lights" (ibid.).

As this conception which unifies the existential with the unknown was founded on prior knowledge of things, rightly or wrongly it excluded those Surrealist artifices intended, like automatic writing and parapsychology, to show the unconscious more or less in the broad light of day. Breton, incidentally, as he said in conversation, had noticed in Magritte " progress which was not automatic but fully conscious". The return to a style of painting "à la Renoir", drenched in sunlight effects, was above all an attempt to apply visually what the extramentalists wanted to promote: pleasure and joy. In 1943 these were somewhat incongruous sentiments, but in 1946, after the Liberation, they were perhaps easier to justify. Joy and pleasure, perhaps ... However, this exercise certainly did not have any negative effects on the remaining aspects of the development – neither on the work which went before, nor on what came after. This is demonstrated by the insistence placed on the sense of isolation, and thus of alientation, of people and objects – both among themselves and with reference to the general context. This sense was certainly more profound than was the appeal to pleasure. So much so, that the so-called "Renoir period" cannot really be said to have replaced Magritte's other form of expression. The difference between the two lay less in the essence than in the genre. The painter himself had the following explanation (letter to Jacques Wergifosse, dated 12 September 1946):

"In 1930, it was the custom to speak of the alienation of an object or of its isolation: the locomotive emerging from a dining-room fireplace [he was referring to the picture entitled Time Stabbed (illus. p. 89)] altered the usual sense of isolation (the isolation which only seems to be applicable to individuals was being applied to movable and immovable objects). In 1946, the sense of isolation applies to the whole universe (the universe we perceive or undergo or with which we interact via our senses, our feelings, our reason, our intuition etc.). In this isolated universe, the combinations of objects as such are a matter of indifference. Their only importance derives from their moral consequences: some bad, some necessary for a life of intense pleasure. The bad things must be eliminated or combatted: terror, dirt, boredom, despair ... It is worth noting that without the extension of the sense of isolation to the whole universe, these

"It is not my intention to make anything comprehensible. I am of the opinion that there are sufficient paintings which one understands after a shorter or longer delay, and that therefore some incomprehensible painting would now be welcome. I am at pains to deliver such, as far as possible."

The Blank Cheque, 1965
Le blanc-seing
Oil on canvas, 81 x 64 cm
Washington, National Gallery of Art,
Mr. and Mrs. Paul Mellon Collection

The Beyond (Study), 1938
Drawing, 27 x 18 cm
Courtesy Galerie Isy Brachot, Brussels–Paris

The Beyond, 1938
L'au-delà
Oil on canvas, 73 x 51 cm
Private collection

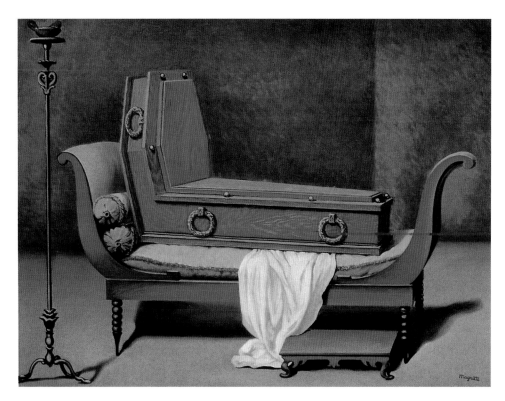

Perspective I:
David's Madame Récamier, 1950
Perspective I: Madame Récamier de David
Oil on canvas, 60 x 80 cm
Private collection

bad things were regarded as stimulants . . . and that from this morose point of view, the joyous life was seen as 'superficial'."

A Surrealism of hope, in a way, set against an Existentialism that was still not regarded as humanistic.

The "alternative Surrealism" proposed by Magritte and his friends during this period was, incidentally, the subject of an attempted explanation by Marcel Mariën. In so doing, he made Breton and his entourage the barely concealed target of a vindictive diatribe. In a lecture delivered in January 1947 on the occasion of an exhibition of Magritte's works in Verviers, Mariën declared that ever since the appearance of Breton's doctrine, certain Belgians had challenged it with a different conception, a conception which "could only facilitate comprehension of the mental and moral attitude which is the source of Magritte's pictorial endeavour. An attitude which "always harked back to the unconscious", which underlay the theories of Breton, was replaced in the case of Magritte by "the vision of an effective picture . . . a vision closely tied to a long and meticulous search, untiring critique and a conscious analysis of its deeper potential". Thus Magritte's œuvre was the opposite of a kind of painting which arose from an "inner model, to grasp and reproduce which was the painter's sole task". For this reason alone it represented the rejection of a "suspect purity", such as was responsible, in Mariën's view, for the admiration accorded to the productions of the Naive, Wild, Primitive and autodidact painters. Or else of a "suspect purity" like that which encouraged interest in "manifestations of superstition and obscurantism", as transmitted by exotic art – the Hopi dolls, for example, which had so aroused Breton's enthusiasm. This unforeseen return to a form of religiosity Mariën contrasted with "the con-crete, everyday meaning" on which Magritte's pictures relied "so as to induce profound feelings with these images"(quoted from Mariën 1947, pp. 101 ff.).

Certain objections might be raised to these ideas of Mariën's, in particular that the changed conditions of today have altered people's approach to instinc-

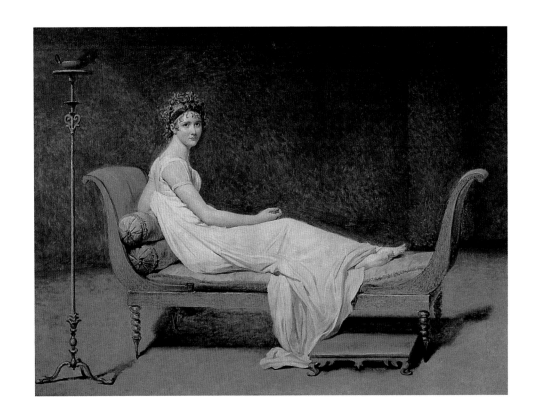

Jacques-Louis David:
Madame Récamier, 1800
Oil on canvas, 173 x 243 cm
Paris, Musée National du Louvre

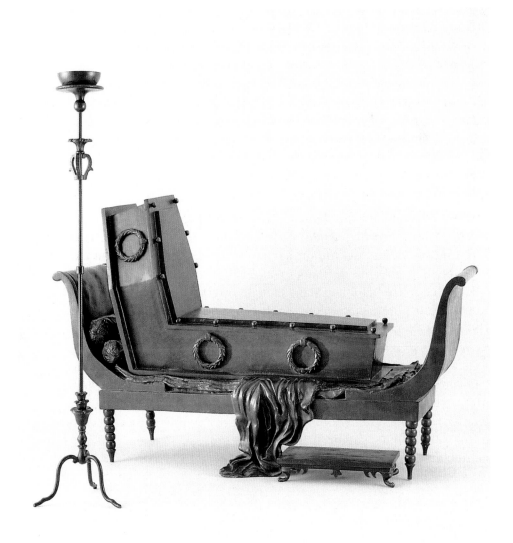

Madame Récamier, 1967
Bronze, sofa and coffin: 114 x 188 x 67 cm
Houston (Texas), courtesy of
The Menil Collection

ILLUSTRATION OPPOSITE:
Perspective II:
Manet's Balcony, 1950
Perspective II: Le balcon de Manet
Oil on canvas, 81 x 60 cm
Ghent, Museum van Hedendaagse Kunst

Edouard Manet:
The Balcony, 1868/69
Oil on canvas, 170 x 124.5 cm
Paris, Musée d'Orsay

tive art. And where Magritte is concerned, one could pose quite different questions regarding his notions of God and his attitude towards superstition, in spite of his atheism, and whatever one's attitude to mysticism in general. This would be a perilous enterprise, certainly, but looking at Magritte's own writings, it is hard to resist the impression that he never lost the latent idea of the existence of an immanent deity. Does this show remnants from an upbringing marked by mystification? In his manifestos, Magritte noted: "It is becoming possible to think of the PROBLEM OF GOD in this light" (original capitals; Mariën 1947). This sentence is ambiguous in more ways than one: is he referring to one of his "false mysteries, upon which doubt must be cast", or is it simply noting a fact? For example, the fact that what is rendered accessible by the mental, and is thus common property, is only of value when transformed by the imagination. The imagination: is it God? Or the opposite?

We shall not at this juncture risk analyzing an agnostic Magritte haunted perhaps by thoughts of ultimate destiny. "We behave as if there were no God"(Mariën 1947). Or, we behave as if Man were congenitally incapable of accepting his freedom, unless sanctioned somehow or by someone. Is the painter God-like? And does the death of God imply the death of painting?

Perspective II:
Manet's Balcony (Study), 1950
Drawing (detail), 30.5 x 23 cm
Courtesy Galerie Isy Brachot, Brussels–Paris

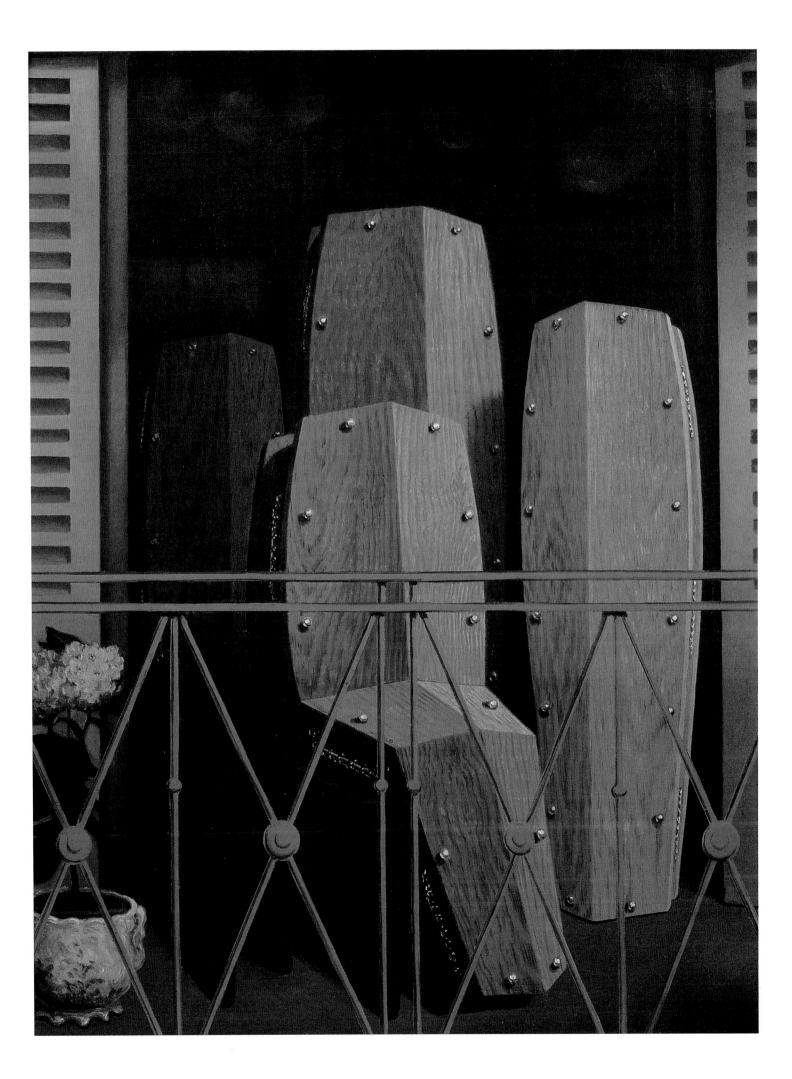

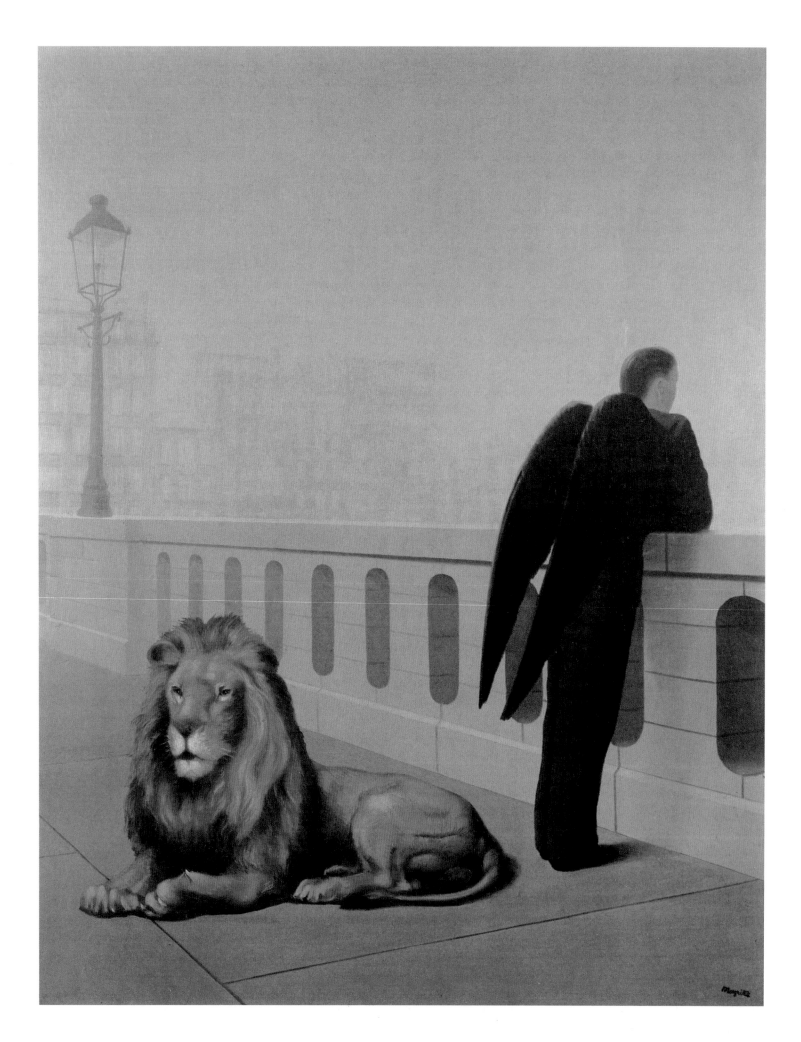

Magritte the Realist –
Imagination and Inspiration

Magritte was a "realistic" painter. This observation stresses just one of his more striking original features. And at the same time it underlines one of his principal features; one which distinguishes him from so-called "modern art" – in all its manifestations – on a comprehensive revision of the approach by art to reality. Modern art rejected realism explicitly, denying that painters and painting, above all, had any mission to reproduce nature, living or dead, in favour of a doctrine which affirmed the expression of feelings, sensations, emotions, inward reflexions and so on. It is tempting, in a word, to declare that in place of 19th century Impressionism which, confronted by the landscape before which one had set up one's easel, knew how to recover sensations through techniques of colour diffraction, there was a desire to substitute an impressionism of diffuse feelings proceeding not from the subject painted, but from the manner in which it was painted.

There is none of this in the work of René Magritte. His painting choice was based, from the very beginning of his definitively Surrealist period, on an observation whose actual implications were not understood until later: namely that by the most faithful reproductions of objects, things – including people – and all that we see around us in everyday life, one can force the beholders of these images to question their own condition. There is one proviso, however: it is necessary for these objects and things to be combined or contrasted in some unexpected, or in other words, unaccustomed, manner. In this way Magritte turned traditional logic inside-out like a glove and, in so doing, he played an intimate part in an enterprise to undermine the commonly accepted meanings of words and things. This subversion immediately became a firm institution, serving the aim of revealing secondary meanings, or rather, of the meanings which the mind gives to words and things subjected to its accustomed ravings. For this enterprise did not necessarily address itself to minds forewarned! Every time a word is spoken, the mind associates it with another, similar in sound, but not necessarily in meaning. The word "furious" could remind you of "fuming". So why not an object? A lighted cigar could remind you of smoke. The notion of reality, the notion of the real, have suddenly taken on a different meaning from that which ordinary usage assigns to them, and different from that which they had in the world of fine arts. And if it is only recently that the effects of this revelation have come to be understood, the reason, presumably, is that until a short time ago there was an imperative supposition that a work of art derived from an interpretation of reality which it was the task of the artist to effect, using tricks of the trade designed to create "equivalents of nature", in other words, "inspired" equivalents. In the case of Magritte, there is no interpretation of reality; he created no equivalents.

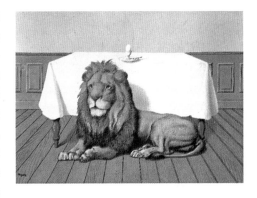

The Wedding Breakfast, 1940
Le repas de noces
Gouache, 31.5 x 42 cm
Private collection

Homesickness, 1940
Le mal du pays
Oil on canvas, 100 x 80 cm
Courtesy Galerie Isy Brachot, Brussels–Paris

73

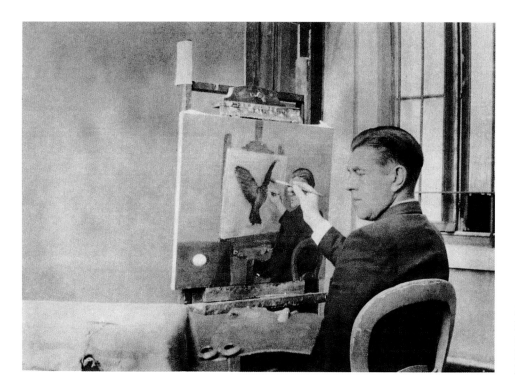

Double Self-Portrait, 1936
Magritte working on the painting
Clairvoyance, 1936
Photograph (unique print)
Brussels, private collection

The principal characteristic of the way the interpreters of reality went about their business was the use of artful materials: in painting, for example, oils and other paints on a canvas stretched over a board. From the landscape or the portrait to the still life, or from the representational to the abstract, the goal was always, in the final analysis, starting from a given subject – even if only an idea – to create a kind of synonym: the sensitive image of this same subject, whatever the modifications it underwent by dint of art. This still applies, note, to a good part of artistic activity in the traditional sense. The concept artists of the 60s called this procedure "formalistic" or an art of taste, in contrast to a real "conceptual" art, which casts doubt on its own vision of itself and questions its own essence. This doubting and questioning have something in common with Magritte. Trends such as Pop Art and Hyperrealism, which arose in the 50s and 70s respectively, have also acknowledged their links with Magritte. Why? Because in common with his work, the doubting and questioning which all these movements introduced into contemporary artistic activity have a connexion with the relationship which the artist – and thus the beholder of the work of art – has with reality and with the real, just as it is.

This all presupposes serious modifications of our habits. It is not easy: reality is what reveals itself to the view of us all; the real is what we ourselves extract from this "universal reality" and which we recognize because we know what it is. But everyone knows that he doesn't necessarily see the same as the next man, nor remembers the same details of what he does see. Police reports are sufficient evidence of this: eye witnesses whose statements they take down usually give differing accounts of the same event. "What you see is not what I see." And what is true of every individual, is true in equal measure of the painter. He is in this respect freer, in that he interprets, and properly reserves the right to alter reality. The landscape painter moves a tree if it suits his composition to do so. The Cubists moved the eyes of their subjects to another part of their face in order to counteract the effects of perspective. And so on.

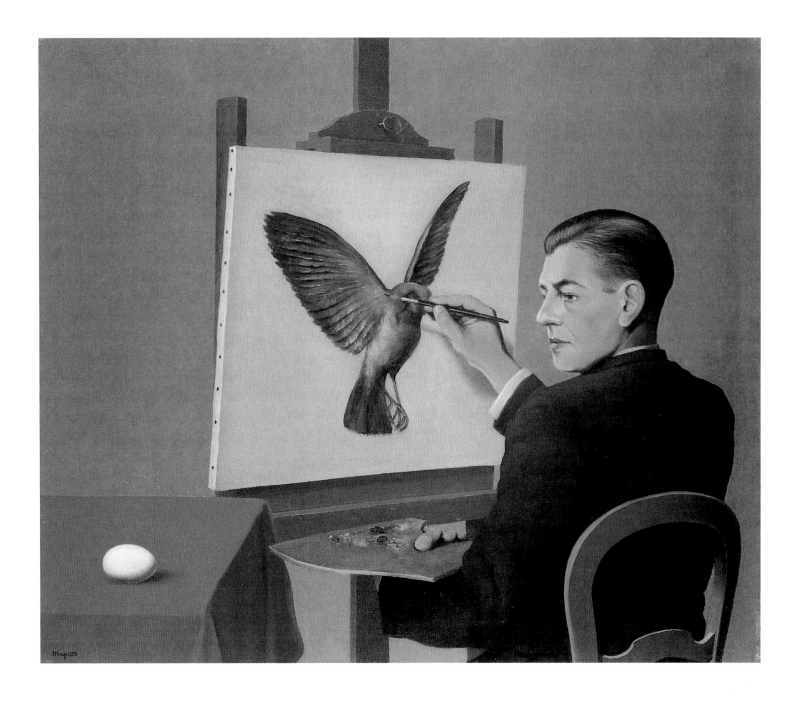

Clairvoyance (Self-Portrait), 1936
La clairvoyance (Autoportrait)
Oil on canvas, 54.5 x 65.5 cm
Courtesy Galerie Isy Brachot, Brussels–Paris

This freedom however is still quite recent. It evolved as soon as the political and religious authorities could no longer issue rigid decrees and thus create styles to which artists had to conform. In those days any genius they might have had was forced into the framework of these rules and stylistic prescriptions. The best-known example was and is religious painting and sculpture throughout history.

This history demonstrates that reality and the visual arts have only got on well together sporadically at best. This difficult relationship was well-nigh ruptured altogether by the intentions proclaimed by the moderns. This fact explains the revolution in painting which Magritte's work triggered off among these same modern artists. Before the realism of Pop Art and Hyperrealism, the previous recognized movement satisfying the definitions of reality-oriented art was Realism itself, which arose in France around 1848 and was put to death shortly afterwards by Edouard Manet. Among the most convincing exponents of this Realism, without a doubt, were Gustave Courbet and Jean-

François Millet. Both pursued a haughty socio-pictorial effect, but their work was disquieting, if at all, only insofar as it depicted personalities from among the common people, while the painting of the day preferred allegories and the rich. We shall not risk trying to find subtle links between this short realist intermezzo and the realism of Magritte, tempting though the prospect is. Except for their faith in reality, they had nothing in common, apart perhaps from the fact that both felt attracted to painting techniques which would have as little influence as possible on the inspired effects. This characteristic is also striking in Courbet's and Millet's Belgian rival Charles De Groux, who held brilliant colour contrasts and demonstrative shading in a pre-Magritien contempt.

The essential difference between the Realism of these 19th century artists and that of Magritte lay in their respective attitudes towards the painter's mission. Perhaps, viewed from the distance of more than a century, it lay too in their relationship to politics in the broadest sense. On the basis of precarious social situations, Courbet wanted to testify and convince. Magritte for his part wanted to use the known to reveal the unknown. Not that social life and its problems were a matter of indifference to him; though he thought that "interest in social questions distracts from interest in mystery", he was nevertheless of the opinion that art could only find its social justification in the social role that it played (cf. letter to the Drapeau Rouge). He feared a compromising confusion in this question, though, for example in the political sphere, and thus in the class struggle. In a "Note to the Communist Party", he observed that "the translation of political ideas into painting is useful for illustrating party posters". On the other hand: "This does not automatically imply that the only valid role for the artist is just to paint pictures expressing the class struggle in a more or less lyrical fashion, nor that the workers must forgo the pleasure of seeing pictures capable of enriching their consciousness in a way different from that which gives them their class-consciousness." He thus condemned so-called "Socialist" Realism which, incidentally, could have claimed antecedents in the circle around Courbet and Millet.

So, wherein does Magritte's Realism lie? On the term "Realism" itself Magritte only expressed himself vaguely and periphrastically, as though he regarded it as diffuse and difficult to define with adequate precision. Certainly he admitted to being a "realistic painter". Yet he did not see this as implying that he faithfully depicted reality without further ado. When he wrote that "what one should paint is restricted to a thought which can be represented in painting", he was firmly setting his target. But immediately afterwards he declared that in order to express this thought which could be described in pictures, one had to find an intermediary able to present the thought. "The thought which can be represented in painting and be made visible" was thus for him identical "with what the visible world presents to our consciousness" (taken from: "After I took the course . . ."). Thus the visible world contains the real. It constitutes our perception, as Gaston Bachelard showed. For Magritte, the thought comes into action when it unifies the figures of the visible world "in an order which conjures up the mystery of the world and of thought". For Magritte, it was this unification which justified the pleasure felt by the viewer of a picture, insofar as it awakens within him a kind of blissful inward astonishment; as if, finally, everything would lighten up in the mind of each of us and dreams would come true. For Magritte, all the same, dreams are of no importance if they are not tangible. Thus his painting never draws its inspira-

"The fanatics of movement and of motionlessness will not find this picture to their taste."

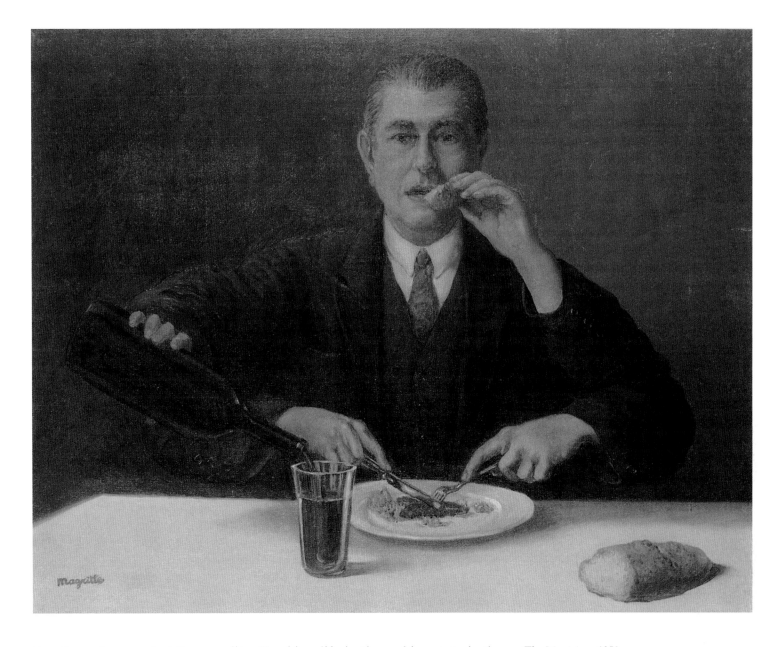

The Magician, 1952
Le sorcier
Oil on canvas, 34 x 45 cm
Courtesy Galerie Isy Brachot, Brussels–Paris

tion from dreams, but from reality. For him, life in the waking state is the translation of the dream, just as the dream is the translation of life in the waking state. He illustrated this by means of a necktie which, according to Freud's interpretation of dreams, can represent a phallus. By drawing the necktie in an exemplary fashion, the painter retrieves the object back to the realm of the real; dreams are in fact images of reality because that is where they arise. In this connexion we might quote the Victorian English novelist Ivy Compton-Burnett, who declared that things only became real after they had been said. For the painter, it is only when things are painted that they become knowledge. It is then that a picture, dictated by thought, becomes reality. Necktie and phallus become one. Pictures are "portraits" of ideas, not of objects or people.

Among the pictorial examples of this theory, Magritte named the subjects of two well-known paintings, *The Empire of Light* (1954; illus. p. 101), and *The Domain of Arnhem* (1938; illus. p. 140). On the first picture can be seen "a nocturnal scene beneath a sky bathed in sunlight", while the second depicts "a mountain-range in the shape of a bird". Day and night, a nocturnal landscape and a bright daylit sky "just as we see it", united in a single picture – that is the theme of *The Empire of Light*. The painter said of this picture: "This evocation

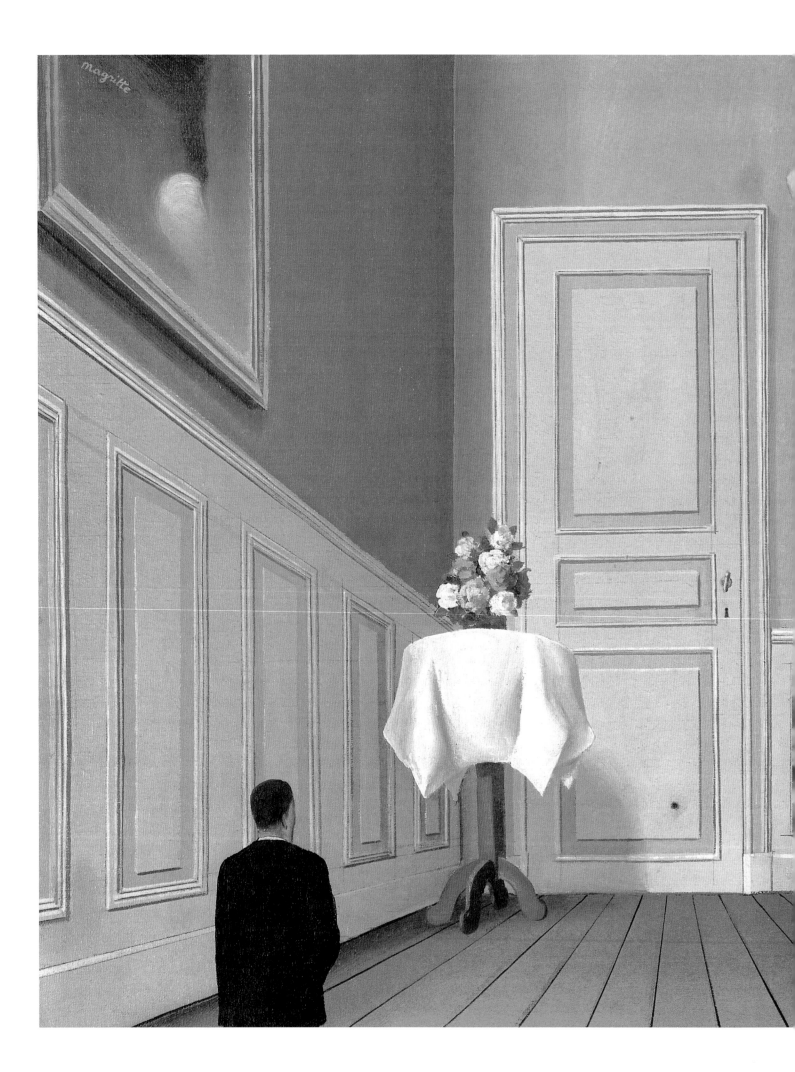

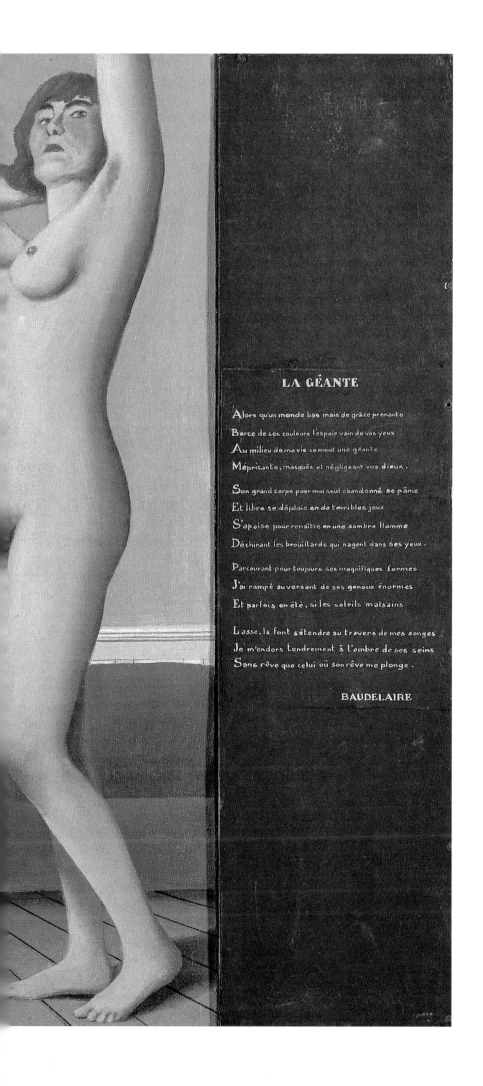

LA GÉANTE

Alors qu'un monde bas mais de grâce prenante
Berce de ses couleurs l'espoir vain de vos yeux
Au milieu de ma vie se meut une géante
Méprisante, masquée et négligeant vos dieux.

Son grand corps pour moi seul abandonné se pâme
Et libre se déploie en de terribles jeux
S'apaise pour renaître en une sombre flamme
Déchirant les brouillards qui nagent dans ses yeux.

Parcourant pour toujours ses magnifiques formes
J'ai rampé au versant de ses genoux énormes
Et parfois en été, si les soleils malsains

Lasse, la font s'étendre au travers de mes songes
Je m'endors tendrement à l'ombre de ses seins
Sans rêve que celui où son rêve me plonge.

BAUDELAIRE

The Giantess, 1929/30
La géante
Tempera on paper, cardboard and canvas,
54 x 73 cm
Cologne, Museum Ludwig

of day and night seemed to me to possess the power to surprise us and to enchant us. This power I call poetry." *The Domain of Arnhem;* a title borrowed from Edgar Allan Poe, depicts a high, rocky mountain range whose ridge has the shape of a golden eagle with wings spread. In the 1938 version, it rises against the background of a blue-green sky; a masonry window-opening, of which only the lower and left-hand edges are visible, allows us a view of the mountain. On the window-sill are two bird's eggs. Here too there is a reference to poetic power, only by other means. The motionless stone in the shape of a bird stands without a doubt for the unexpected conjunction of the living and the fossil, the solid and the volatile. Parallel with this, the two eggs could represent the permanence of such paradoxical phenomena ("mysteries"), since the bird is continually reborn, even of these stones. The legendary phoenix is not necessarily mythical.

Instead of "realism" in the traditional sense, Magritte preferred to speak of "likeness". The ideas associated with these two terms are not the same. The difference between the two could equally well determine the difference which, in Magritte's case, distinguishes pure realism – which has led painting to depict nothing but the real – from the actual function which he attributed to his pictures, which consists in the use of the likeness to make obvious the mystery which surrounds all things – that aura, which Walter Benjamin, for example, has described as the sign of artistic intervention. In this connexion, dictionaries are of little help. Their definitions are those of everyday usage. Magritte provided a corrective by pointing out that if one says, as one does, that one egg resembles another, one can also say that "a forgery resembles the original". Hence he rejected the notion of similitude based on comparison.

The notion of likeness thus came to assume special importance in his thinking. He explained what he meant abundantly, and publicly, on three occasions: a lecture given at the Libre Académie de Belgique, of which he was a member, in 1959 and, in 1961 and 1962, in introductions he wrote for catalogues. One was for an exhibition of his work at the Musée de Beaux-Arts in Liège, organized by the Verviers-based magazine "Temps mêlés" and the director André Blavier, and the second for an exhibition at the Obelisk Gallery in London. A number of passages from these sources are revealing in this context, even though the concepts are philosophical rather than artistic in their approach. Magritte declares, for example, that to be like is "an act which belongs only to thought". To compare likenesses, in fact, is an intellectual act. He continued by asserting that "to be like is to become the thing one takes with one", thus "only the thought can become the thing which one takes with one". What one thinks, is. It is in fact because one thinks that things become comprehensible. Thus it is true that "the essential act of thought is to become knowledge". Magritte thus spun a logical yarn uniting the reality of what is with the thought one has of it and the knowledge which results. Since as a painter he knew how to exploit this yarn to produce pictures which took account of thoughts capable of being painted, what he depicted could not but reproduce things that were "like", in other words, recognizable. But the picture of a thing is not the thing itself. "A painted image only arises when the appearance of colours spread on a surface coincides with an image which has similitude with the visible world." But this process alone is not enough; the figures must be placed on the picture in an arrangement "determined by the way of thought." So it is that inspiration comes about: "a necessary event in order for the thought to become the likeness itself."

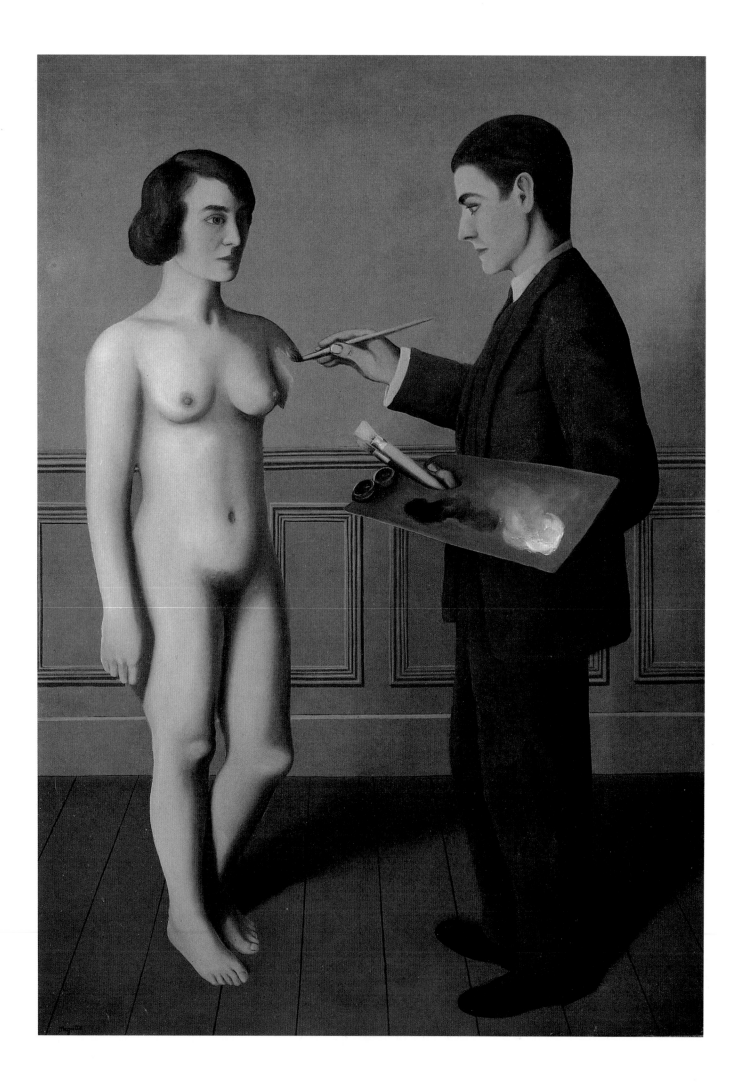

To unravel the yarn formed by this succession of events, one can fall back with some assurance on examples offered by the painter himself. A human body and a horse suggest a rider on his mount; it represents an ordinary combination of two elements which the mind pairs off immediately, without surprise. A human body and horse: this may also represent a centaur. That is not the first thing that comes to mind. The manner in which human body and horse complement each other, in this example, is alien. Yet it is "well on the way to becoming familar" because the centaur already exists in everybody's imagination as well as in popular iconography. Finally, a human body and horse, fused into a centaur, can be placed in a "parodic context" giving free rein to fantasy: a centaur in bathing trunks. The same thing happens when you draw a horse in a jam-jar and call the whole thing *Horse Jam* (undated drawing). This leads from a familiarity with figures and situations to a necessarily alien unfamiliarity. This strangeness, however, derives less from the elements which make up the picture and which are known than from the unusual context in which they are placed. Inspiration has caused a particular way of thinking to open out on to a "wondrous aspect" of reality. Even if the picture uses elements of reality, it does not render them tangible as a result. One cannot touch them any more – they are merely painted images. The picture depicts in an untouchable form figures which are the likenesses of otherwise tangible objects. It is thus in order for the artist to display imagination. Let us suppose, with Magritte, that one had depicted a "slice of bread and butter", an edible product, in other words. You certainly can't eat the picture! If the interplay of thought and inspiration cause the artist to give this picture of a slice of bread and butter the title "This is not a slice of bread and butter", then he is not only telling the truth – because the painted bread and butter is not edible – but he is above all shocking the beholder, who is accustomed to taking likeness for reality. The same is true of other elements. The surprise picture of a "nocturnal landscape beneath a sunny sky" (*The Empire of Light;* illus. p. 101) is confusing by comparison with the more familiar picture of "a nocturnal landscape beneath a starry sky". The painter, by giving play to ambiguous contrasts, is showing clearly that between a realism which expresses itself, as he puts it, de facto, and one which expresses itself de jure, there is a decisive difference. A realism "de facto" means the representation solely of the likeness of isolated objects; "de jure" realism means production of an amalgam inspired by objects bearing a likeness to what they are in reality. The mental process – a far from simple one – which leads thus from the loan of objects and things in reality, right up to their apparently illogical reunion in an invented image. Magritte emphasized that he was not at all concerned with creating "any old picture which flies in the face of common sense" and which would be "nothing but potential contradiction". On the contrary, he explained, likeness "doesn't care whether it accords with common sense or defies it". He expected from a likeness that it should "spontaneously unite the figures of the visible world in an arrangement determined by inspiration".

In about 1954 Magritte painted a small picture entitled *The Likeness* (illus. p. 92). As it was kept in his studio until the death of his widow, it remained relatively unknown. Even though it might not be among the painter's most important works, it certainly bears witness to his ability when he really wanted to create "likeness". It is actually a portrait of a young woman, very close up, the face occupying almost the whole surface of the picture. This face is totally realistic, in other words, reproduced with photographic accuracy. It is an

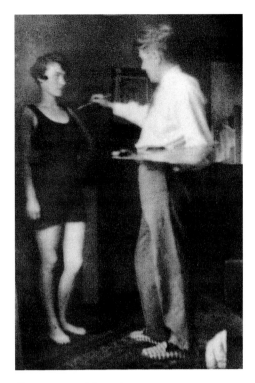

Georgette and René Magritte in
Le Perreux-sur-Marne, 1928
Photograph
Courtesy Galerie Isy Brachot, Brussels–Paris

Attempting the Impossible, 1928
La tentative de l'impossible
Oil on canvas, 105.6 x 81 cm
Courtesy Galerie Isy Brachot, Brussels–Paris

René Magritte as *The Therapist, 1937*
Photograph
Courtesy Galerie Isy Brachot, Brussels–Paris

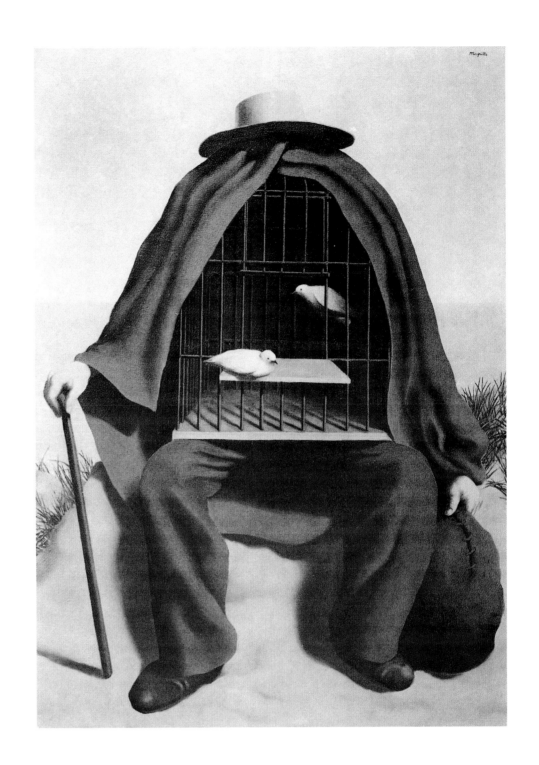

The Therapist, 1937
Le thérapeute
Oil on canvas, 92 x 65 cm
Courtesy Galerie Isy Brachot, Brussels–Paris

indisputably perfect likeness. There is not the slightest ambiguity in the picture (cf. *Portrait: Georgette Magritte,* 1936; illus. p. 158). Or perhaps there is; coming from this painter, is it not too perfect? It is an archetype, almost, of the face of a particularly beautiful woman. The experts consider it to be a preliminary study for a more comprehensive composition, which might have become a supplementary version of *Eternal Evidence* (illus. p. 81), the original of which dates from 1930. This consists of five framed pictures placed one above the other, the whole forming a nude. The top picture does indeed depict the close-up of a face, here seen in three-quarter profile. This likeness to the model of a female face used for a composition crops up again on other occasions. For example in the picture entitled *The Ignorant Fairy* (1956; illus. p. 93) and for the mural in the Palais des Beaux-Arts in Charleroi, dating from 1957, which bears the same title (illus. pp. 162/163). These too depict a young woman's face occupying the foreground of the picture. It is not difficult to see the resemblance between this and the *Portrait of Anne-Marie Crowet* painted the same year.

This realism, and what the painter made of it by introducing it into his less true-to-nature pictures, led to a definition of his development and his work as sur-realist (in two words, hyphenated) rather than Surrealist (in one word). That is, he expressed himself by taking reality as his starting point and not giving up a true-to-life form of representation, while the Surrealists mostly tried to express themselves by looking for equivalents of what existed in the unconscious. Even Salvador Dalí, whom one could class as a relatively realistic painter, and who was certainly an altogether representational painter, always appealed to hallucinations, the irrational, and to psychoses in the practice of his "paranoiac-critical method". Magritte's pictures, by contrast, are the least elitist which could possibly arise from complex thought. One really need make no very great effort to see what the pictures are all about, nor to be surprised by them.

In this context, while the orthodox Surrealists had a very high opinion of the French poet the Count de Lautréamont and his commentaries, none of them was more faithful in practice than Magritte to his celebrated declaration on the

ILLUSTRATION LEFT AND CENTRE:
Man Ray:
Photographs of Edward James, 1937
Antwerp, Sylvio Perlstein Collection

ILLUSTRATION RIGHT:
The Pleasure Principle
(Portrait of Edward James)
Study, 1936
Pen and ink drawing
Private collection

The Pleasure Principle
(Portrait of Edward James), 1937
Le principe du plaisir
(Portrait d'Edward James)
Oil on canvas, 79 x 63.5 cm
Chichester, Edward James Foundation

Reproduction Prohibited
(Portrait of Edward James), 1937
La reproduction interdite
(Portrait d'Edward James)
Oil on canvas, 79 x 65.5 cm
Rotterdam, Museum Boymans-van
Beuningen

beauty aroused by the unexpected and incongruous meeting of objects. His formulation is well-known: "Beautiful... like the fortuitous encounter of a sewing-machine and an umbrella on a dissecting table" (6th "Song of Maldoror", 1868–69). For the poet as for the painter, their main concern – and this must be stressed – was realistic objects which were brought together in mutual competition. They were not at all concerned with art designed to make you think of a dream, as practised without a doubt by many other representational Surrealists.

In order to function properly, however, this system requires that inspiration play along. In Magritte's case, it was always given first priority. It resisted all arbitrary influences on its actions – like a second nature, if you like. Inspiration is one of the most difficult phenomena to define. The word has various meanings, over and beyond that of the "creative breath" – a simple notion applied to artistic creativity without the provenance of this breath being known. The French literary critic Albert Thibaudet saw it, in the artistic

context, as the opposite of "manufacture". But the basic etymological meaning of "inspiration" is "breathing in". And then there is the meaning it has when one inspires others to do or to think something. Or yet again, when you have a good idea all of a sudden which moves you to carry out some action. There is a little of all these in Magritte's pictures. And it is this that ensures their constant profound "human-ness".

To inspiration, though, must be added imagination, seen as the sphere in which inspiration can work. In Magritte's eyes imagination creates pictures which combine the "familiar figures of the visible" in such a way that they accord with "the interest we naturally show towards the unknown". As a good realist, he did not regard the imagination as in any way synonymous with the imaginary, as the latter has no foundation, and in a sense the negation of reality. In a letter to Scutenaire dated 31 December 1965, he wrote that "this bullshit with the 'imaginary' is different from the imagination. The latter makes possible the appearance of things which are not unimportant: the locomotive, the bicycle, the cigarette, the black sun of melancholy and so on." This conviction was basic to virtually all his pictures. When in the passage quoted above he referred to the locomotive, he was surely thinking of his picture *Time Stabbed* (1935, 1939; illus. p. 89). A locomotive appears in the fireplace of a living-room, rushing towards the viewer at full steam. The bicycle surely refers to the picture of a bicycle placed flat on a smoking cigar. This list could be extended indefinitely, and it would be otiose to do so.

Inspiration swallowed up in imagination, the possibility of depicting "things which are not unimportant", which Magritte encouraged, are manifested most clearly in a series of pictures, extremely simple in their composition, which crop up again and again throughout Magritte's creative life. A few examples: *The Treason of the Pictures (This is not a Pipe)* (1928/29; illus. p. 120) and the picture *Untitled (The Pipe)* (c. 1926; illus. p. 122), which preceded and heralded it; *The Tree of Knowledge* (1929; illus. p. 133); *The Rape* (1934, 1948; illus. pp. 38-39); *The Beyond* (1938; illus. p. 67); *Hegel's Holiday* (1958; illus. p. 97); *The Listening Room* (1958; illus. p. 99) and *The Big Family* (1963; illus. p. 138), and so on. All these pictures have in common a rectilinear composition. They are generally flat, without depth (depth is in our imagination, said Magritte), carefully structured, almost always according to abstract schemas. In addition, they contain no more than a few objects so that they are particularly explicit. On one of the pictures there is nothing but a pipe against a monochrome background and the inscription, by way of comment, "This is not a Pipe" (illus. p. 120). Another picture shows, likewise against a monochrome background, a steel pipe from which is emanating a sort of smoke in which a bubble has formed, containing the two words "sabre" ("sabre") and "cheval" ("horse") (illus. p. 133). Or an oversized eye, filling the whole picture, reflecting clouds in a blue sky. Elsewhere we have a tombstone on stony ground under a sky in which there is nothing to be seen but a perfectly round star (illus. p. 67). In the case of a street-lamp, standing in front of a wall, the top part has been replaced by a rose. A mediaeval castle floats in front of a plain reddish background, tree-roots sprouting from beneath its base. A woman's face has the female sex-organs in place of eyes and mouth (illus. p. 39). A gigantic apple takes up the whole of a room, as if in a box (illus. p. 99). On a raised umbrella, there balances a glass of water three-quarters full (illus. p. 97).

This last picture, *Hegel's Holiday*, evolved from experiments described by Magritte in detail. This description of the process by which he arrived at the

René Magritte beside his painting
Time Stabbed (1939)
Courtesy Galerie Isy Brachot, Brussels–Paris

idea for a picture is particularly instructive as to the manner of its inspiration: namely, with reality as the starting point. Magritte wanted to paint a glass of water. As he was drawing it, he says, a line kept pushing its way on to the paper and taking the shape of an umbrella. So he drew the umbrella in the glass, albeit without much conviction. The picture which resulted left him dissatisfied. Finally the umbrella came to be placed beneath the glass, in accordance with the law of visual balance. The picture was thus the result of the felicitous encounter of a technical problem – painting a glass of water – with the solution of this problem, as supplied by imagination.

Another example of the way in which Magritte's imagination used reality as its starting point is provided by the "portraits" of the English banker and collector Edward James, in whose house Magritte spent several months as a guest in 1937. There are a number of versions of these "portraits". In fact, they are not true portraits except in an allusive sense, because the best-known pictures in which James is the subject never actually show his face. In *The Pleasure Principle* (1937; illus. p. 87) there is, in place of the head, an intense flash of light. In *Reproduction Prohibited* (1937; illus. p. 88), the subject is seen from behind looking at himself in a mirror; the reflexion in the mirror, however, is also a rear view. Many people thought these false portraits were an exercise in mocking their subject. Who knows? It is just as easy to assume that the artist was expressing his disinclination to paint recognizable portraits to order. Above all, one may assume that this was his very personal way of confirming two guiding principles of his own conception of painting. The first, as formulated as early as 1925, was: "No longer to paint objects" (or people, whom he saw as objects) "except in their visible details". The second, which he repeated often, was to represent these objects or people in a realistic manner and thereby to attune them to each other, in order thus to create a picture "in which familiar figures of the visible world are united in a poetic order".

On the very question of portraits, a conversation between Nougé and Magritte casts valuable light on the painter's intentions. Nougé remarked that "it happens sometimes that a portrait tries to resemble its model", to which Magritte replied: "It would be a good thing if the model tried to resemble its portrait" ("Propos", 1943). In short, things are what they are. They are as one sees them. But their fortuitous association, likeness for likeness, can very easily suggest quite different revelations from those produced by mere seeing.

Perhaps the most curious feature of the portraits of Edward James, in particular of the picture entitled *The Pleasure Principle,* is the fact that photography played a major part in its creation. This points not only to the interest taken by Magritte in this medium, but even more, his use thereof in the production of pictures confirms a fortiori his concern with achieving a realistic likeness. And indeed no other graphic technique is characterized as strongly as photography by its primary capacity to capture reality on a picture. To this extent, the photographic image is a likeness of reality. No wonder, then, that Magritte used photographs of his models rather than have them undergo lengthy sittings when he was painting their portraits. Edward James is not an isolated case. What is special about this, though, is the very fact that Magritte painted no recognizable portrait of him, even though, perhaps, there is a psychological likeness where concealed aspects are revealed. For this purpose, Magritte engaged his friend Man Ray to photograph James in surroundings which he himself dictated (illus. p. 86). In these photos we see the English banker in a tie and double-breasted jacket. In one, he is seated behind a table,

The Wrath of the Gods, 1960
La colère des dieux
Oil on canvas, 61 x 50 cm
Turin, private collection

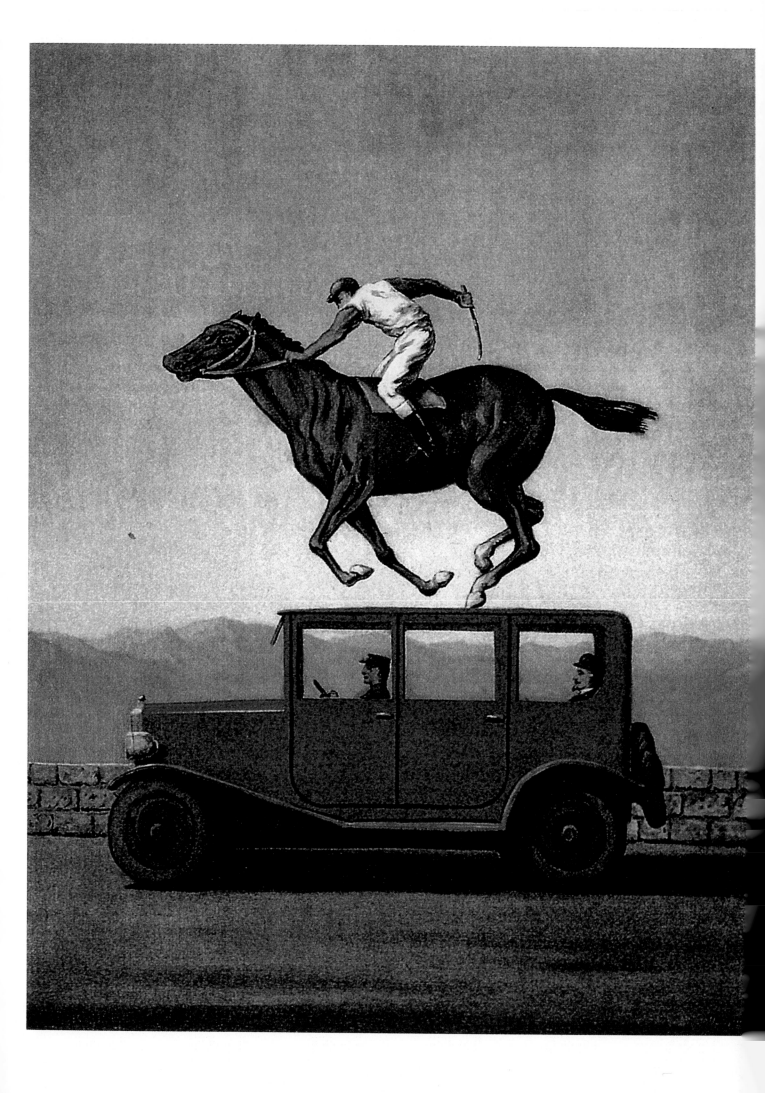

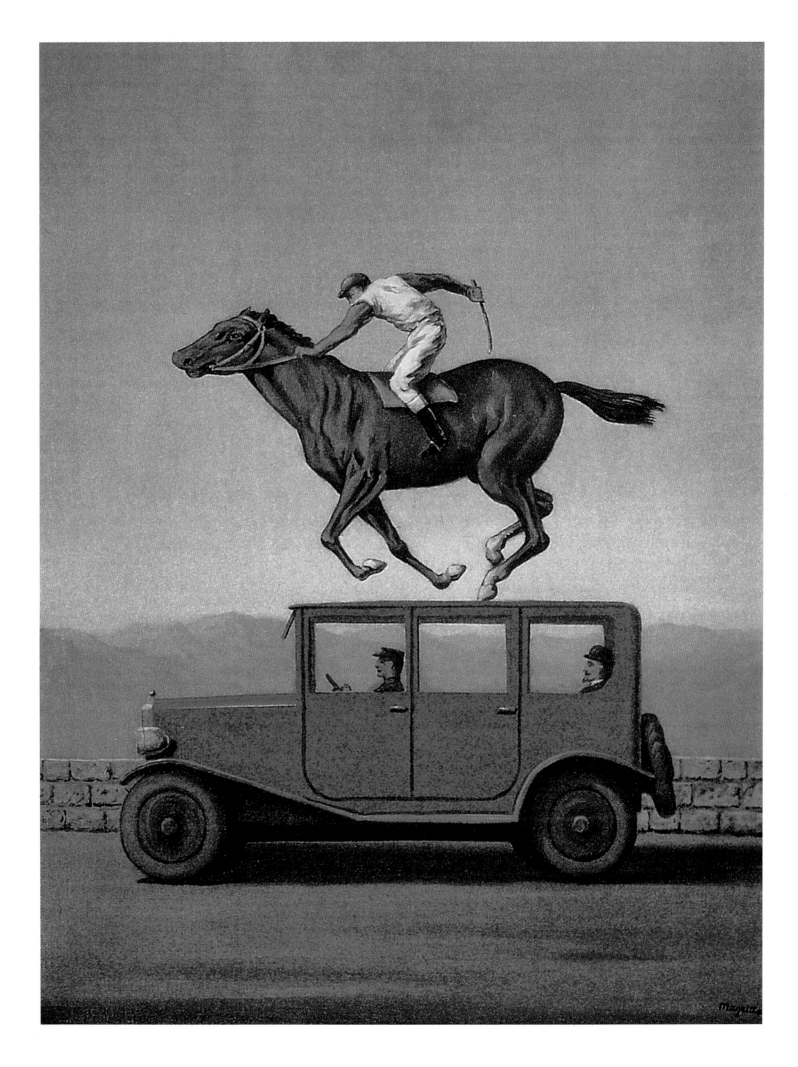

the fingers of the left hand spread out on the table-top. The right hand is hidden beneath the table, upon which, in addition, is a stone. On the other picture, the same in reverse: the right hand is visible, and the stone is on the left. The picture *The Pleasure Principle* depicts James in almost the same position, but with a number of important modifications. Thus in place of the head there is a dazzling light, as if from a flashbulb. The viewer is dazzled by the light, to be sure, but so is the model. The pattern for this picture was the photograph on which James' right hand was showing and the stone was on the left. His fingers are more strongly crooked. Why did Magritte choose this photo rather than the other? It is clear from his correspondence with the banker that the painter gave the photographer very precise instructions, not only regarding the pose of the model, but also regarding the lighting. It is true that James also had his say. On the back of the photograph he wrote in bad French that he preferred the photo with the right hand visible, because "the folds in the jacket are fuller and more accentuated", and also because "the shadow and the position of the hand are clearer". James added: "But of course you can combine them by taking the best of each, however it seems best to you. And perhaps for your idea the version with the smoother jacket is preferable."

On the other hand, one can't help comparing *The Pleasure Principle* with the unfinished work that was found in Magritte's studio after his death. This is a chalk drawing on canvas, evidently the preparatory sketch for an oil painting. It must date from 1967. It is untitled, and is technically a masterpiece. Here too can be seen a person, sitting behind a table, dressed in a high-buttoned coat, with both arms hidden beneath the table-top. The resemblance to the James portrait is obvious. But there are major differences between the two canvases. The fact of both arms being hidden is one. Then, there is no head at all. The starched collar of the shirt is like an empty tube constricted by the tie. On the

René Magritte with his painting
The Likeness (1954)
Courtesy Galerie Isy Brachot, Brussels–Paris

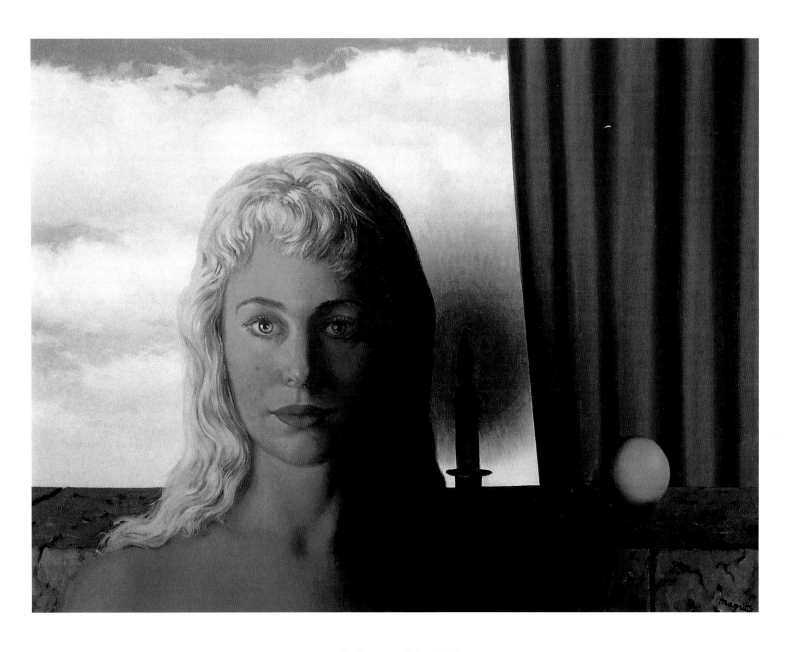

The Ignorant Fairy, 1956
La fée ignorante
Oil on canvas, 50 x 65 cm
Brussels, private collection

table is a closed book. On the book is a hand, palm down; but the hand is not connected to the body.

The recurrence of subjects is a feature of Magritte's work. With respect to this unfinished picture, one might also note another, *The Idea,* dating from 1966. Here the head is replaced by a green apple, which is not connected to the body by anything at all.

In any case, had the painter wanted to paint a purely "objective" portrait of Edward James, he would have chosen to depict him in a way which "corresponds to the photographic appearance of the object, with modifications appropriate to the eye which beholds and the hand, more or less expert, which depicts". However, he also observed: "One cannot say that the representation of an object obtained by a camera is 'conventional', even though the relationships between the objects thus obtained are 'lacking in fantasy'" ("Aesthetic Pleasure"). He declared further: "If I just had a camera, I would not evoke the mystery" (Interview with Jean Neyens). Even in the portrait, mystery counts for more than likeness or the photographic lens. "If I depict a person, it is his or her existence which is at stake, and not some activity." Is this the origin of the title *Reproduction Prohibited,* borne by another portrait of Edward James (illus. p. 88)? Prohibited, the reproduction of external appearances?! Photography for Magritte was thus an ambiguous process. However, he had understood its almost contradictory character, which resides in the fact that its objectivity is dependent upon a photographer who is never objective. If Roland Barthes rediscovered his young mother by photographic trickery, Magritte questioned the invisible component which is contained in every photograph: "I have seen photographs of a young woman and a child, and guessed that the woman was the mother of the child" (Undated Writings V).

However that may be, Magritte was a keen amateur photographer and, as he put it, "cinematographer". He was so good that, after his death, now an acknowledged celebrity, exhibitions of his photography were held here and there, and albums of his photographs published.

"La fidélité des images" was the title of the first exhibition of Magritte's photographs, at the Musée Royaux des Beaux-Arts in Brussels in 1976. The exhibition's title, and that of the first collection of photographs published for the occasion, was not, to be exact, Magritte's own. Certainly it was chosen by Louis Scutenaire, who also wrote the introduction. It does, though, bring out very well what it means, in respect of the eternal intentions of the artist. Faithfulness, in fact, to the real in the pictures he created. The photographs attributed to him were not in fact all taken by him, even though he carried out the preparatory work for most of them. "Just as he arranged the components of his pictures in order to create 'another world'", wrote Scutenaire, "on his free days René Magritte took pleasure in placing people – his wife, his friends – in invented situations, before having their 'portrait taken' by one or other of those close to him" (Scutenaire 1976). While this was perhaps no more than an undemanding pleasure, it is nonetheless curious to observe that the painter set the scene for photographs that are very strongly reminiscent of certain compositions in his paintings. Thus there are more or less faithful reconstructions "in natura" of the subject of his famous painting *The Therapist* (illus. p. 85). But are they reconstructions or preliminary studies? All we know is that the photographs (illus. p. 84) and the first version of the picture date from the same year (1937). One photograph dating from 1928, called "Love" by Scutenaire, shows Georgette and René Magritte in a room at Le Perreux-sur-Marne (illus.

"I think the best title for a picture is a poetic title . . . which is compatible with more or less lively emotions such as we feel when looking at a picture. . . The poetic title needn't tell us anything, but should surprise and delight us."

The Imagination, 1948
La folle du logis
Gouache, 17 x 14 cm
Brussels, private collection

p. 83). It is not unlike the picture entitled *Attempting the Impossible* (illus. p. 82), oil on canvas, dating from the same year. The photo shows Magritte painting his wife, who is wearing a bathing costume. In the painting, she is naked. A further example, among many others dating from 1943, is a photo of Scutenaire wearing a check suit. He has a floppy hat on, and a scarf round his neck. He's carrying a broom over his shoulder as if it were a gun. The photo is entitled *The Destroyer*. There is no doubt that this picture has to be seen in close connexion with a painting from the same year entitled *Universal Gravity*. This is a portrait of Scutenaire, in the field, so to speak. He is wearing gaiters, and dressed almost exactly as in the photo; over his shoulder, on a bandolier, he is carrying a rifle: a huntsman stretching his arm over a brick wall, beyond which is a forest with tree-trunks rising like columns above the wall.

There can be no doubt then that there was, from then on, a complicity, as it were, between the photographs and certain paintings. A game, no doubt. But there is also an "essential relationship" between the one and the other, as Scutenaire rightly said in regard to the cinematographic exercises which Magritte pursued after buying himself an 8-millimetre amateur film camera in

Hegel's Holiday, 1958
Les vacances de Hegel
Oil on canvas, 61 x 50 cm
Courtesy Galerie Isy Brachot, Brussels–Paris

ILLUSTRATION OPPOSITE:
Fine Realities, 1964
Les belles réalités
Oil on canvas, 50 x 40 cm
Courtesy Galerie Isy Brachot, Brussels–Paris

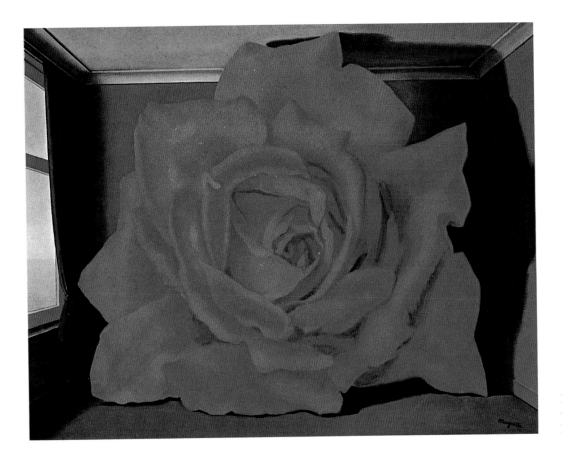

The Wrestlers' Tomb, 1961
Le tombeau des Lutteurs
Oil on canvas, 89 x 117 cm
New York, private collection

Personal Values, 1951/52
Les valeurs personnelles
Oil on canvas, 80 x 100 cm
New York, private collection

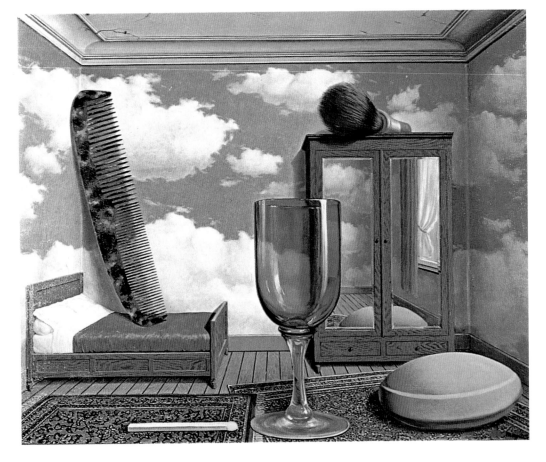

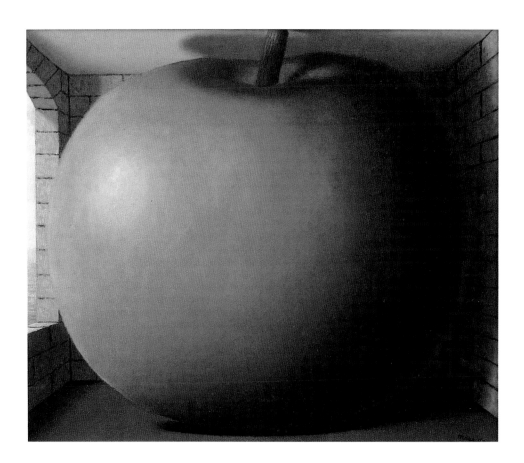

The Listening Room, 1958
La chambre d'écoute
Oil on canvas, 38 x 45.8 cm
Private collection

1956. He went about the preparation and execution of his film work with great gusto, and took great pleasure in it. He wrote little "Surrealist" film scripts which he went on to actually produce. He is even said to have been "temperamental" and "biting" while directing scenes in which his friends were the actors. Many objects he employed for his paintings turn up again in his films. And, moreover, the titles of these filmstrips are sometimes clearly symptomatic of the "Magrittian" atmosphere; thus: "The Colinet Affair", "The Antilles Dessert", "The Red Wolf" or "The Altered Cards".

One further observation is offered concerning the system of reproduction as utilized in photography. It has already been pointed out that Magritte was totally unmoved by the idea of a work of art as a unique piece of hardware, even to the extent of producing copies on demand, naturally with inevitable variations. In consequence he was by no means indifferent to the opportunities presented by photography. We have already mentioned the use of photographs in the preparation of painted portraits. There is another example: when he received commissions to paint murals in Brussels, in Charleroi and in Knokke-Heist/Le Zoute, Magritte did not shrink from using colour transparencies of his own pictures, projecting them on to the wall in order to compose the murals he had in mind, murals which were then finally painted, in their definitive versions, by interior decorators (illus. pp. 162/163). He was clearly not the only one to employ this technique. He conceded, incidentally, when asked about the interest of the general public in painting, that "there is no need to see a painting . . . For me, a reproduction is enough!" He was thus in agreement, on this point at least, with Walter Benjamin, a German philosopher who had said that "the technical possibility of reproducing a work of art changes the attitude of the masses towards art" (Benjamin, 1955). In the

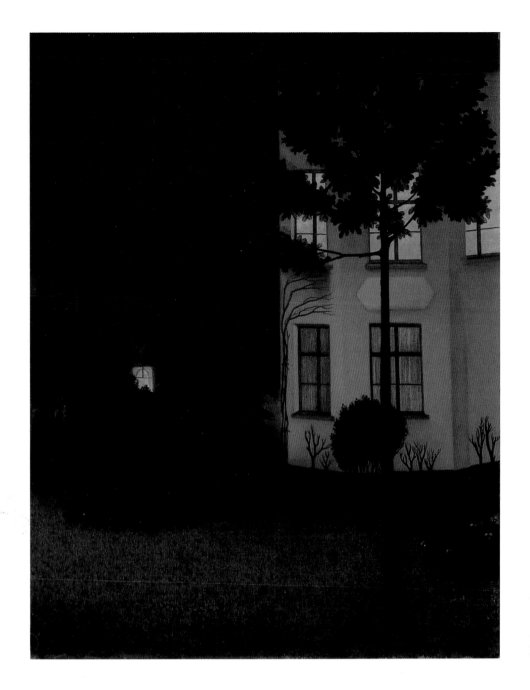

ILLUSTRATION OPPOSITE:
The Empire of Light, 1954
L'empire des lumières
Oil on canvas, 146 x 113.7 cm
Brussels, Musée Royaux des Beaux-Arts

W. Degouve de Nunques:
The House of Mysteries, 1892
Oil on canvas, 63 x 43 cm
Otterlo (Netherlands), Collection
Rijksmuseum Kröller-Müller

matter of relationships with the masses: it should not be forgotten that Magritte had a close relationship himself with advertising. He did advertising work as a pot-boiler. Commercial graphic artists have often copied him, because both his imagination and his manner of painting lent themselves particularly well to the production of a striking advertisement. And what is more mechanistic and necessarily more reproductive than advertising?

Magritte and the concept of realism: for the first time in 20th century art a painter tried not to evade reality, but rather to make reality proclaim its mystery. The first time, and perhaps the only time. In the face of diffuse impressions and sentiments impossible to reproduce in pictures, here was a totally new approach to Nature, one which treated her as an object. What he has taught us, and what cannot be repeated too often, is this: "What one sees in an object is another, hidden, object."

Magritte beside: *The Empire of Light (1954)*
Courtesy Galerie Isy Brachot, Brussels–Paris

100

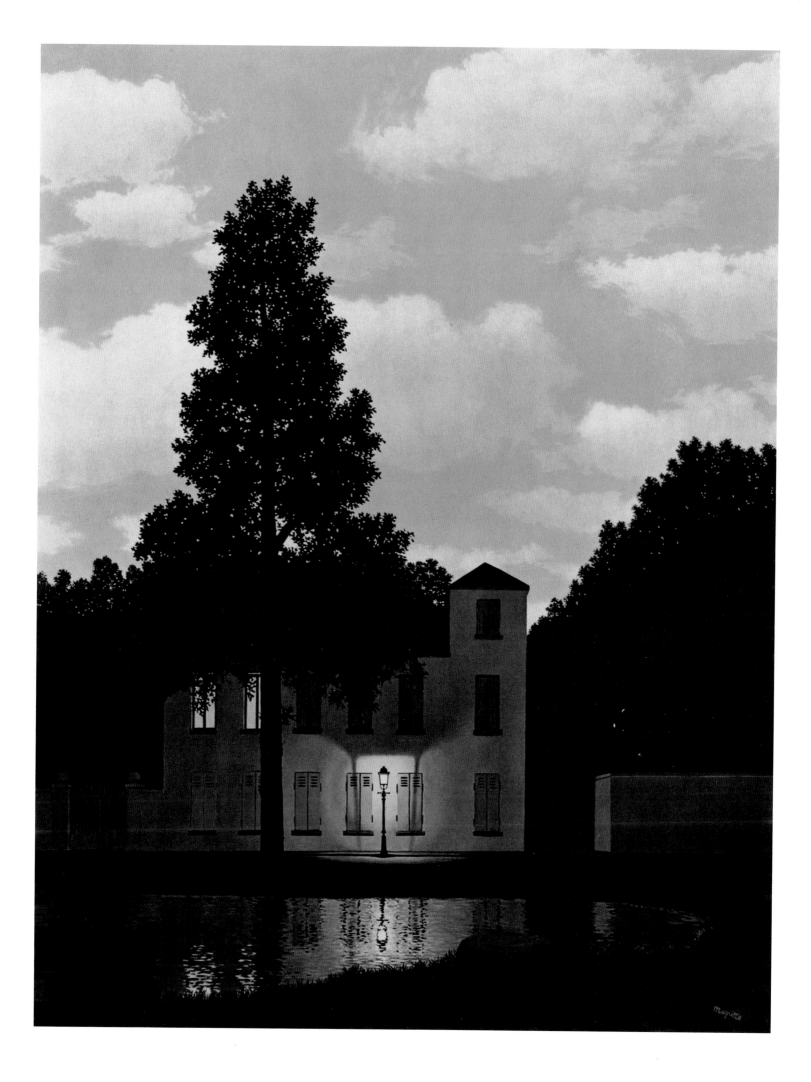

From Reality to Poetry and Mystery

The central idea running through the work of René Magritte was that painting must be poetry, and that poetry must evoke mystery. The key word is "mystery". His whole œuvre was comitted to an attempt to evoke this mystery – to evoke it, not to reveal it. But just what *is* mystery? There is no lack of definitions. All of them, incontestably, have something to do with the idea of something hidden, something secret. Some of them are also marked by religious or mystical connotations. In other words, according to the churches or to religious dogmas, it is necessary either to receive some sort of initiation in order to penetrate these "mysteries", or else they are forever inaccessible to human understanding and have to be accepted as they are. This is the case with the mysteries practised by the Christian religion as embodied in its sacraments. It is the domain of esoterism, more beloved of Surrealism in general than to Magritte in particular. As he wrote to Jacques Van Lennep, who had just written a treatise on art and alchemy, "I am not interested in penetrating secrets as the alchemists were" (letter dated 9 May 1967).

The word "mystery" has yet other meanings, giving us perhaps better access to Magritte's concept of this indeed in many respects poetic notion. For poetry is also concerned with posing riddles for the intellect to solve, but riddles which can only be suggested by the use of extraordinary language. Among other definitions, some are appropriate, perhaps, to the painter's intentions, and others not. We have seen that he did not like to talk in terms of penetrating secrets. For him it was no doubt useful to invoke the philosopher Martin Heidegger, who thought that mystery was inherent in the essence of truth. If one cannot explain what mystery is, one can at least have a foreboding of it. And, insofar as he assumed, in his pictures, the truth of objects and things, Magritte was acting as if their realistic depiction and their associations had necessarily to awaken in us the essential question which the foreboding of mystery invokes. "The success of a work", he wrote in 1926 or 1927, "seems to depend very little on its point of departure or on the problems of its execution. The finished picture is a surprise, and its creator is the first to be surprised. One always wants to achieve a more astonishing, more unexpected effect." In 1958 he declared: "A painting must be a thunderbolt." Even so, he had no recipe for cooking up this thunderbolt. Rather than searching unceasingly for a way to uncover secrets, what the painter had to do was above all to arouse in the viewer the intuition of something hidden. This is the meaning of his observation that one object always conceals another. Painting a glass of water leads to painting an umbrella, to return to the example, quoted above, of the picture *Hegel's Holiday* (illus. p. 97). The revelatory aspect of painting is thus overlaid by an intellectual one. Magritte's picture sets a many-facetted riddle for the

The Evening Gown, 1954
La robe de soirée
Oil on canvas, 80 x 60 cm
Brussels, private collection

The Schoolmaster, 1954
Le maître d'école
Oil on canvas, 81 x 60 cm
Geneva, private collection

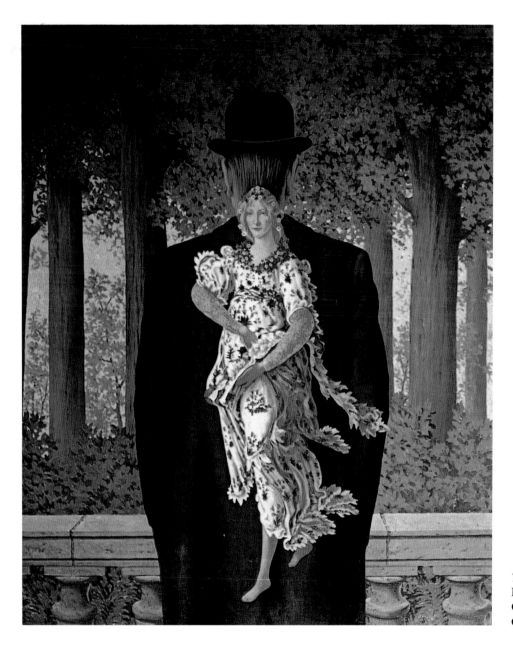

The Ready-Made Bouquet, 1956
Le bouquet tout fait
Oil on canvas, 166.5 x 128.5 cm
Chicago, private collection

viewer, which he solves by thinking. The concealed and the unknown can, even if they are by nature foreign to most people, be known to certain people, artists or not. In any case they can be revealed to all, if only someone – a painter, for example – suggests to their consciousness associations capable of giving birth, in the viewer, to ideas at once unexpected yet plausible. The keys to mystery thus lie to a certain extent in the imagination and in all that feeds it, from memory as such to all the recollections which it awakens.

Magritte dismantled the mechanism of this phenomenon pretty well when he explained the relationship between dreams and reality ("Personal Experience", 1927/28). When he awoke from a long night's sleep, he reported, a "whole crowd of thoughts" came into his head. Many had their origin in dreams he had had. It sometimes happened that in the morning he would meet some of the people he had seen in his sleep. But, recalling these things, he suddenly discovered that "they did not come from a dream". He had seen these people and these situations the evening before "outside a cinema". The mysteries which seem to underlie nocturnal dreams are no longer true mysteries, as soon as one can discover their origins in a reality whose images one had

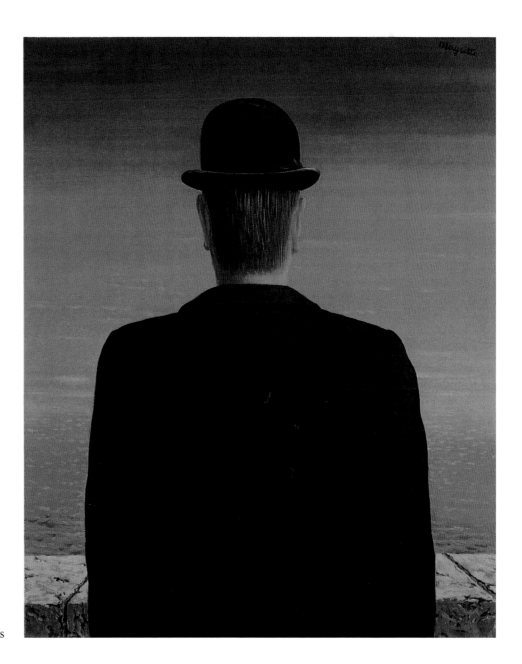

The Spirit of Adventure, 1962
L'esprit d'aventure
Oil on canvas, 55 x 46.5 cm
Courtesy Galerie Isy Brachot, Brussels–Paris

previously registered. All the same, the artist can draw profit from the ambiguity provoked by this mixture of dream taken from reality and reality taken from dream. This became the realm of the "magnificent error" which so excited his imagination, forcing him to find technical solutions to the problem of the hidden and the visible, the problem which he sought to solve by visual means. This "magnificent error" is what is occasionally brought about by a lapse of thought or a momentary and inexplicable disturbance of vision. Magritte used this expression in connexion with the picture *Elective Affinities* (1933; illus. p. 113). This is a picture in which the subject takes up the whole surface against a background lacking in any details. An apparently gigantic egg is depicted in a bird-cage whose pedestal is of wood, turned on a lathe to resemble the skittles which constitute a recurrent motif in his œuvre. How did this subject come into the painter's head? "I woke up in a room in which someone had put a cage containing a sleeping bird. A magnificent error caused me to see in the cage not a bird but an egg in its place. I thus came upon a new, astonishing poetic secret, for the shock I felt had been produced precisely by the affinity of two objects, the cage and the egg, where previously this kind of

The Month of the Vintage, 1959
Le mois des vendanges
Oil on canvas, 130 x 160 cm
Paris, private collection

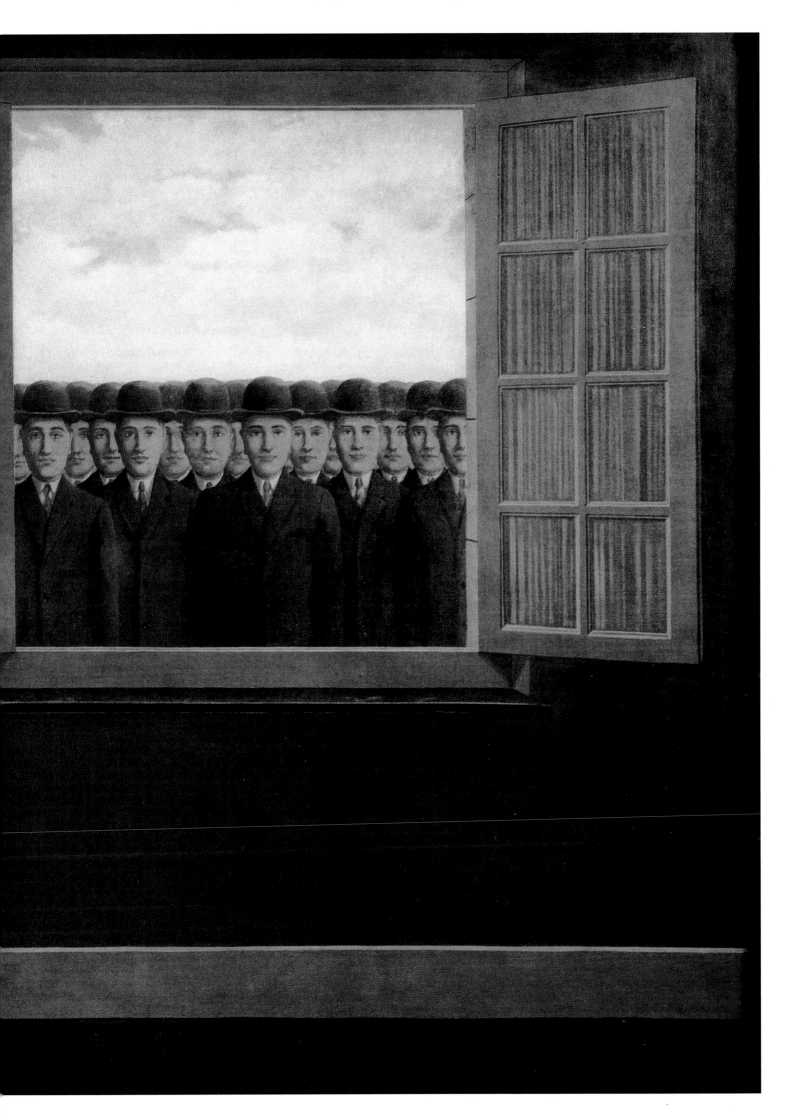

shock had only been produced by the encounter of mutually alien objects" (Lifeline I).

This was written during the 1930s. Magritte was searching at the time for a solution to the problem of connecting different kinds of objects in such a way that they should create an "evident poetry" of the kind he had obtained by the encounter between the cage and the egg. Until then, in fact, the greater part of his "Surrealist" work had been based not so much on the juxtaposition as on the contrasting of objects, however fortuitous. This can be seen in pictures such as *The Difficult Crossing* (1926; illus. p. 25) and *The Birth of the Idol* (1926; illus. p. 24), right up to those entitled *The Central Story* (illus. p. 31), by way of *The Forest* (1926; illus. p. 22), *The Man of the Sea* (1926; illus. p. 23), *Pleasure* (1927; illus. p. 21) or *Symmetrical Cunning* (1928; illus. p. 29). All these important pictures, dating from his decisive years, are characterized by extremely elaborate composition. The painter combined domestic or natural elements with invented ones (the sea, a mirror, a skittle, a table, a staircase etc.). He also introduced real or fictitious personages, some mutilated, some not, some transparent, some opaque, some veiled, some recognizable. There are few compatible objects on these canvases, except in *The Central Story* (illus. p. 31), which depicts a tuba and a suitcase in front of a person with a veiled head. All the same, it must be emphasized that the painter's imagination during this period was dominated by the depiction of isolated objects; and in a very precise fashion, as far as his intentions went. In 1926 he painted a tawny-coloured pipe against a dark brown background (illus. p. 122). He was to derive from this the first version of his celebrated picture *The Treason of the Pictures,* sub-titled *This is Not a Pipe* (1928/29; illus. p. 120). 1927 saw the appearance of *The Museum of a Night* (illus. p. 125), a picture sub-divided into four sections, like boxes, the first three holding a severed hand, an apple, a form obviously deriving from a shoe, while the contents of the fourth are obscured by a screen. Finally in 1928 there appeared the two versions of *The Empty Mask* (illus. p. 124), marking the replacement of representational pictures by words. This was an essential stage in Magritte's inversion of ordinary logic. From this moment on, it could be claimed that his painting was truly language, without thereby being literature.

One is tempted to say that these diverse innovations came in good measure from the quest he pursued following on from the "magnificent error" which led to the creation of the picture *Elective Affinities* (1933; illus. p. 113). As he had done hitherto, with the confrontation of mutually alien motifs, he now realized that he could also arrange encounters between objects which shared certain affinities. Taking as his starting point the idea which had caused an egg to be placed in a cage, he questioned whether "the same evident poetry" might be created by other objects, created, as he explained, "thanks to the illumination of an element proper to them both and also strictly predestined to them". In other words, he abandoned the use of the egg-in-the-cage systematics, based on objects presented to the artist by an error of perception, in favour of the manipulation of three given quantities which go into the process of creating a picture. The three given quantities are: "the object, the thing attached to it in the shade of my consciousness, and the light which this thing must attain" (Lifeline I). And here we have the simplest enumeration of the successive conditions leading to the creation of a work of art. First, an object – of any kind whatever. Then, the search of the memory and the imagination for an equivalent of this object: another object or another motif. Finally, this is all brought

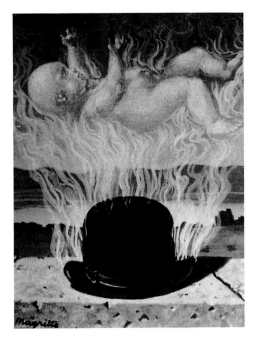

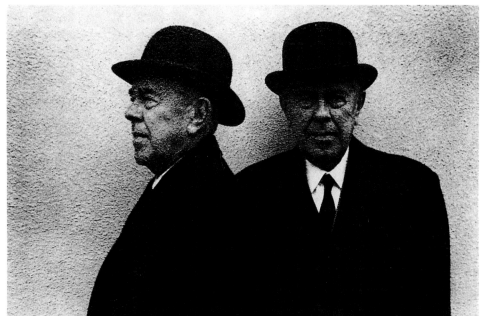

into the open, and lo and behold: a picture! This relating of two objects or two things, and this bringing into the open, which turns them into a picture, presuppose that the artist searches for their mutual accords in the very depths of his imagination. What privileged element is obscurely connected with such an object? How can this thing be imagined? "In the course of my researches I arrived at the certainty that I always recognized this thing in advance, but that this knowledge had somehow got lost in the depths of my thoughts" (*ibid*). But what is really "foreknowledge of the solution"? Magritte gave some examples of these metamorphoses. Thus *The Unexpected Answer* (1933; illus. p. 52) shows a closed door, in which "a shapeless hole gives a glimpse of the night". Closing the door could, indeed, suggest the idea of night, such as is glimpsed through the opening which has been contrived. *The Ladder of Fire* (1939; illus. p. 60) depicts paper, an egg and a key in flames. Burning paper, all well and good; that an egg suggest fire – in order to be cooked: no problem. But a key? That's a puzzle.

The following clues, taken from "La carte d'après nature" (No. 7, 1954), illustrate this same process of association of things in mutual correspondence: "The egg and the cage; the door and the void; the rose and the dagger; the piano and the ring; the bed-sheet and the moon; the squirrel and its floor." These pairings refer to the following pictures: *Elective Affinities* (1933; illus. p. 113) and *The Unexpected Answer* (1933; illus. p. 52), both mentioned above (and to a number of other works on the same theme), *The Blow to the Heart* (1952) or *The Happy Hand* (1953; illus. p. 115), and *The Conductor* (1954).

But what about the mystery? Clearly it lies primarily in the unexpected nature of the nevertheless totally preconceived associations. It can be seen in the pictures whose titles have just been recited. The viewer is urged to question the pictures whose sense escapes him at first sight. To question, though, does not mean to explain. Therein, presumably, lies the mystery. First of all, one yields without reserve to the vivid impression produced by the pictures, without knowing why. Then, if one tries to understand them, another mechanism of judgement must be engaged; on the part as well of the viewer as, previously, of the painter, there must be a "break with all the absurd mental habits which

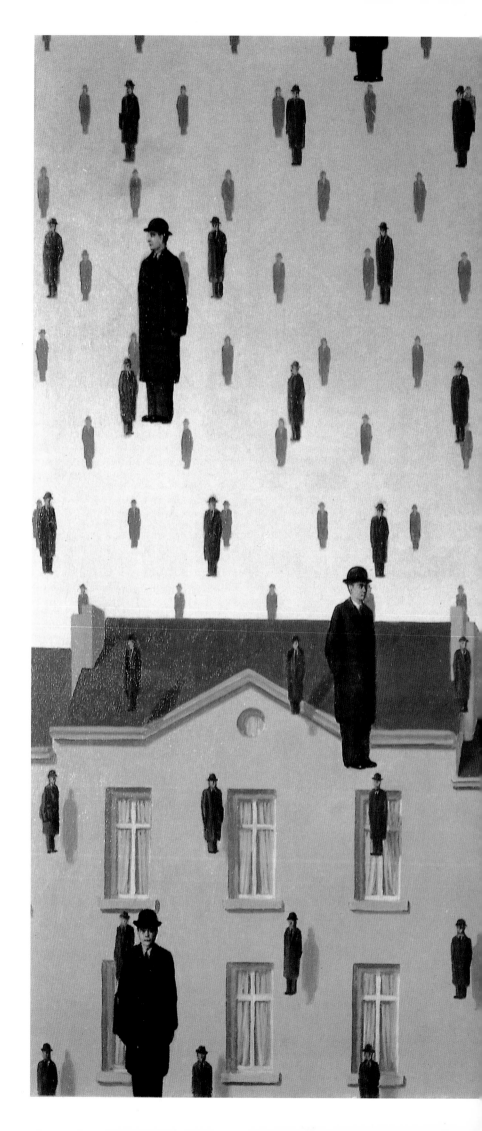

Golconde, 1953
Oil on canvas, 81 x 100 cm
Houston (Texas), The Menil Collection

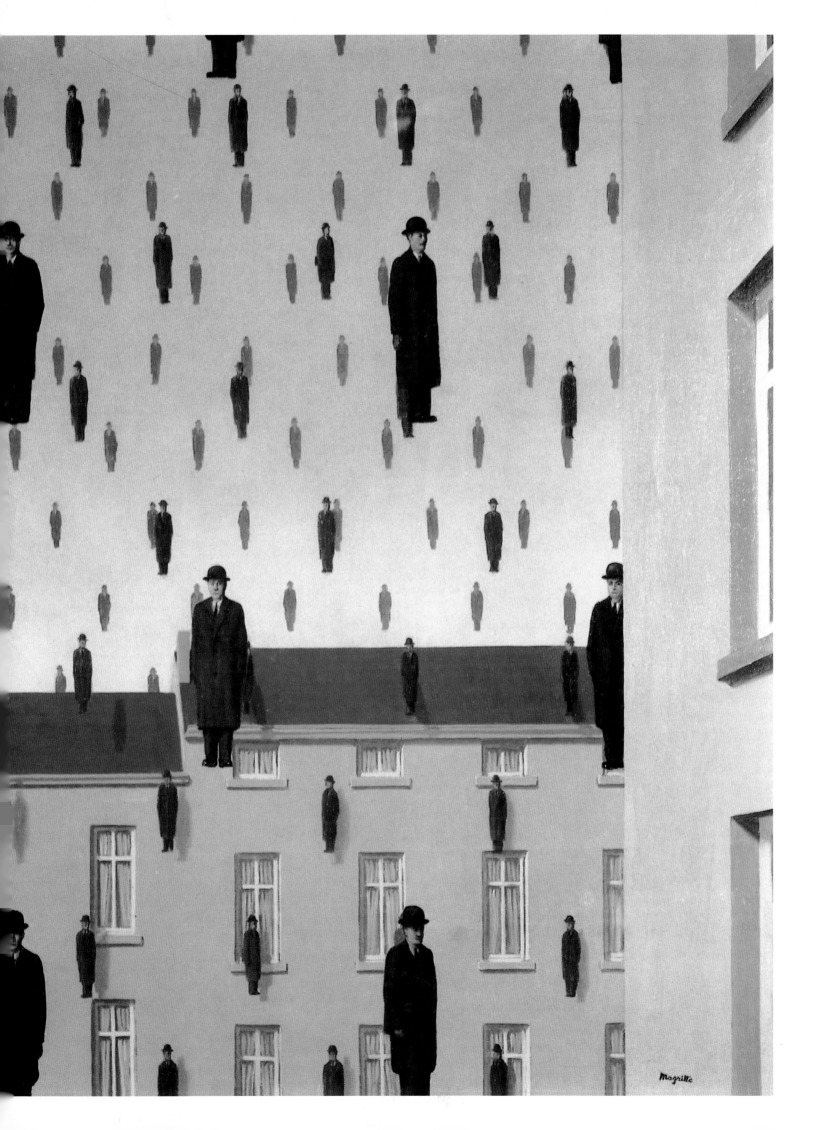

Untitled, 1930
Sans Titre
Drawing, 20.5 x 26.5 cm
Courtesy Galerie Isy Brachot, Brussels–Paris

generally take the place of an authentic feeling of existence". Breaks, in fact, with those habits which catalogue objects in a totally arbitrary, but generally accepted, fashion. If the arrangement of this catalogue is disturbed, lo and behold, one has to start thinking. Or as Magritte put it: "Do you then value the outward appearance in which I clothe my pictures more greatly than their meaning?" Is it in meaning, then, that the mystery resides? Or does mystery manifest itself beyond meaning, whatever that might be? Or in poetry, the final concept which it is permissible to question in the circumstances? But then the notion of poetry is no clearer than that of mystery! In vain do we seek for a rational definition of it. Now in Magritte's case, the rational is not absent, far from it. It is simply disturbed. Poetry, in his eyes, even had a reality of its own. The difficulty the painter felt, evidently, in providing clear and exact definitions of his conception of mystery derive without doubt from the traditional dissociation between deductive knowledge and empirical knowledge. In other words, between what is generally subject to reason and what, for lack of subtlety, escapes it.

In a conversation with Paul Waldo Schwartz in June 1967, first published in 1969 – in the periodical "Studio" – Magritte summed up his global conception in relation to the alliance he proposed between poetry and mystery. "Mystery is there because the poetic image has a reality of its own. Since 'inspired thinking' imagines an order which unites the figures of the visible world, the poetic image possesses the same kind of reality as that of the universe. Why? Because it must correspond to an interest we naturally take in the unknown. When one thinks of 'universe', it is the unknown one is thinking of – its reality is unknown. Likewise I create – using things known – the unknown." In short, while in principle only the things of the visible world can be shown in a picture, the message contained therein opens on to the unknown. For Magritte, the union of visible things, as established by way of poetic thinking, is what introduces us to things alien.

Elective Affinities, 1933
Les affinités électives
Oil on canvas, 41 x 33 cm
Paris, Etienne Périer Collection

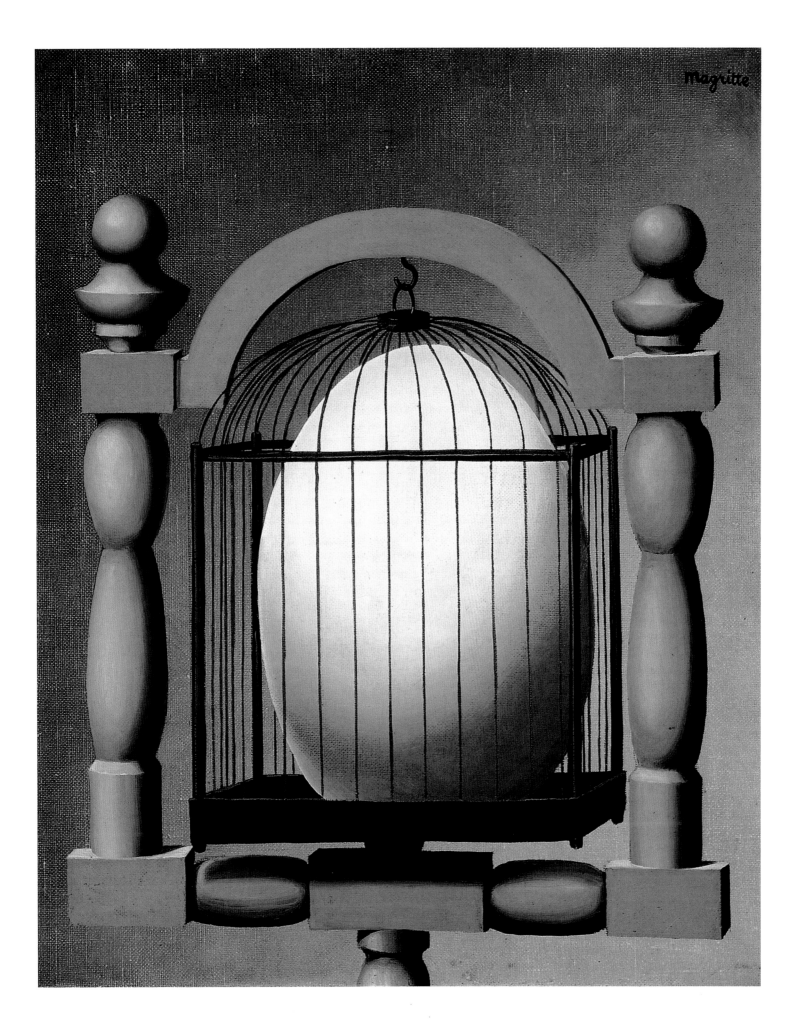

The Happy Hand, 1952
La main heureuse
Drawing, 35 x 24 cm
Brussels, private collection

However, mystery is everywhere. And the enigmas it throws up can be found in many of the works of Man. Enigmas; as far as the works of Magritte were concerned, his friend Paul Nougé preferred this word to "mystery". And indeed, the definition of this term provides a relative solution to the problem presented by Magritte: "guesswork on the basis of an ambiguously couched definition". The description is thus the picture on the basis of which the viewer has to guess at a meaning which suits him personally, whatever it may be. For it can be taken for granted that no picture – these or any others – will explain itself by means of itself. It is always the viewer who interprets. Not only did Magritte agree with this, he also insisted that his pictures did not require any particular interpretation. As his intention was to ask questions, without providing answers, it goes without saying that the freedom of the painter has its counterpart in the freedom of the viewer as an individual. Thus, as has been pointed out above, the interpretation placed on a picture by one person will certainly not be the same as that placed on it by the next person. The art critic is well acquainted with this phenomenon: whatever he writes about the work of a painter will generally go beyond the latter's declared intentions. Artists are aware of this, and frankly concede that a critic sometimes draws their attention to aspects of their work which go beyond, or diverge from, what they themselves had consciously put into it.

The manner in which Magritte's pictures were painted constitutes a further example of this inconstancy between the picture itself and the extremely relative definition given it perhaps by its title. Magritte never made any detailed pronouncement on this matter. The titles of most of his pictures came about largely as the result of a game in which he himself, to be sure, was one of the players, but among whom were also most of his friends. Their meetings, in the presence of a recently completed, but still untitled picture, must have been of a kind with those affected by the Parisian Surrealists when they played the game which they called "exquisite corpses", but which closely resembles that known in the English-speaking world as "consequences". It is played as follows: several people gather with an empty sheet of paper, which is passed from hand to hand. The first player writes or draws something near the top of the paper, which is then folded to conceal what has been drawn or written. The second player then adds his contribution, and the paper is folded once more. This procedure is followed until all the players have had their turn, each writing or drawing something below the previous contributions which they have not, of course, had the benefit of seeing. At the end, the paper is unfolded and the whole story or drawing comes to light. If taken seriously, the result is said to reveal something of the creativity of automatism, notwithstanding the fortuitous arbitrariness of the individual contributions. In general, Magritte and his circle rejected this automatism but they had nothing against this game, which in their eyes was nothing more than a pastime for amusement only. It would appear, though, that the friends changed the rules somewhat, to judge by the known results of their own "Surrealist games" as reported by André Blavier in his "René Magritte: Complete Writings". One such light-hearted exercise, composed by the painter in 1933 and entitled "Small Craftsmen", goes as follows:

"The hat your mother gave you is the result of the work of a whole army of workers.

It passed from hand to hand and an honest hatter gave it an elegant shape.

A horse pulled the wagon full of hats and then ate in the stable.

The Happy Hand, 1953
La main heureuse
Oil on canvas, 50 x 65 cm
Courtesy Galerie Isy Brachot, Brussels–Paris

One day some good-for-nothing, who had no hat and was envious of those who did, set fire to the village barn with the intention that the fire should spread and burn down the hatter's shop.

Moral: One burns hats when they are too dear."

This is certainly not a true "exquisite corpse", nor is it just the product of change. Was it then as it seems, more a biographical game? Need we remind the reader that Magritte's mother was a milliner who made hats? Or that he often depicted hats in his pictures? Or that in his youth he lived among a "whole army of workers"? Or that he spoke of the noise of horse-drawn carts, a childhood memory from which, without a doubt, his predilection for these animals, so often depicted in his paintings, derived? Or that in the parental home there was once an incident which nearly led to a fire, something which left a lasting impression on him? Or that there is a painting attributed to him which depicts a burning barn? Was he a "malicious brat" or just a lively child, as Louis Scutenaire would have us believe? Whatever the case may be, even if this manuscript from the painter's hand does reveal a certain mental attitude – and his skill in manipulating ideas – it still does not seriously prejudice what is actually a philosophy of painting.

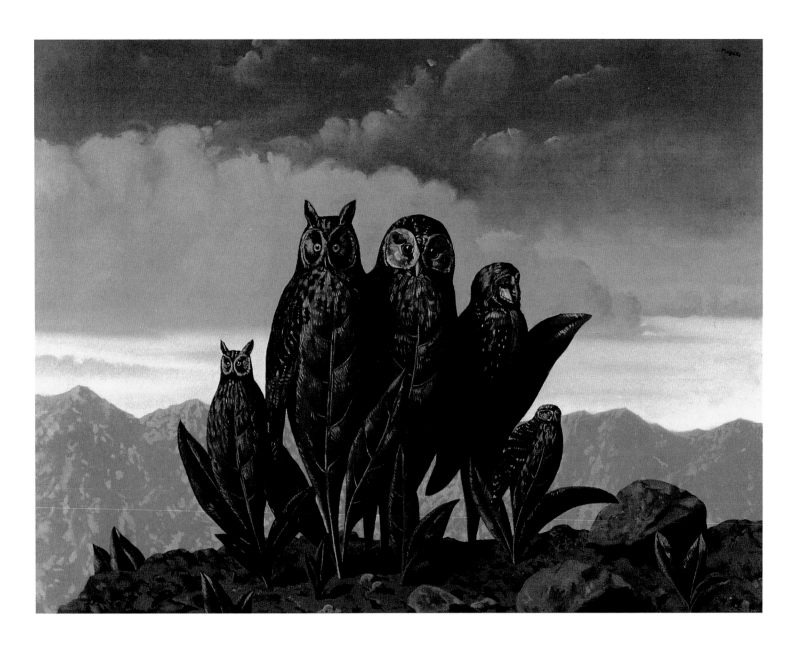

The Companions of Fear, 1942
Les compagnons de la peur
Oil on canvas, 70.4 x 92 cm
Brussels, B. Friedländer-Salik and
V. Dwek-Salik Collection

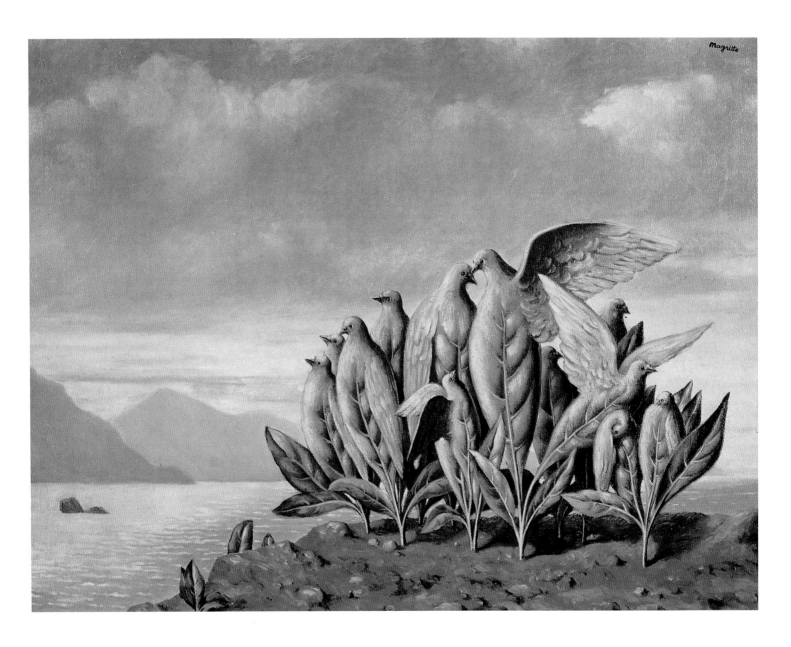

Treasure Island, 1942
L'île au trésor
Oil on canvas, 60 x 80 cm
Brussels, Musées Royaux des Beaux-Arts,
Gift of Mme Georgette Magritte

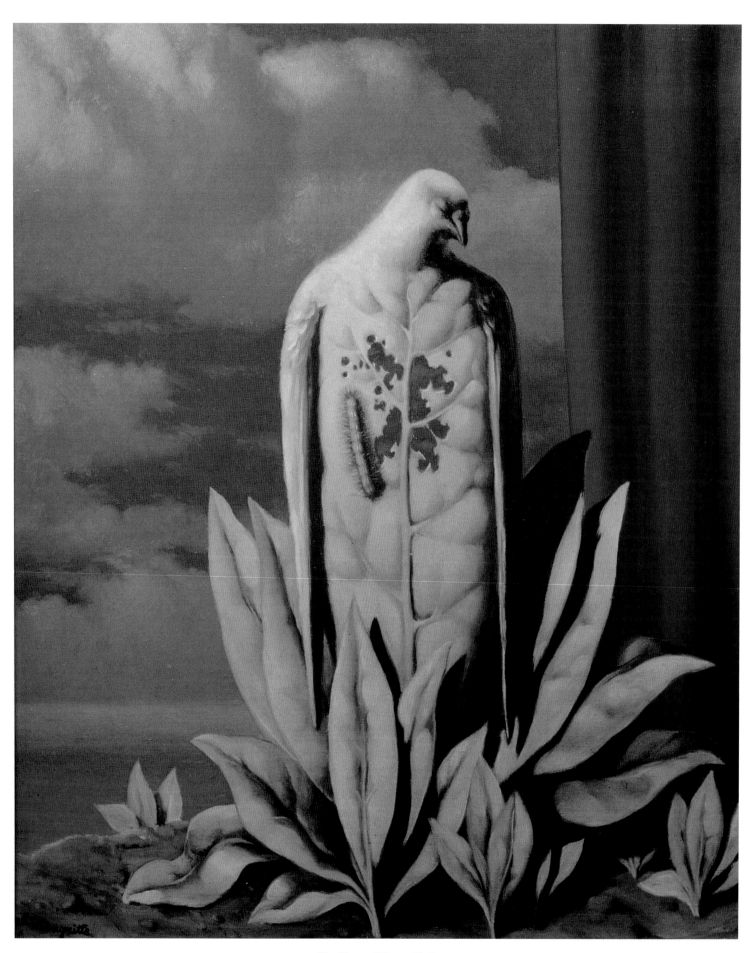

The Taste of Tears, 1948
La saveur des larmes
Oil on canvas, 59.5 x 50 cm
Brussels, Musées Royaux des Beaux-Arts

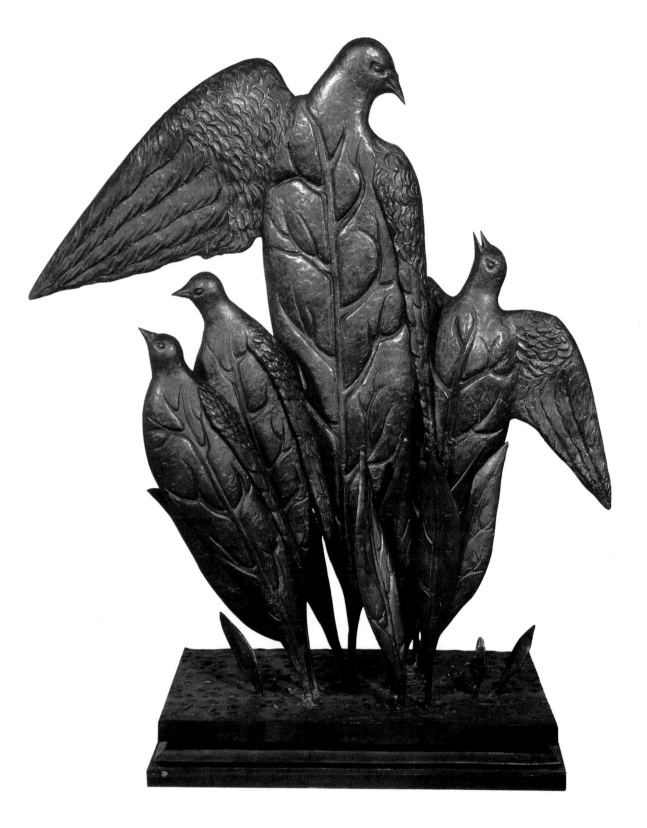

Natural Graces, 1967
Les grâces naturelles
Bronze, height: 107 cm
Patrimoine culturel de la Communauté française
de Belgique

The Treason of the Pictures
(This is not a Pipe), 1928/29
La trahison des images (Ceci n'est pas une pipe)
Oil on canvas, 62.2 x 81 cm
Los Angeles, County Museum

On the other hand, the games designed to find definitive titles for his pictures implied a totally different attitude. Assembled around the painter, confronted with the recently finished painting which they had come to name, the circle of friends would exchange ideas, of which at least one had the prospect of being finally retained. In order to count as good, a title had to have certain qualities which were not determined entirely by chance, even if one might be forgiven for thinking that chance sometimes played a role. What was needed, in fact, was a title which accorded with the mental process which had led the artist to paint the picture. It was therefore necessary to proceed along the same mental path as that taken by the visual artist, from the representation of one object in reality to another object in reality, linked in such a way as to reveal similarities capable of giving rise to questioning and surprise. It was also necessary for the title not to define in words the picture concerned, as it never depicted a conventional subject open to description as such. The subjects were never landscapes, or portraits, or still-lifes. The title thus had to open up horizons sufficiently alienating for the viewer to wonder about the ulterior message conveyed by the picture. In other words, what is hidden behind this image? Another criterion was that the title should introduce a poetic domain, that is to say, ensure that the statement made by the picture appeal to the viewer's imagination – and to his secret reactions – both through what was shown and through what was not shown, but hinted at.

These gatherings in front of the completed but as yet untitled painting must have been both interesting and contentious. Certainly they must have given rise to conversations – pleasurable and revealing in turn – on the motivations of everyone present. Friendly tournaments, where each participant advanced his own small contribution regarding the picture submitted to his judgement, and proposing his own solution to the problem of the title thus posed. Everyone had their say, no doubt, but Magritte remained in control of the proceedings. He it was who necessarily had the last word, and he it was who took the final decision. Which is not to deny that the whole debate is instructive as to the

manner in which the painter's close friends, evidently aware of his intentions and used to his method of working, would approach his work. One of the dialogue sequences in the film "Magritte ou La leçon des choses", made in 1959 by Luc de Heusch, reconstructs one of these debates. The new picture, just completed and now submitted for examination by the painter's friends was finally given the name *The Month of the Vintage* (1959; illus. pp. 106/107). It depicts a window whose two leaves, instead of opening outwards as one might expect, are opened wide into a room. Outside this open window can be seen a crowd of identical people, in serried ranks, each with a bowler hat on his head, wearing an overcoat, collar and tie – all these accoutrements being likewise identical (and, incidentally, the same as Magritte used to wear). This whole weird spectacle is set beneath a cloudy sky with a few blue patches. The participants in the dialogue, standing in front of the work, were Camille Goemans and Louis Scutenaire accompanied by his wife Irène Hamoir. Plus Magritte, obviously. The film reconstructs the following succinct extract from the exchange:

Magritte: "Okay, let's describe the picture." (after a pause) "I did think of adding a musical instrument in the corner of the room."

Goemans: "There was no reason to suggest the presence of musicians in the room."

Admittedly, this extract from "Dialogue Scenes in the Film by Luc de Heusch" would be too short to form a basis for interpreting the procedure whereby the painter and his intimates arrived at the title of a picture. Fortunately, however, the artist was much more explicit on the relationships between a picture and its title. Or rather on the lack of relationship. What he said was: "The titles are not descriptions of the pictures and the pictures are not illustrations of the titles." ("On the Titles"). It is doubtful, even, whether there were any connexions between picture and title, even though it does sometimes – seldom! – happen that one can discover suggestions in one which might possibly be valid for the other. As often as not, these clues only suggested themselves after the event, once the artist had endeavoured, by means of a quite personal interpretation, to fix a title to an image or vice versa. He drew up a list of titles and commentaries for the pictures which he exhibited at the Galerie Dietrich in Brussels in 1946. With regard to *The Crystal Bath* (1946; illus. p. 167), he wrote: "In the magical light of the desert, a giraffe appears in a large crystal tumbler" (*ibid.*). This is exactly what one sees. By contrast, it is very hard to imagine how such a beautiful picture as *The Taste of Tears* (1948; illus. p. 118) is supposed to depict what Magritte wrote about it: "The sight of a fallen tree is a joy and a cause for sadness at the same time" (*ibid.*). There is no fallen tree in the picture; what it does show is an imaginary plant whose leaves form a bird with folded wings, whose body is being slowly devoured by a voracious insect. This subject is not dissimilar to that of another artwork, a sculpture dating from a few years earlier, entitled *Natural Graces* (1967; illus. p. 119). Here the leaves of the plant likewise take on the shape of birds, but their appearance is far more friendly. This time, there are indeed correspondences between picture and title. Via an explicit suggestion of nature – the leaves of a plant – one has no difficulty in discovering "grace" – the birds depicted in a pleasant state. Then again, between *The Taste of Tears* and *Natural Graces* there is a major qualitative difference in the impact produced by these works of art on those who see them. From the first, it is clear that *The Taste of Tears* is much more striking than *Natural Graces*. But it is obviously

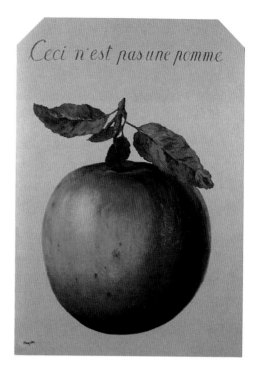

This is not an Apple, 1964
Ceci n'est pas une pomme
Oil on wood, 142 x 100 cm
Courtesy Galerie Isy Brachot, Brussels–Paris

impossible to deduce from this, to paraphrase André Gide, that pleasant feelings never make a striking picture.

In the matter of titles, too, for Magritte everything resolved itself in poetry and thus in the mystery linked to it. "The relationship" [between picture and title] "retains only some of those characteristics of objects generally ignored by the conscious mind, but sometimes the subject of a premonition on the occasion of an extraordinary event is something ordinary reason has been as yet incapable of explaining"(*ibid.*). If the painter translates *The Aesthetics Class* (1946) thus: "In the forest, the huntsman encounters an artistic spectacle", then it is easy to understand that the aim of this description is to signal to the viewer of the picture something different from what it actually depicts. Perhaps, beyond the traditional pleasures of the chase or just of a walk in the woods, what is presented to the viewer's imagination is a quite different spectacle from that generally expected by hunters or walkers – the "effects of art", in other words. And yet, for Magritte, these "effects" were something to be avoided at all costs. In his mind, they were effects generally used by sentimental painters who prevented the awakening of poetic mystery by their habit of artificial tricks to transmute reality, instead of bringing out its basic alienness.

Alongside these approaches, which relate solely to the art of painting, there are other ways – new and unexplored – of penetrating the arcane aspects of Magritte and the allusions to mystery which we find there. These are the ways of which Magritte himself was ignorant, because during his lifetime they had not yet been sufficiently investigated, nor were their implications so public as they are today. In the light of certain work in the field of logic, and its application in the area of cognitive research ("artificial intelligence"), it is now possible to apply more up-to-date findings to Magritte's paintings and to what he said concerning his intentions. In the matter of the problem of the titles and the linguistic games which generally gave rise to them, it is also possible to probe more scientifically into the concept of mystery as Magritte understood it. It is certainly a matter of no little surprise to discover, in this innovatory

Untitled (The Pipe), c. 1926
Sans titre (La pipe)
Oil on canvas, 26.4 x 40 cm
Antwerp, Sylvio Perlstein Collection

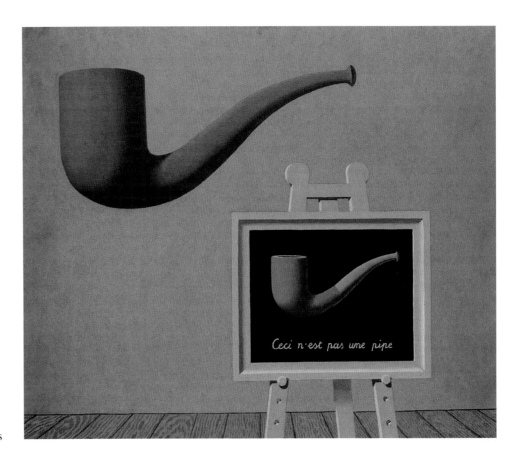

The Two Mysteries, 1966
Les deux mystères
Oil on canvas, 65 x 80 cm
Courtesy Galerie Isy Brachot, Brussels–Paris

dialectic, that logicians share with Magritte the notion of a direct liaison between the principles of reality and the hidden enigmas of intuitive knowledge, notions incidentally which were very dear to Magritte. Thus are combined object-lesson and figurative meaning under the terms of a rhetoric which could not previously have been formulated so clearly.

Logic must, in fact, be considered under two aspects: In the usual sense of the word, and in its technical academic sense. The latter sees logic as the formal study of the rules of truth-values. In popular usage, logic refers to the drawing of what seem to be coherent conclusions. But this is to leave out of the account those "traps" which the discipline itself encourages vis-à-vis common sense. The case most often quoted is the paradox of the liar: if I assert that I am lying, then my statement is false and I am telling the truth, namely that I am lying . . . And so on. There are many other examples of plausible inversions of ordinary meanings, leading in each case to a paradox. Magritte came up with one of his own: "The sense of exactitude is no obstacle to a pleasure in inexactitude." Or again: "The language of authenticity 'gives the word' to words by making them say what they never said" ("Object Lesson"). Words and pictures, they're both the same: if poetry is a special art based on the use of language, as Paul Valéry maintained, this is true of the poetry of pictures no less than of written poetry. However that may be, in Magritte's case – as we know quite well – words and pictures are mutually equivalent. This is documented by, among other things, the essay entitled "Leçon des choses" ("Object Lesson") published in André Bosmans' magazine "Rhétorique" in 1962, and illustrated with drawings. A (slightly revised) English version also exists. In this essay, allusion is made in particular to the picture *The Magician* (1952; illus. p. 77). It shows Magritte himself, full-face and expressionless, in jacket and waistcoat, sitting at a table on which a meal has been set: a plate, a bottle and a glass of wine, a loaf of

The Empty Mask, 1928
Le masque vide
Oil on canvas, 73 x 92 cm
Düsseldorf, Kunstsammlung Nordrhein-Westfalen

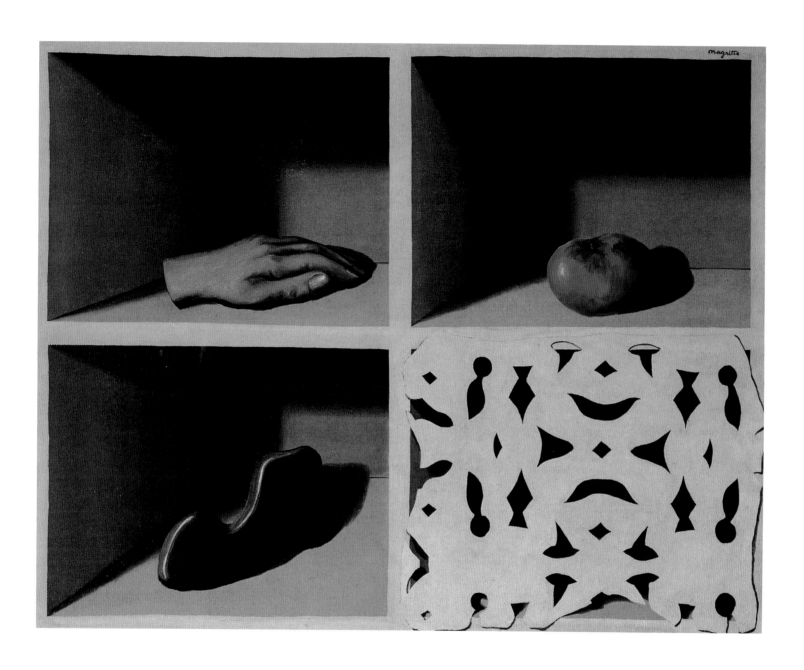

The Museum of a Night, 1927
Le musée d'une nuit
Oil on canvas, 50 x 64.5 cm
Courtesy Galerie Isy Brachot, Brussels–Paris

Les mots et les images

Un objet ne tient pas tellement à son nom qu'on ne puisse lui en trouver un autre qui lui convienne mieux:

Le canon

Il y a des objets qui se passent de nom:

Un mot ne sert parfois qu'à se désigner soi-même:

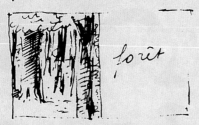

Un objet rencontre son image, un objet rencontre son nom. Il arrive que l'image et le nom de cet objet se rencontrent:

forêt

Parfois le nom d'un objet tient lieu d'une image:

canon

Un mot peut prendre la place d'un objet dans la réalité:

le soleil

Une image peut prendre la place d'un mot dans une proposition:

Le ⊙ est caché par les nuages

Un objet fait supposer qu'il y en a d'autres derrière lui:

Tout tend à faire penser qu'il y a peu de relation entre un objet et ce qu'il le représente:

l'objet réel l'objet représenté

Les mots qui servent à désigner deux objets différents ne montrent pas ce qui peut séparer ces objets l'un de l'autre:

personnage cachant le miroir corps de femme

Dans un tableau, les mots sont de la même substance que les images:

On voit autrement les images et les mots dans un tableau:

montagne

Une forme quelconque peut remplacer l'image d'un objet:

le soleil le soleil le soleil le soleil

Un objet ne fait jamais le même office que son nom ou que son image:

cheval

Or, les contours visibles des objets, dans la réalité, se touchent comme s'ils formaient une mosaïque:

Les figures vagues ont une signification aussi nécessaire, aussi parfaite que les précises:

Parfois, les noms écrits dans un tableau désignent des choses précises, et les images des choses vagues:

canon

ou bien le contraire:

brouillard

RENÉ MAGRITTE

bread from which a piece has been cut. But: the person has four arms and hands instead of two. One hand is putting bread into the mouth, two are using the knife and fork, while the fourth is pouring wine from the bottle into the glass. Here we have immobility of the body and movement of the limbs on the same picture. "The maniacs of movement and those of immobility will not find this picture to their taste." Alongside other more or less direct or indirect explanatory commentaries to this picture, Magritte declared: "A picture can occasionally expose its viewer to serious accusations." Or again: "An unknown picture of the shade is called forth by a known picture of the light." Or again: "Whatever the strokes, words and colours spread over the page, the resulting figure is always full of meaning." Object lesson. "Figurative" meaning...

While on the subject of ambiguities, Magritte's work offers, once words and pictures have come into mutual confrontation, numerous other explicit examples of the invasion by the artist of territory seemingly foreign to painting. When he painted the first version of *The Key to Dreams* (1927; illus. p. 128), or *The Living Mirror* (1928/29; illus. p. 131) or *The Tree of Knowledge* (1929; illus. p. 133), as well as the other pictures in which words appeared, he was venturing into a world still little explored even today. It is a world which is all the more turbid insofar as it urges a revision of the everyday meanings of language and thus a thorough-going revision of our mental habits. The question he posed – a seemingly improper one for a visual artist – was whether words really do have the meaning usually attributed to them in everyday usage. Thus the picture entitled *The Key to Dreams*, dating from 1927, is divided into four sections: a satchel, sub-titled *The Sky,* a pen-knife, sub-titled *The Bird,* a leaf sub-titled *The Table,* while the fourth, depicting a sponge, actually is sub-titled *The Sponge.* In *The Living Mirror,* we have balloons like those used in comic-strips, containing words and phrases: "Personage éclatant de rire" ("person laughing fit to burst"); "horizon"; "armoire" ("wardrobe"); "Cris d'oiseaux" ("bird-calls"). Both pictures give expression to two different approaches to phenomena which the artist wished to illustrate, and to two kinds of perception which he desired from the viewer of his works. In *The Key to Dreams* clearly recognizable objects are confronted with definitions which are, on the face of it, inappropriate. In everyday parlance, penknives are not called birds. Only one of the objects depicted is given its usual designation: the sponge. There is then clearly a desire to use pictures as a means of confusion where received definitions are concerned. By contrast, in *The Living Mirror,* a different intention is being pursued, but one which nontheless rejoins the former. In this picture, objects are replaced by words which do, however, refer to objects or situations. In the case of the wardrobe or the laughing person, the objects are replaced by written words, while in the case of the horizon or the bird calls, it is situations which are replaced by words. This time, the viewer is not confused but is, rather, confronted by a truly conceptual picture. What we have here is not so much painting as language. One word replaces another, a word appears with a picture which is not that which one would have expected, one or more words suggest a picture which is not there... On one occasion only words are depicted but no objects, and at a stroke a question-mark is put against accustomed logic. On the other occasion, objects are combined with words which seem inappropriate: an appeal to associations conjured up by the image which results from the amalgam of object-plus-definition.

Other pictures, too, bear witness to this intention, among them *Rapid Hope* (1927; illus. p. 130), *The Museum of a Night* (1927; illus. p. 125), *The Empty*

Words and Pictures, 1928
Les mots et les images
Pen and ink drawing, 27.5 x 21.2 cm
Courtesy Galerie Isy Brachot, Brussels–Paris

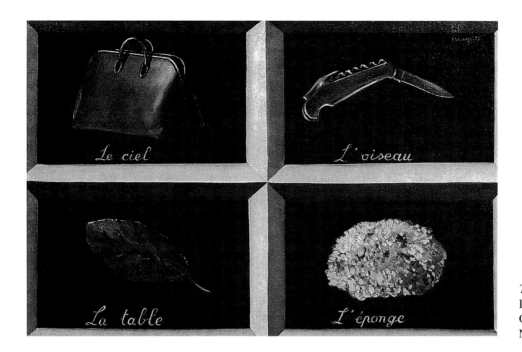

The Key to Dreams, 1927
La clef des songes
Oil on canvas, 38 x 53 cm
New York, Sidney Janis Gallery

Mask (1928, illus. p. 124) and the 1930 version of *The Key to Dreams* (illus. p. 129). This problem area seems to have been in the forefront of Magritte's interest constantly from the mid-1920s to the mid-1930s. And from then on, the same preoccupation with disorientation dictated practically the whole development of his work until the very end of his life. He not only replaced a picture by a word, but one picture by another – by the second picture which lies hidden beneath the first.

Painting as language: Magritte had said that "words have all kinds of meanings" and that "words can represent pictures, but they don't have to" (cf. "Interview with Michèle Coraine"). So where's the logic? It can be found where we least expect it: in the treachery of words and in the treachery of pictures towards what "common sense" has made of them. But is it treachery or is it just a question-mark? Magritte lined himself up with Lewis Carroll, who put into the mouth of Humpty Dumpty, the hero of "Through the Looking Glass", the words: "When *I* use a word, it means just what I choose it to mean . . . and when I make a word do a lot of work . . . I always pay it extra." As is well known, Lewis Carroll, the author of "Alice's Adventures in Wonderland", was the pen-name of Charles Lutwidge Dodgson, a mathematician and logician, who also wrote "Logic Made Easy". In a preface to the French edition of this latter work ("Logique sans peine"), Jean Gattegno reminds us that the idea of logic as practised by Dodgson strove to impose a three-stage reform on the vocabulary of words. The first stage consisted in a "regular demolition of our everyday ideas of words" by means of an effort to "make us lose our confidence in them". The second stage was to be the establishment of "a vocabulary with very secure definitions". Finally, the third stage aimed at voicing "suggestions for reconstructing a form of language secure against all these weaknesses". Given all this, it is not difficult to draw a parallel between Dodgson-Carroll and Magritte. We need only to take the three stages mentioned and apply them to the painter. First, the demolition of everyday ideas: this is precisely the intention behind both versions of *The Key to Dreams* (illus. pp. 128 and 129), analyzed above, which shows objects defined by words which

do not apply to them. The establishment of secure definitions: the poetry conveyed by the pictures must replace a literal interpretation thereof. It is not what the picture shows that matters, but what it suggests. Reconstruction of a form of language: the juxtaposition of unexpected objects, combined or not as the case may be with written words, paradoxically bestows quite different meanings on things which at first sight appeared quite unambiguous.

It is not by chance that paradoxes, the children of logic, have come to be mentioned here. According to the dictionary, a paradox is "that which is contrary to received opinion, a self-contradictory statement". They fly in the face of "common sense". However, flying in the face of common sense was not really the goal which Magritte was pursuing. It is tempting to say, indeed, that he restored common sense to its place of honour, by depicting in his pictures only things that were immediately recognizable. Thus is was that, commenting on *Homesickness* (1940; illus. p. 72), he quite simply said: "You've never seen a man leaning over the parapet of a bridge, looking into the water, with a lion behind him? Really? Well, thanks to this painting, now you have." This could almost count as a joke. Here, the paradox lies in the fact that it is unusual for a lion to be sitting on a bridge, for a man to have wings, and for him to be totally indifferent to the presence of the animal. Another example is the series of pictures in which the realistic depiction of an object is accompanied by the subtitle "This is not a . . .". We have *This is not an Apple* (1964; illus. p. 121), above the picture of an apple. Above all, we have *This is not a Pipe* (1928/29; illus. p. 120), beneath the picture of a pipe. The pictures in this series carry the respective titles *The Treason of the Pictures* (illus. p. 120) and *The Two Mysteries* (illus. p. 123). They were painted between 1928 and 1966. The fact that the painter pursued this same subject for so many years with such perseverance is sure evidence of the importance which he attributed to this form of representation. It was in a sense his ultimate paradox.

These pictures were the subject of numerous philosophical interpretations, especially by Michel Foucault. Following his essay "Les mots et les choses", he wrote another entitled "Ceci n'est pas une pipe" (1973), in an appendix to which two letters from Magritte are published. It is quite clear that the most obvious, and simplest, explanation lies in the observation that the picture of a pipe is nothing other than the representation of a smoker's accessory, and cannot itself be used for smoking. This is the "temporal" logic of Lewis Carroll, and the "logic of reason" of Magritte. But equally it throws the gates wide open to paradox and aporia (aporia being a "a difficulty arising from an awareness of incompatible views on the same theoretic matter"). For the viewer of this painting, the object represented clearly is a pipe, no doubt about it. The problem derives solely from the inscription which accompanies it. And why should this pipe not be a pipe? For the same reason that the word "dog" doesn't bark, as William James has observed (quoted by Suzi Gablik in her book on the painter).

Thus philosophy and philosophers have come to the rescue of a painter who himself philosophized without believing in it too much but, still, an artist who read the philosophers and even corresponded with some of them. And now we have the spectacle of scientists invoking him. Magritte could never have expected that. For several decades it has been understood that mystery is inherent in research to the extent that the exact sciences now acknowledge that rationalism alone is not enough. Thus the scientists have turned into philosophers, in order to reflect on their procedures. One might mention here

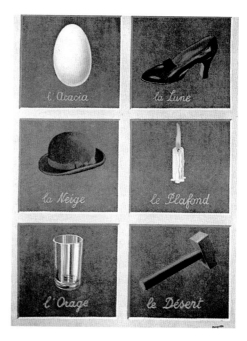

The Key to Dreams, 1930
La clef des songes
Oil on canvas, 81 x 60 cm
Paris, private collection

the numerous writings, from the Princeton Gnosis to the report of the Cordova Colloquium, right up to the current works of physicists and biologists since the 1970s – representatives of a new phase in the common pursuit by science and the humanities. From the Cordova Colloquium of 1980, with its theme of "Science and Consciousness", up to "Between Time and Eternity", published by Ilya Prigogine and Isabelle Stengers in 1988, science has developed along a track which exhibits a singular parallelism with that followed by Magritte. On both sides, in fact, there has been a discovery that there exist several legitimate forms of rationality "to take account of the data of our senses". This has been confirmed in turn by the biologist Henri Atlan in his book "A tort et à Raison" (1986); he also advocates the need for "a humour which takes seriously the multiplicity and relativity of games of knowledge, of intellect, of the unconscious and of language".

Logic, together with its accompanying paradoxes and aporias is, however, just as much the concern of mathematics as it is of philosophy. Now in this very special area the intuitive demonstrations on the part of Magritte take a totally unexpected and intriguing turn. How could the painter ever have imagined that one day an American specialist in cognitive science would take his pictures as evidence of his theories? In his book "Gödel, Escher, Bach" published in 1986, the mathematician Douglas Hofstadter hopes to move his readers to a new vision of the unbridgeable chasm which seems to divide the formal from the informal, the animate from the inanimate, the supple from the rigid. Above all, he endeavours to convince his readers by using the well-tried technique of dialogue between man and beast, as employed by the Cretan logicians and by La Fontaine. Hofstadter's method is to push the obviously absurd so far that it leads to totally functional conclusions.

One of the dialogues he composed bears the title "Edifying Thoughts of a Tobacco Smoker". It features protagonists named Achilles and the Crab. To

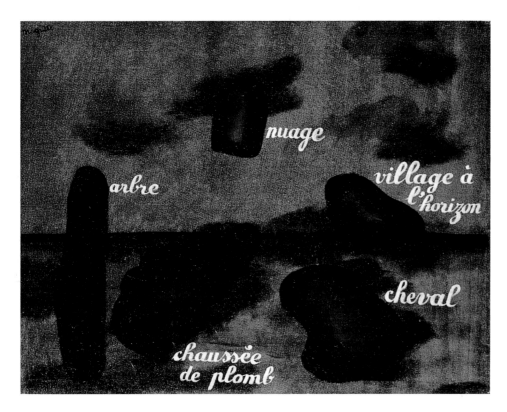

Rapid Hope, 1927
L'espoir rapide
Oil on canvas, 50 x 65 cm
Hamburg, Hamburger Kunsthalle

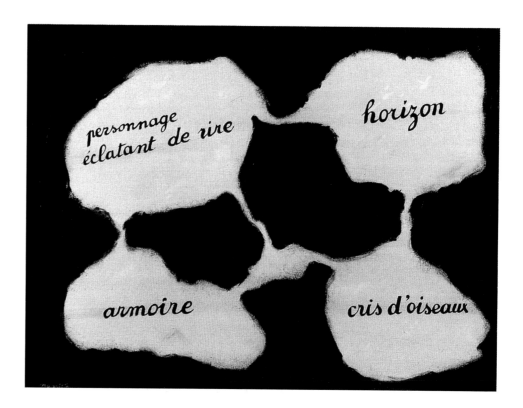

The Living Mirror, 1928/29
Le miroir vivant
Oil on canvas, 54.2 x 73.5 cm
Private collection

illustrate his proof, the author has chosen the works of none other than René Magritte. Not only does he reproduce one of the versions of *This is not a . . .* (*The Air and the Song;* 1964), but he also includes in his book reproductions of pictures such as *The Shadows* (1966). This picture shows a tree with leaves in front of a pipe of exaggerated proportions. The biggest and the smallest – one of the artist's obsessions. Another picture reproduced by Hofstadter is *The State of Grace* (1959). It brings out the incongruity of associations of opposites: a picture of a bicycle placed on a lighted cigar. Another picture used by Hofstadter as an example is *The Beautiful Prisoner* (1947). Here we see a picture within a picture, but in the context of an extremely complex pictorial structure: on an ocean beach the painter has placed a single stone, a burning tuba und an easel on which, through an empty frame, we can see the (painted!) realistic likeness of the sea beyond.

In this popular but intelligent scientific work there are further examples of pictures by Magritte: *Common Sense* (1945/46), *The Two Mysteries* (1966; illus. p. 123), and *The Human Condition* (1933; illus. p. 41) among others. They serve the author as illustrations of what he calls "Magritte's semantic illusions". A Cubist townscape dating from 1931, entitled *Mental Arithmetic,* likewise serves to illustrate the theory of "the universe of blocks" being investigated at the Massachusetts Institute of Technology.

Hofstadter has Achilles and the Crab observe, in the course of their disputation, that Magritte's pictures explore "the worlds of paradox and illusion with great realism" (p. 514). That is obvious. He adds that "the painter has a great intuition of the evocative power of certain visual symbols". Indeed, by the use of paradoxes which give a particular slant to the coherence of the original reasoning and accentuate its revealing powers, Magritte set in motion – in ignorance of the terms of formal logic – one of the processes described by Hofstadter. Mixing the natural with the supernatural, reality with sur-reality, verist exactitude with creative imagination, the visual artist aroused the emo-

tions of those who saw his works "by the self-engulfment of reality". This self-engulfment represents, it should be noted, the moment when our judgement of received truth begins to vacillate. Hofstadter, the specialist in artificial intelligence, writes that "first through the rich images of his painting, and then through his words, Magritte expresses the links between the two questions: 'How do symbols work?' [we shall pass over the term "symbol", which Magritte rejected] and 'How do our minds work?'" In parallel with this, asking about the meaning of the world, he declared: "My pictures are intended as material signs of the freedom of thought. For this reason they are accessible to the senses and do not contravene this meaning" ("The Meaning of the World"). But: "The meaning is impossible for possible thought." The possible and the impossible – would they have been felt intuitively by the artist at the same time, just as they are felt, scientifically, by researchers concerned with mysteries thrown into question by the exploration of a possibly artificial intelligence? In the case of Magritte, reality as known, received reality, is self-engulfed in a real "otherness". What is and what is not: the picture of the pipe engulfs the reality of the pipe. And lo and behold – the picture and the text cancel each other out! The pipe as painted is certainly no use as a pipe. But to write beneath the picture: "This is not a pipe" shows that the pipe does exist after all. The impossible dissolves in the possible.

The Tree of Knowledge, 1929
L'arbre de la science
Oil on canvas, 41 x 27 cm
Courtesy Galerie Isy Brachot, Brussels–Paris

Painting – No; Image – Yes

It has sometimes been said of Magritte's painting that it is an example of what is occasionally called "anti-painting". The term is inappropriate for this type of painting. And quite obviously it would be all the more inappropriate if it were supposed to mean that Magritte was not a painter. The only thing that can be said is that he did not paint like most other modern painters. Taken in this sense, his painting could perhaps be termed – in relation to the post-Renaissance tradition – "non-painting" rather than "anti-painting" in the accepted modernist sense of the expression.

Likewise it has been said – and this time with more justification, that Magritte's painting has rehabilitated, in modern and contemporary art, the notion of "image". And indeed, his realism on the one hand, his deliberate choice of colours, and the restrained manner in which he applied them to the canvas on the other, have resulted in most of his Surrealist works appearing as observations rather than as accounts of the emotions. To this extent, insofar as they make no use of the conventional effects of art, they appear as realistic icons, exact – *prima facie* non-analogical – reproductions, archetypical of the notion of "image".

In order to explore more deeply the quantitatively greater part of Magritte's œuvre – that which can be termed Surrealist – we need to examine these two concepts more closely, albeit without going exhaustively into the consequences of our exploration.

"Anti-painting" refers – insofar as the term has a definition at all – to a way of producing works of visual art which, not belonging to recognized styles, use none of the customary ingredients of the art of painting and do not lead, either, to the creation of pictures. Or it might mean using painting for completely different ends from those which envisage the creation of pictures. One will not succeed in finding many convincing or definitive examples: certain "installations" perhaps, or works of so-called "body art" or "land art", or those trends which make use of domestic rubbish or industrial waste. In short, "anti-painting" is the opposite of painting, and always excludes the use of materials indispensable to painting, in the same way as it excludes the production of pictures as generally conceived. In the recent history of contemporary art, the notion of "anti-painting" has certainly been used for critical ends and for reasons connected with opposition to tradition. During the 1960s, in particular, it was the subject of renewed attention by the artistic community on account of various recurrent attempts designed to destabilize what was called "easel" painting (to distinguish it from other forms). The term was thus used, in the United States as well as Europe, to justify such artistic trends as the New Realsim, neo-Dadaism, and those which used objects in a post-Duchamp style.

The Nightingale (Study), 1962
Drawing, 23 x 13 cm
Courtesy Galerie Isy Brachot, Brussels–Paris

The Nightingale, 1962
Le rossignol
Oil on canvas, 116 x 89 cm
Courtesy Galerie Isy Brachot, Brussels–Paris

These were doubtless interesting ventures, whose creative elements consisted predominantly of – in the traditional sense – non-artistic materials, such as the products and the refuse of the consumer society, or else which were connected with particular aspects of this society. Alongside many others, and for all their mutual contrasts, the works of the American couple Edward and Nancy Kienholz and of Joseph Beuys are good examples of "anti-painting" or "anti-sculpture" as the case might be.

In this context, anti-painting is equivalent to anti-art. Or at the very least, to a re-integration of industrial production and its sociological effects into artistic endeavour. This is evidenced by the series of attempts to revise the concepts on which the modern conception of art is based. It is difficult to tell what share the influence of Magritte and his development may have had in these ethical and aesthetic revisions, revisions which have led to the advent of the "artist-anthropologist" (according to Joseph Kosuth) and of a post-industrial art. These options were largely foreign to Magritte. While many adherents of this art rightly acknowledged their debt to his thought and works, it was as it were to the fringes of his expressed opinions that they referred. The occasionally – as in the case of conceptual art – important objections to this observation were not raised for the most part until after his death. Claims and speculations on the basis of his thought and his work relate in any case less to the ideas which Magritte had concerning art in general, than to that section of his work which raised a particular questionmark against the language of painting.

Whatever the appearances may be, the notion of anti-painting implies nothing but disparagement as far as a notion of "image" is concerned. By contrast a painting, while it may still be a picture, does not necessarily correspond to the general idea of what constitutes an "image". And, *a fortiori,* a painting – an "aesthetic" painting – apparently does not correspond to the extra-artistic conception conveyed by the word "picture", or at least "image", as generally understood. Moreover, applied to a painting, the word acquired a pejorative sense. In popular usage, indeed, an "image" can be a photographic image, or a printed reproduction – in any case something reproduced by some mechanical technique. It is flat, without relief, lacking all the attractions (resulting from the use of various materials) which the idea of painting conveys to large numbers of people, and without the exquisite sense of colour which one looks for in painting. In this most widespread meaning of the word, an "image" is part of a sample-sheet of pictures. It reproduces undemanding, illustrative figures recognizable by the great majority because they share in the collective mythology which haunts every conscious mind. These "clichés" are always realistic, always a "good likeness", often contrived and insipid, even if they claim to be symbolic, pious or edifying. It is not for nothing that they call to mind above all sentimental pictures of saints,and the decor chosen for the packaging of semi-luxury products.

It goes without saying, however, that alongside this everyday, popular understanding of the word "image", there are others – more refined, more intellectual and certainly more complex. Moreover, they extend to other spheres and other concepts beyond those which belong to the world of art properly speaking. When the dictionaries and encyclopaedia define an "image" as "a picture or representation in the imagination or memory", then we can clearly feel the spirit of Magritte. He fits all the better into the framework of this definition insofar as it is linked to the idea that an "image" should be an exact reproduction of a thing or a living being. It is in this context, moreover,

"Psychoanalysis . . . is only one interpretation among others. It gives a symbolic value to the things depicted, the objects chosen by the artist. I believe however that a cloud in a painting is a cloud and nothing more. I do not believe in the subconscious, nor do I believe that the world presents itself to us as a dream, except when we are asleep."

The Raw Nerve, 1960
La corde sensible
Oil on canvas, 115 x 146 cm
Courtesy Galerie Isy Brachot, Brussels–Paris

that the notion of an "image", applied to paintings and works of art in general, has recovered its topicality. Posthumously, Magritte must be reckoned among the initiators of this renewal, to which Pop Art and its derivatives, with their concern for verist representation, have made a decisive contribution.

Works such as *The Threatened Murderer* (1926; illus. pp. 46/47) or *The Man with the Newspaper* (1927/28; illus. p. 49) are highly indicative of the formulation of painting in terms of images. In them we find the processes of production, representation and graphic encapsulation borrowed, even at this early stage, from the techniques of comic strips and Epinal prints, or from elsewhere, such as the picture puzzles or rebuses and the illustrations of the popular novels and magazines of the period. This is true, for instance, of the story, divided into four windows, in *The Man with the Newspaper,* which is drawn with exemplary, faithful precision, and whose ambiguous statement is reminiscent of the games published in certain magazines, along the lines of: "Spot the mistakes in this picture", or "Where has the man with the newspaper disappeared to?" In the case of *The Threatened Murderer,* we find the same characteristics of anonymous production – it is as though the persons and objects were cut-outs stuck on to the canvas. In this picture, the story hinted at

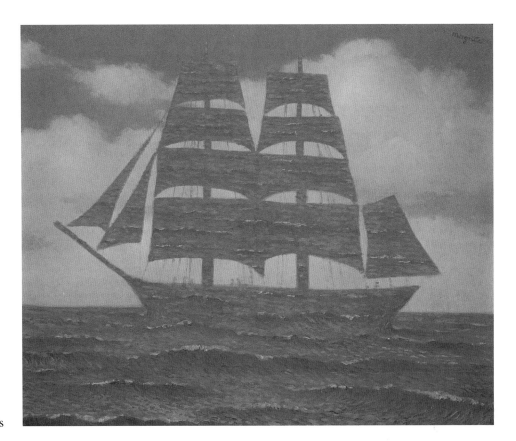

The Seducer, 1953
Le séducteur
Oil on canvas, 38.2 x 46.3 cm
Courtesy Galerie Isy Brachot, Brussels–Paris

The Big Family, 1963
La grande famille
Oil on canvas, 100 x 81 cm
Private collection

by the painter no longer contains any riddle (Magritte once said of picture puzzles that they satisfied the curiosity all the more if one neither looked for nor explained the solution). This picture is relatively unambiguous; its language is that of a local newspaper report under "miscellaneous events". The murdered woman lies bleeding on a divan. The murderer, a "gentleman", is listening to music, his luggage to hand. The plain-clothes policemen who have come to arrest him are going to use gladiatorial weapons to effect the capture. And three individuals are watching the scene through a window. The effect of surprise is achieved here by means of elements seemingly introduced by chance, such as the strange choice of a club and a net to arrest a criminal, who himself remains perfectly cool the whole time, and also by the fact that he seems totally indifferent to what he has done, and again, that there are witnesses to an event which does not concern them but who make no attempt to conceal themselves.

The innovatory character of Magritte's work is already apparent in the fact that he distinguished between "being a painter" and "being an artist", a distinction expressed in his denial that he was an "artist-painter". The distinction is likewise made clear in his treatment of an iconography derived from non-aesthetic, or even anti-aesthetic, sources, as employed by cheap or "low-brow" literature, the literature of incredible adventures: cowboys and Indians, cops and robbers, Nick Carter, Arsène Lupin and so on. Magritte was a keen fan of the genre. It was not for nothing that he chose Lupin as the model for his picture *The Barbarian* (cfr. illus. p. 45), which was destroyed during an air-raid on London in World War II, or later for *The Return of the Flame* (1943; illus. p. 44), in which we see the gentleman-burglar in evening dress and opera hat, a rose in one hand, his chin resting on the other, arising out of the Parisian townscape viewed from above. In *The Barbarian* (illus. p. 45), only Lupin's

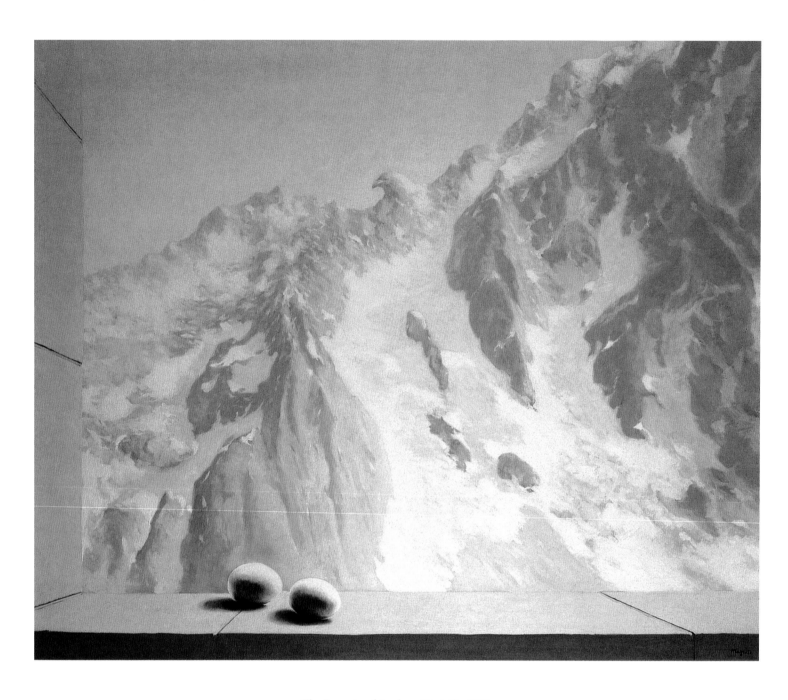

The Domain of Arnhem (Detail), 1938
Le domaine d'Arnheim
Oil on canvas, 73 x 100 cm
Private collection

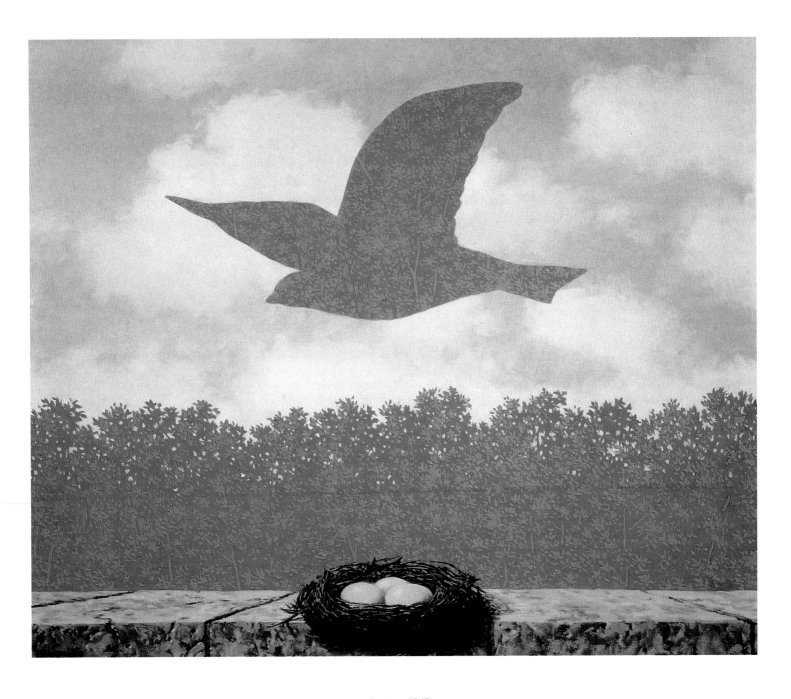

Spring, 1965
Le printemps
Oil on canvas, 46 x 55 cm
Switzerland, private collection

head was depicted, in shadow against the background of a brick wall. The picture was painted like some illustration lacking in depth or dexterity of stroke. In *The Return of the Flame,* by contrast, he is depicted practically full-length. But the major difference between the two works resides in the fact that the latter was painted *con brio,* with visible brush-strokes on the canvas, and with colours and shapes *à l'impressioniste.* It was precisely in 1943 that Magritte was entering the brief – barely year-long – golden sunshine of his "Renoir Period".

In the context of the relationship between paintings and images, one curiosity is worth pointing out. It could indicate where, on occasion, Magritte found the sources for his imagination, and where this imagination interfaced, almost by chance, with certain trends in popular culture, trends which differed from those conveyed by the polular literature of the sort composed, among others, by Maurice Leblanc. An interesting, albeit perhaps marginal, aspect, it too implies an idea of "mystery". Consider the following: In 1890, there appeared in Paris a work entitled "La Science Amusante" ("Science is Fun"), by one Tom Tit, the pseudonym of Arthur Good. The intention was to introduce the reader to the "study of physics". What it did was to provide simple explanations, interposed with "amusing" experiments, of phenomena which the reader might have observed in nature, but in ignorance of their scientific background. The text was supported by curious illustrations by one Poyet. Thus a picture-language was created for the occasion, depicting everyday objects arranged in a particular order; a very unusual order, in fact, not to say "magical". For example, a cup of coffee is balanced on a glass of water, in order to demonstrate the position of the centre of gravity. How can one fail to be reminded of *Hegel's Holiday* (1958; illus. p. 97), a picture which Magritte said was the result of a visual experiment aimed at establishing the best method of painting a glass of water. Incidentally, some of the experiments described by "Tom Tit" and illustrated by Poyet involved elements – things, objects – which also turn up in Magritte's inventory of pictures. The gouache *Weights and Measures* (c. 1949) is just one example: shadows, a tray suspended by steel wires from a key inserted in a lock; on the tray are a number of geometric forms, plaster-of-Paris pyramids as used in art classes for teaching drawing. This piece of serendipity is less surprising than it appears, if it is true, as we have been assured, that Magritte had a copy of "Tom Tit's" book in his library.

Every artist must take his inspiration where he finds it, and it is no part of our intention here to show that Magritte was guilty of copying or plagiarism. On the contrary, we are concerned with drawing attention to a chance encounter. This unorthodox excursion confirms the existence of links between an unceasing quest for mystery, as expressed in the – soon-to-be-solved – riddles investigated by the experiments in "La science amusante", and the interpretation of things on a second plane, as practised by Magritte and evident in his true-to-life but unconventional pictures. "Tom Tit" and Magritte have thus demonstrated that the mysteries, applied to a reality susceptible of physical demonstration, take on, in themselves, an importance which transcends poetry, and which is refined by their own experiences.

On repeated occasions, in his correspondence, in the authorized interpretations of his works, in the commentaries he gave on his way of looking at the subjects he intended to paint, Magritte denied being an "artist-painter" or appearing to be one. As already mentioned, he wrote in a letter, dated 27 March 1959, to one of his favoured correspondants, Andrè Bosman: "If I had

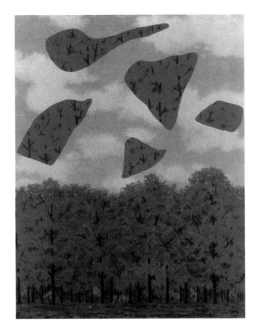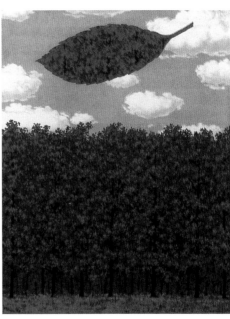

ILLUSTRATION LEFT:
The Choir of the Sphinxes, 1963
Le chœur des sphinges
Oil on canvas, 100 x 81 cm
Brussels, private collection

ILLUSTRATION RIGHT:
The Choir of the Sphinxes, 1964
Le chœur des sphinges
Gouache, 40.5 x 28.7 cm
Private collection

been an artist-painter...". Louis Scutenaire has said of him that while he denied being "a painter", he was nonetheless "a great painter". He went on to explain: "With Magritte, painting gives up its role of visual tit-bit, of emotional stimulus or safety valve, and begins to help Man to discover himself, to discover the world and to enrich it." Or: "Never for one moment was it Magritte's intention to attack painting; he merely wanted to subdue it, to ensure that it hold the torrent of pictures gushing from his inner fire" (Scutenaire, 1977). Using the means which painting provides, in other words, and to subordinate it to a purpose different from that of all the other painting of his day; – and turning his back on art as a safety-valve for the emotions. It meant a revision of what art was all about, and about what was worthy of being painted. Therein lay the revolt. In the foregoing chapters, we have attempted to define the essence of this unwritten message. Here, we are trying to define the pictorial means by whose introduction the message was actually delivered.

It must be emphasized once again that the demonstration of his vision of painting is contained in the whole of that part of Magritte's œuvre which is of explicitly Surrealist origin. His fundamental techniques and particular procedures were always harnessed into the service of his demonstrative intent. Thus this commentary on Magritte's "non-painting" leaves out of the account that most obviously pictorial section of his work, namely the short-lived periods in the 1940s which later came to be known as his "Renoir" and "Vache" periods. These will form the subject of the next chapter. Nonetheless it ought to be pointed out at this juncture that they do bear witness – if such were needed – to the quality of Magritte's technical virtuosity, his interpretative skill and his wide-ranging knowledge of the history of art. Knowledge, skill and craftsmanship: these were the qualities he acquired in the years between 1915 and 1924, when he completed his apprenticeship and produced the first convincing samples of his virtuosity: Impressionist, Expressionist, and Futurist – but not representational. These first essays, and the acquisition of the tricks of the trade which resulted from them, formed the foundation for his Surrealist commitment of 1925 and, above all, the introductory works of 1926 which, at last, were utterly original.

143

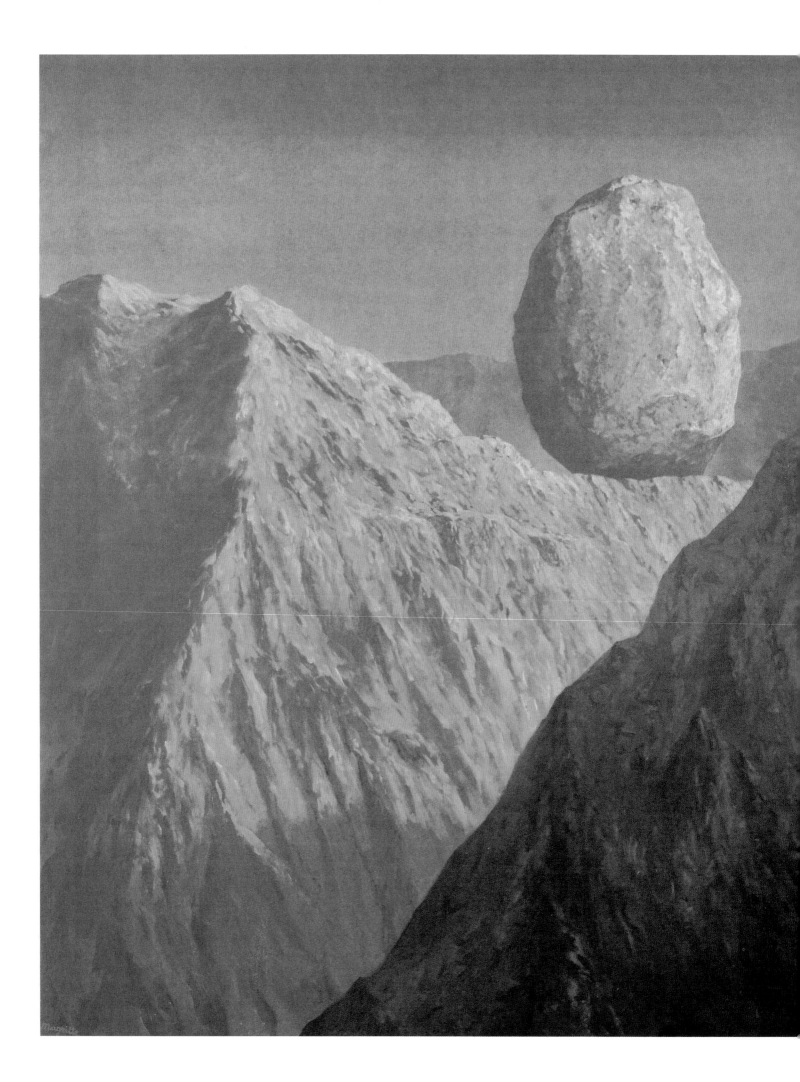

The Glass Key, 1959
La clef de verre
Oil on canvas, 129.5 x 162 cm
Houston (Texas), courtesy of
The Menil Collection

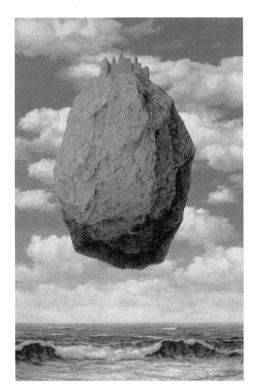

The Castle in the Pyrenees, 1961
Le château des Pyrénées
Oil on canvas, 200 x 140 cm
Jerusalem, The Israel Museum,
Gift of Harry Torczyner

That year, it is said, Magritte produced pictures at the rate of one per day. By his own report, he painted "sixty odd" in 1925 and 1926, which were exhibited in the "Le Centaure" Gallery in Brussels in 1927. Of the paintings dating from this period, those still extant make clear the profound changes that had occurred in his style and, moreover, certain hesitations he seems to have undergone while arriving at the choice of appropriate techniques. Pictures like *The Difficult Crossing* (illus. p. 25) or *The Birth of the Idol* (illus. p. 24), both dating from 1926 and fairly similar in inspiration, for example, have something in common with *The Blue Cinema* (illus. p. 6) of 1925, a work still characterized by a blend of Futurism and Art Deco. The comparison between this last and the other two might be considered illustrative of the transition between the former and the new conceptions of the "pictorial vision", and how it is to be composed and reproduced. Illustrative, too, of his hesitation in the choice of materials inherent in painting in oils.

In *The Blue Cinema,* the tones are elaborate, mildly reinforced pastels, somewhat "à la mode", flattering; they are applied evenly, without any perspective effects. The woman and the object stand out thanks to the strict geometric arrangement. The whole ensemble in the composition has a certain dryness about it, reminiscent of advertising placards. The rectilinearity of this composition, alongside the flatness of the colours, turn up once again in the foregrounds of *The Difficult Crossing* and *The Birth of the Idol,* which are likewise painted without any effect of depth. By contrast, the arsenal of objects depicted has become more complex and far more diversified, both in selection and in nature. Here we have the bilboquet, emerging from a conventional turned table-leg. The scenario of one of the pictures is an almost closed space, while in the other, the scene is shifted outside. Panels cut out in the form of façades, but lying flat, appear side by side with anthropomorphic shapes, derived from the components of shop-window dummies. Some are depicted in a way commonly used for "Surrealist objects": a severed hand holds a bird, an arm is stuck to one of the lathed wooden posts, a looking glass reflects the sky.

Between 1925 and 1926, then, the inventory of pictorial elements underwent a more radical und fundamental change than the manner of painting, i. e. of applying the paint to the surface of the support. Even though the artist has passed from a world of arranged decor to an invented dream universe, there is nonetheless no perceptible difference between the works as far as their crafting or use of colour and paint is concerned, apart from the fact that the colours used are no longer part of the same colour scales. There are more matt tones; stronger "mineral" colours are in evidence, such as smoke-black, clay-yellow, rust-brown or washing blue (information from Scutenaire). But their neutral character remains, as does the impression of immateriality surrounding the objects depicted. By contrast, the message conveyed by these pictures has in no way remained unchanged during the intervening year, and neither has the meaning conveyed by the methodology of their composition. The formalistic-decorative appearance of *The Blue Cinema* has been replaced by a deliberate confusion of pictorial genres in *The Difficult Crossing* and *The Birth of the Idol,* and the tastefulness of the first has given way to the tragic gravity of the others. This change is emphasized by two connected factors: the depiction of the scenes, and the specific details of the craftsmanship. First, the presentation of the tragic: in the background, a rough sea on which a three-master in the midst of the waves is at the mercy of the tempest, while the dry land threatens to be flooded by the storm. Secondly, the specific details of the craftsmanship: by

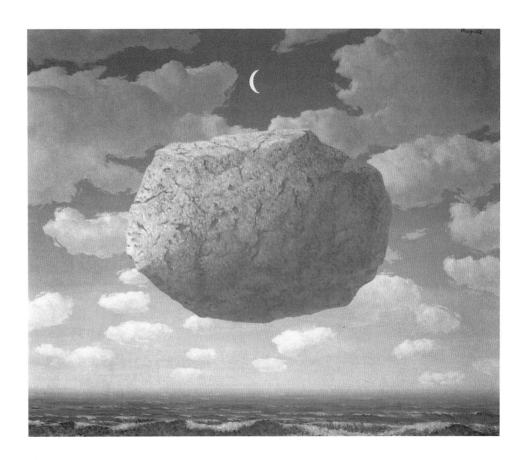

Zeno's Arrow, 1964
La flèche de Zénon
Oil on canvas, 54.5 x 65.5 cm
Private collection

this is meant the manner in which the artist has chosen to place the oceans in the background; this is the most characteristic difference between the respective techniques of the 1925 and 1926 pictures. The rough background ocean is found almost identically in *The Drop of Water* (1948; illus. p. 2). But here, the foreground is occupied by the bust of a woman, an imitation of a well-known classical Greek torso, a Venus without head, legs or arms, whose sensual materiality is emphasized still further by the medium of painting and its flesh colours, by comparison with the white of the marble or plaster. Coloured semi-precious stones are scattered over it as geometrical droplets.

Sea and skin in these pictures are treated in a way that could hardly be described as modern; the style is more like that of the pre-Expressionists or, more precisely, that of the German romantics such as Caspar David Friedrich. To this "non-painting", i. e. the use of flat colours with no indication of affective impressions, of motionless – that is to say anonymous – colours filling out powerfully drawn shapes, there is added an impetuous manner of painting with strongly marked gestural effects. The paints are applied, in the best tradition, with vigorous brush-strokes; the drawing is informal, strongly marked by emotivity and even the echoes of anecdotal genre painting. This confusion of genres, this hesitation between different aesthetic options, were obviously deliberate. His recourse to the expressive effects of the brush-strokes was, however, hardly in keeping with his subsequent styles, especially as the effects, at first sight, contradict the intentions of the painter, who claimed that he wanted to keep his distance from all passionate approaches to art.

Most of Magritte's other works of this period show that he took a very one-sided position on what he saw as the painter's mission. This attitude is clearly

Souvenir of a Journey, 1955
Souvenir de voyage
Oil on canvas, 33 x 41 cm
Private collection

seen in the way he distanced himself from an art of pure sensibility. It is articulated in his "conception of the art of painting", which consciously links a concern with the message to be delivered, the specific details of its contents (see the preceding chapter) and the methods or techniques necessary to convey it. As far as these methods and techniques are concerned, in particular, seen from the point of view of the production of pictures by means characteristic of painting, but without copying its sentimental accoutrements (whence "non-painting" in contrast to "bourgeois art"), we need to take another look at Magritte's own writings, in particular those texts he wrote shortly before his death in 1967 for the catalogue of the retrospective exhibition of his work at the Museum Boymans-Van Beuningen in Rotterdam. Written at the very end of his life, they succinctly summarise his attitude, in which medium and message are, quite properly, mingled.

Edouard Manet once said that a picture was primarily, before it became a nude woman or a war-horse, a particular arrangement of colours. This is a definition which served to justify abstract painting and, above all, the fact that painting is an exercise in pure composition before it becomes a message, that is to say, an anecdote. Magritte did not go the whole way with him on this. The two things were connected, as far as he was concerned, or rather, the pictorial medium was conceived in intimate relationship with the message. If he had to paint the picture which he had in mind, he had to use the particular techniques appropriate to conveying this image, this idea. Thus he wrote: "I conceive of painting as an art of juxtaposing colours in such a way that their actual aspect disappears, giving way to an image in which are united – in a poetic arrangement – familiar figures from the visible world." This brings us back to the basic realism which dictates the appearance of the picture. The juxtaposition of

The Big Table, 1962
La grande table
Oil on canvas, 54 x 65 cm
Courtesy Galerie Isy Brachot, Brussels–Paris

colours – a matter of craftsmanship – disappears in the face of the actual appearance which the picture presents, behind that which we see. "Sky, people, trees, mountains, stars, bodies, inscriptions and so on." These are all, beyond doubt, familiar objects of the visible world. The word "disappear" is of decisive importance in this context. It bears witness to the artist's wish to dispense with any pictorial quality in the traditional sense of an emotive art, in favour of a clarity which must still, nevertheless, be transcended. The pictorial anonymity which the familiar objects thus acquire, allows their juxtaposition in unaccustomed fashion, without any loss of the realism which makes them unambiguously recognizable. Thus there arises a poetic image, which "hides nothing", but which conjures up the "invisible", itself foreign to painting, which is "unsuited to its representation". How, as Magritte repeatedly asked, are "pleasure and pain, knowledge and ignorance, sound and silence" to be depicted? But that is precisely what "bourgeois" painting was trying to do! "An example of mediocre painting would be what was necessary to flatter the patriotic feelings and libidinous inclinations of a wealthy banker" (from: "The True Art of Painting").

One of Magritte's decisions most specifically connected with his art was thus to reject all forms of interpretation and all artifice. Herein lay his great originality, in a context which was tending to turn art into some kind of magical, sacral operation. He specifically declared that the goal of painting, in his eyes, was not the picture itself, which was merely a unique item which had no value except in relation to itself; what counted was what the viewer saw, and what he recognized. Thus it is the act of viewing which matters first and foremost, and which has to be disencumbered of the dross of optical illusion. "The art of painting has as its goal the perfection of the functioning of the act of

viewing, by means of a pure visual perception of the external world by the sense of sight alone." This sense of sight "being, in fact, the only one of interest for a picture". The picture must be created on the basis of an invention capable of interesting – and of challenging – the eye of the beholder. So what is needed? Magritte has given us a good example of what, in his opinion, distinguishes a mediocre work from an interesting one. A mediocre work would be a picture depicting a blindfolded man, walking in a forest being approached by a murderer with a knife. A good picture, on the same theme, would be one depicting a man walking blindfolded through a forest, but without any murderer visible. In the first version, according to Magritte, the fact that the walker was deprived of the use of his sense of sight prevents him from saving his life, because he cannot see that the murderer is there. The importance thus attached to the sense of sight, Magritte stresses, is only noticed "by favour of a passing feeling of anguish". By contrast, in the second version, the importance of the painted figure's eyesight would certainly be "a matter of interest", but not so much as with a painting in front of which it would be the living eyes of the viewer which had occasion to experience a perfect functioning. In short: "The perfect picture does not allow contemplation." One has to rid oneself of habits, while the painter must "surpass himself with each new picture through a process of useful renewal". In order to do this he "must be thrown off the rails by the technique of the art of painting". And to confirm all this: "The painter is faced by the problem of technique . . . in proportion to the result which he sets himself." It is just a means to an end. And, keeping his distance from the confused sensations of a conformist affectation, Magritte thought that the true goal of art was to "conceive and to create pictures capable of giving the viewer a pure visual perception of the external world", while "the painter must not thwart the natural functioning processes of the eye which sees the objects according to a universal code".

The Art of Conversation, 1950
L'art de la conversation
Oil on canvas, 65 x 81 cm
Courtesy Galerie Isy Brachot, Brussels–Paris

The Legend of the Centuries, 1948
La légende des siècles
Gouache, 25 x 20 cm
Private collection

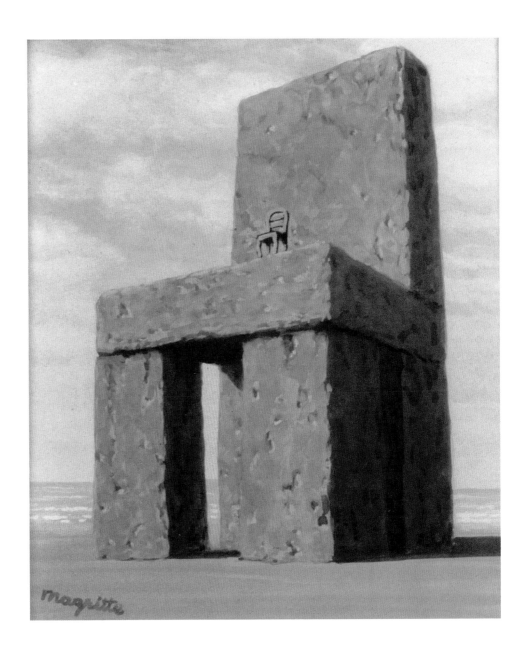

According to Magritte, the history of art is strewn with systems at the heart of which techniques have developed which, by clever trickery, tend to substitute the view of the painter for that of the beholder. "The Impressionists, the Cubists, the Futurists thus had their moments of excitement and exultation, thanks to techniques which while original, were useless, because means other than painting could provide the same moments of excitement and exultation, and better (the cinema, for example, whose capacity to capture movement, in contrast to painting, was adduced by Magritte in this connexion). Having concluded his investigations, he summarized the problem as follows: "For the painter, the search for appropriate means of depicting the sky, a pipe, a woman, a tree or any other object constitutes his principal task." He has to "make sure he is not carried away on the magnetic fields of chance" *(ibid.)*.

And with that Magritte did indeed put an end to the eternal dispute about the concrete and the abstract. He saw how to eliminate the apparent conflicts between these two concepts. By turning his back on an interpretative art, one based on clever use of perspective or exact anatomical representation, he wanted to demonstrate in practical terms the indifference, characteristic of him, towards prefabricated artistic illusions. This indifference found expres-

sion in his works in the form of a manifest disdain for contrived skills. This disdain, however, clearly was not incompatible, in his case, with a perfectionist familiarity with the materials he used; oil, brushes, canvases.

The path he followed towards the attainment of his goal, through all the storms that beset him, was less meandering than might appear at first sight. In "Lifeline I" (lecture at Antwerp in 1938), he himself drew up an account of the various stages on this journey, describing both the development of his aesthetic projects and the evolution of the means he employed to achieve them. These stages cover, by and large, the period from 1919 to 1925, extending from the para-Cubist picture entitled *Three Women* to that entitled *The Window* (illus. p. 17), in other words from his first publicly exhibited painting to the first picture bearing witness to the artist's concern "from now on only to paint objects with their visible details". On the basis of personal utterances by Magritte himself, we can sum up these phases of his development as follows:

1. An investigation into movement and rhythm. This period was characterized by "shapes and colours lacking in rigour", so as to be able to submit to "a rhythm of movement". They were "completely free" shapes, attuned to a nature "which does not confine itself to a strictly invariable colour, shape and dimension". Typical of this lyrical tendency are the portraits of *Pierre Bourgeois* (1920) – and *Pierre Broodcorens* (1921; illus. p. 12), and above all *Women and Flowers* (1920).

2. An investigation into the relationships between objects and their shapes. Magritte was of the opinion that the preceding period "hardly questioned the relationship between an object and its shape, or between its apparent shape and what was essentially necessary for its existence". He therefore had to find "visual equivalents for this essence." Hence the pictures "representing motionless objects, stripped of their details, and of their accidental individualities". It was at this point that Magritte turned from concrete reality to relative abstraction. There are obvious traces, of varying degree, in *The Model* (1922; illus. p. 10), *Self-Portrait* (1923; illus. p. 15), and *Georgette at the Piano* (1923; illus. p. 14), as well as in *Woman Bathing* (1925; illus. p. 11).

3. An investigation into the coincidences between the concrete and the abstract. "Finally I found in the appearance of the real world the same abstraction as in pictures." He could see beyond the natural complexities of a landscape "as though it were no more than a curtain before my eyes". He thus lost his confidence in optical illusions: "I was less sure of the depth of the landscape, hardly convinced of the distance of the light blue on the horizon, immediate experience placing it simply at the level of my eyes." Perhaps *The Armoury* (1925/26) partially illustrates this period?

4. An investigation under the aspect of resurrecting the unsettled world. "I now had to animate this world which, even in movement, lacked all depth and all substantiality." He went back to observing objects which might be able to "eloquently reveal their existence". What means does a painter have at his disposal to document this revelation? Magritte confides that his first attempts consisted in a return to his previous style of painting, clouded by his discovery and having lost sight of the fact that "my previous experiments were losing their usefulness". This stage is represented by *The Woman with a Rose in Place of a Heart* (1924). This picture "did not produce the overwhelming effect which I had expected," because of the lack of association between intention and realization.

5. A decisive investigation in favour of a mysterious realism. This was when

Souvenir of a Journey, 1951
Souvenir de voyage
Oil on canvas, 80.3 x 64.8 cm
Houston (Texas), The Menil Collection

René Magritte beside his painting
Souvenir of a Journey III (1955)
Courtesy Galerie Isy Brachot, Brussels–Paris

ILLUSTRATION OPPOSITE:
Souvenir of a Journey III, 1955
Souvenir de voyage III
Oil on canvas, 162.2 x 132.2 cm
New York, The Museum of Modern Art,
Gift of D. and J. de Menil

153

the painter set off on the great path of his own originality. "I introduced into my pictures elements with all the details they present in reality, and I soon saw that these elements, represented thus, directly called into question their counterparts in the real world." The result: "In about 1925 I decided from now on only to paint objects with their visible details, since my investigations could only proceed on this condition. I merely gave up a particular way of painting which had brought me to a point which I had to overcome." This was the origin of pictures like *The Window* (1925; illus. p. 17). Magritte declared that this was his "first painting", meaning the first picture compatible with the project he had just developed. The window motif was to be a constant preoccupation, and he was to use it as a "picture within a picture", for example in *The Human Condition* (1933; illus. p. 41; and 1935; illus. p. 43), *The Key to the Fields* (1933, illus. p. 40) or *The Call of the Peaks* (1942; illus. p. 40), to mention only some of the better known.

In addition, we have the picture *The Month of the Vintage* (1959; illus. pp. 106/107), in which we see a group of men in identical clothes and identical pose, all looking through a window into a room. A preparatory drawing throws some light on the method used in that it gives precise details of the arrangement of the subjects, thus reinforcing the impression that Magritte prepared the transfer of his ideas on to the picture with great care, i. e. in great detail. A conspicuous point is that the margin of the paper on which the study is sketched out contains a series of notes. Each of these notes consists of one or just a very few words, presumably hinting at associations in Magritte's head, or perhaps they are suggestions for a title: "Mer et nuit (Salon, Dieu)", "Réveille-matin" or "La saignée" and so on. At the upper margin of the preparatory study there are similar notes, this time numbered. Another study is sketched out on the same sheet of paper. It does not depict a window, but a framed picture itself depicting a brick wall. There are pictures which actually use this trick, for example *The Threshold of the Forest* (1926; illus. p. 20).

In 1925, then, *The Window* heralded the first picture which Magritte acknowledged as entirely "Surrealist", namely *The Lost Jockey* (illus. p. 26), in two versions – a water-colour collage and oil-on-canvas – both dating from 1926.

It makes entertaining reading to discover how Magritte, by his own description, had the inspiration which put an end to his initial investigations and led him along his highly original path. "This decision, which made me break with an already comfortable habit, was made easier for me at the time by an opportunity I had for lengthy contemplation in a cheap café in Brussels. The state of mind I was in made it seem to me that the mouldings of a door were endowed with a mysterious existence, and I remained in contact with their reality for a long time."

Decorative mouldings were another constantly recurring motif for Magritte. They crop up almost everywhere in his pictures. They are at the same time abstract, linear, geometrical shapes and the shapes of an everyday item to which, as a rule, one would not give any great attention. They also form the frame which can either close off a picture or open it up on itself. Examples are to be found in *The Unexpected Answer* (1933; illus. p. 52) and *Amorous Perspective* (1935; illus. p. 53). These two works have something of the perfect picture: composed without any aesthetic devices, seen from the front, painted so realistically that in one of them the painter has reproduced the structure of the grained wood, pitch-pine, of which the door is made. The two pictures

Memory, 1948
La mémoire
Oil on canvas, 59 x 49 cm
Patrimoine culturel de la Communauté française de Belgique

154

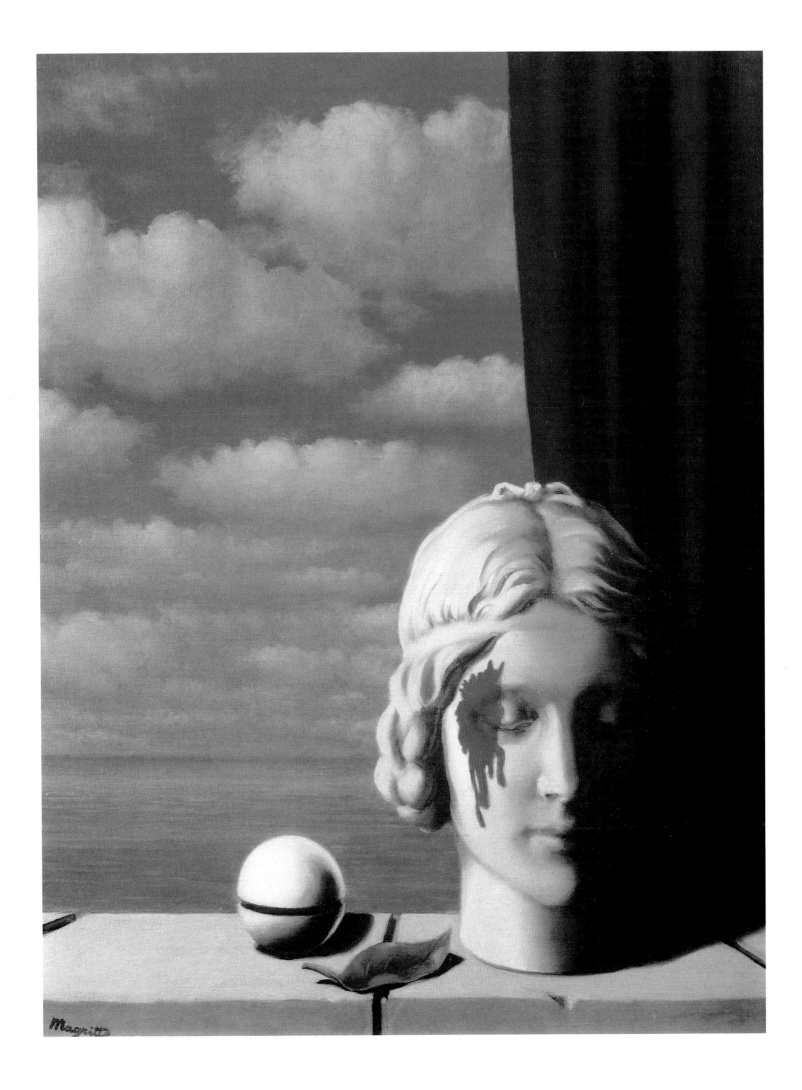

depict an inside door from which in each case a practically identical piece has been cut out, resembling the silhouette of a person (notwithstanding the painter's description of it as "shapeless"). One of the doors opens out on to a dark room, while the other opens on to an imaginary landscape, containing a tree apparently larger than life-size, in the shape of a leaf, the branches themselves being leafless, and next to it a square building, on which is placed one of the globular bell-like objects which Magritte scattered about many of his pictures (see, among the early ones, *The Voice of the Winds* (1928; illus. p. 57). For the rest, the problem of the door, with or without mouldings, illustrates the cast of mind of an artist confronted with the veracity of things, but at the same time, while still basing himself on the truth, playing with the traps set by logic. He wrote in "Lifeline I": "The problem of the door called for a hole one could pass through." Although it is depicted as closed, the door is open as a result of this trick. On the other hand, the fact that the tree in *Amorous Perspective* is larger than life-size, or at any rate taller than the nearby building, raises the question of the proportions of objects and things. By distorting the dimensional relations between the subjects and falsifying the perspective, what Magritte has done is to disrupt the usual process of perception.

Magritte often proceeded thus. We find evidence of it in numerous otherwise very different works. For example *The Choir of the Sphinxes* (1963 and 1964; illus. p. 143); *The Plain of Air* (1941; illus. p. 55); or in certain artworks with leaves shaped like birds: *The Taste of Tears* (1948; illus. p. 118); *The Natural Graces* (1967; illus. p. 119); *Treasure Island* (1942; illus. p. 117); *Companions of Fear* (1942; illus. p. 116). On the theme of birds properly so called, we have *The Big Family* (1963; illus. p. 138); on that of rocks, *Zeno's Arrow* (1964; illus. p. 147), *The Castle in the Pyrenees* (1961; illus. p. 146). On the theme of people, there are *The Spirit of Adventure* (1962; illus. p. 105); on fruits and flowers, *The Listening Room* (1958; illus. p. 99); *The Wrestlers'*

René Magritte beside his painting
The Drop of Water (1948) in his studio
in Brussels, 1965
Courtesy Galerie Isy Brachot, Brussels–Paris

Memory, 1945
La mémoire
Oil on canvas, 45 x 54 cm
Courtesy Galerie Isy Brachot, Brussels–Paris

Tomb (1961; illus. p. 98) and *Fine Realities* (1964; illus. p. 96). On the theme of glass and clouds we have, among others, *The Raw Nerve* (1960; illus. p. 137).

All these pictures are Surrealist to the extent that they are representative of periods in which Magritte made no secret of his adherence to the movement. In view of the originality of the works, and compared with those of his co-religionists affiliated with the same movement and, as we have mentioned, compared with André Breton's dogmatic definitions, they are more "Magritte" than "Surrealist". His works are more particularly Surrealist by virtue of his particular faculty of combining the physical reality of things as one sees them with the novel impression that arises when one questions this reality otherwise than one is accustomed to do. As Paul Nougé has written: "It may seem opportune to question the purpose of these magnificent objects which pursue us through the whole of history." He added that one had to apply "a certain skill". On the other hand, Magritte and Scutenaire declared categorically: "This is a complete break with the mental habits of those artists who are prisoners of talent, virtuosity and all the little aesthetic specialities." Confirmation, in other words, of the concern not to be an "artist-painter". Confirmation likewise, of the concern to surpass talent and virtuosity, in order to place them at the service of a "subversively" poetic intent, whose result seems to be unaware of both.

In the whole history of modern art, there can hardly be an œuvre whose virtuosity is less conspicuous. And in this context, talk of "non-painting" is justified, for Magritte himself not only understood the ideological practice of "defying common sense", or indeed to depict in his pictures "objects situated where we would never expect them", but also for this purpose deliberately did without the hallowed tricks of the trade inherent in pictorial technique. He dispensed with recognized orthodoxy in favour of a "healthier interpretation of

Portrait: Georgette Magritte, 1936
Drawing
Brussels, private collection

pictorial phenomena". Thus the deliberate-realism of the subjects depicted in his pictures led him to pursue a form of painting which managed without all the clever knacks and tricks of the artist's trade, without all the pictorial qualities which the critics value so highly, without all the "private manias and petty preferences". He practised a "detached manner of depicting objects". Thus he delcared: "I used a light blue when it was a question of depicting the sky, and I never depicted the sky as these bourgeois artists did, in order to have an opportunity of showing off such and such a blue alongside such and such a grey, according to my preferences." Or else: "The traditional notion of the picturesque, the only one authorized by the critics, is absent from my pictures for one good reason: the picturesque is ineffective, and negates itself every time it appears identical to itself." To deny the picturesque was to deny the passage of time; it meant assuming "a universal style". [All passages in this section are quoted from "Lifeline I"].

It is certainly not easy to review in a sufficiently detailed manner the general characteristics and the preferred subjects of those works characteristic of the phase which we have here called the "Non-Painting" period, in contrast to "Anti-Painting", which in this case would be inapposite. This period included, as we have said, almost the total course of Magritte's forty years and more of artistic creativity, with the exception of the intervening "Renoir" and "Vache" periods, which one might describe as "pictorialist" periods in relation to the procedures Magritte then employed, without however necessarily leaving the Surrealist orbit. The examples adduced above bear witness – as does also David Sylvester's catalogue of Magritte's works – to the significance of this creative journey, as measured by the number of pictures of high quality. These pictures document the enormous variety of themes and of the elements called on to illustrate them, as well as the individualities of style employed to give them shape.

On the level of the manner of the production of the pictures, too, we can see a diversity which manifests itself in the framework of an expressive intention at once continuous and direct. As we have already noted in the context of a quotation from Louis Scutenaire, from about the mid-1920s coarse shapes and "mineral" colours begin to crop up in Magritte's works. We have stressed elsewhere how neutral, how anonymous, how indifferent they are vis-à-vis aestheticizing effects. All the same, during the course of the artist's development we see other kinds of colours, too, and other intentions besides that of neutralist detachment or indifference to materials. These things changed from case to case. Scutenaire is of the opinion that between 1927 and 1940, Magritte changed his manner of composition in order to achieve more universal results and to convey messages "less difficult for timid souls".

Even though the basis of thought which dictated the subjects remained unchanged, Magritte never hesitated, according to Scutenaire, to paint "extraordinary pieces of bravura", nor even to have recourse to a "style of painting more in conformity with conventional demands". That's as may be. But the role which convention played in the final analysis, if it played one at all, did not deprive the content of any of its significance, though by the use of more fetching colours and cleverer techniques it tended to make it more accessible. However that may be, the difference in the approach to the material is clearly visible in, for example, *Clairvoyance* (1936; illus. p. 75) and *The Therapist* (1937; illus. p. 85). The former is characterized by unfriendly, almost lacklustre coloration, and forms almost totally lacking in relief, while the second is

Georgette Magritte, 1937
Courtesy Galerie Isy Brachot, Brussels–Paris

marked by well-modelled shapes and brilliant colours – red and blue-green. Even so, both state a message of the same import, even if the appearance is different.

For the rest, nothing was definitive; with Magritte, there was an imbalance between the various means of producing a picture. The "pictorialist" style was always employed sparingly; from time to time it came to be employed as a substitute for the flat style of the "picture sheet", a highly provisional highlight, and perhaps, simply, as a wink and a nudge. In fact it was not so much a substitute for his usual style as an overlay. The whole series entitled *Souvenir of a Journey* (illus. pp. 148, 152 and 153), and above all those pictures in it dating from 1951 to 1955, are symptomatic of the search for an unstable balance between cold and warm: the cold of the ubiquitous textures of the stone structures, which spare not even the animate objects – this coldness is mixed with attempts to warm and to humanise the material by a more formal moulding process – either of the decorative rocks, or of the living subjects (the pose of the poet Marcel Lecomte, for example, who acted as model for *Souvenir of a Journey III* [illus. p. 152], or of the lion sitting at his feet). One is thus inclined to think that the pictorial "bravura" aspect, noted by Scutenaire, was fairly short-lived. There are more major canvases by Magritte, dating from both before and after 1940, in which the sober, not to say glacial, style

The Lull, 1941
L'embellie
Oil on canvas, 65 x 100 cm
Courtesy Galerie Isy Brachot, Brussels–Paris

Large gaming-room in the casino
at Knokke-Heist/Le Zoute, with the
mural *The Enchanted Realm (1953)*
by Magritte
A.C.L., Brussels

ILLUSTRATION PAGE 162/163 ABOVE AND CENTRE:
The Enchanted Realm, 1953
Le domaine enchanté
Mural, 4.30 x 71.30 m
Knokke-Heist/Le Zoute, Casino

ILLUSTRATION PAGE 162/163 BELOW:
The Ignorant Fairy, 1957
La fée ignorante
Mural, 2.40 x 16.20 m
Charleroi, Palais des Beaux-Arts

Hall in the Palais des Beaux-Arts
in Charleroi with the mural
The Ignorant Fairy (1957) by Magritte

predominates, than there are those of a "conventional" style. In *Homage to Mack Sennett* (1937; illus. p. 32), dating from the same year as *The Therapist* (illus. p. 85), we come across the "mineral" style once more, except for the contours of the nightdress hanging in the wardrobe. Between *The Wedding Breakfast* (illus. p. 73) or *Homesickness* (illus. p. 72), both dating from 1940, and *The White Elephant* (1962; illus. p. 134), there is no fundamental difference; nor is there between *The Call of the Peaks* (illus. p. 40) or *The Companions of Fear* (illus. p. 116), both 1942, and *The Blank Cheque* (1965; illus. p. 65). Nor is there any obvious caesura – except on the surface, the product of chance or caprice – between the various versions of *Perspective* (illus. pp. 68, 70 and 71) and the pictures from the series *The Empire of Light* (illus. p. 101), dating from 1954, whose subjects and construction directly herald the final, uncompleted, work of 1967. Nonetheless it is certainly correct to say that the appeal to the view and to his emotions is stronger in *The Therapist* (illus. p. 85) and *The Empire of Light* than in most of the other pictures.

Here, Magritte was flirting to a greater or lesser degree with a more melodious manner of painting – a challenge to his nature, so to speak, in view of the universalist character of his message.

The Great War, 1964
La grande guerre
Oil on canvas, 81 x 60 cm
Private collection

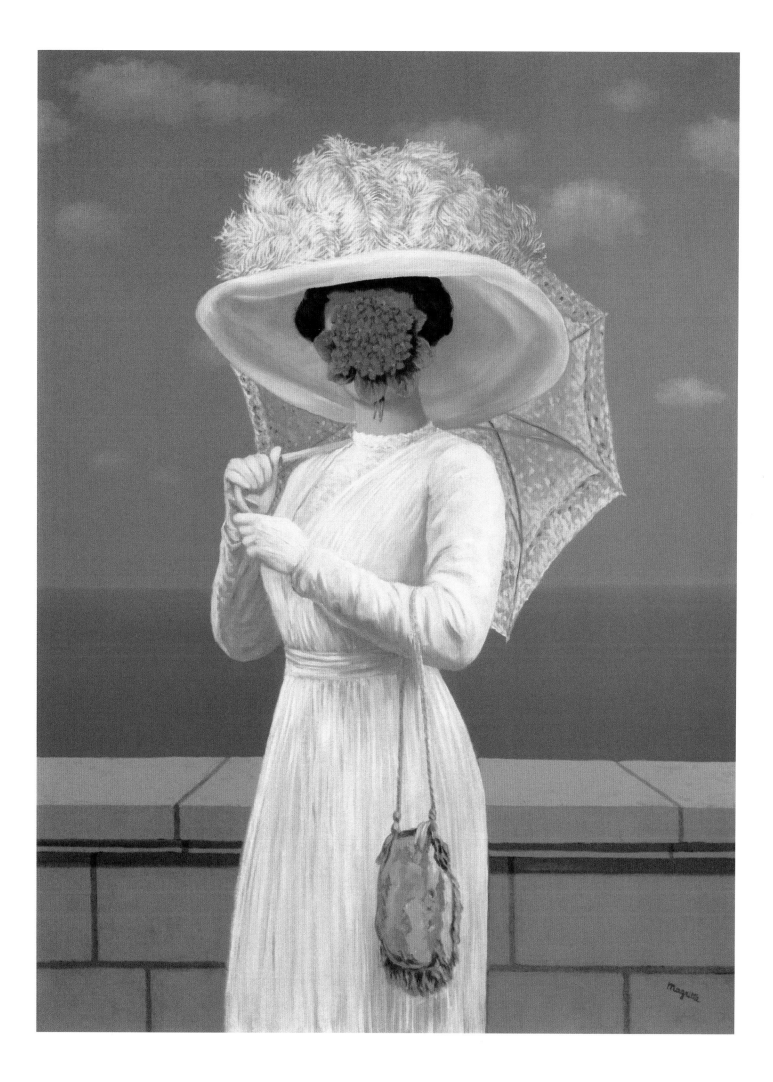

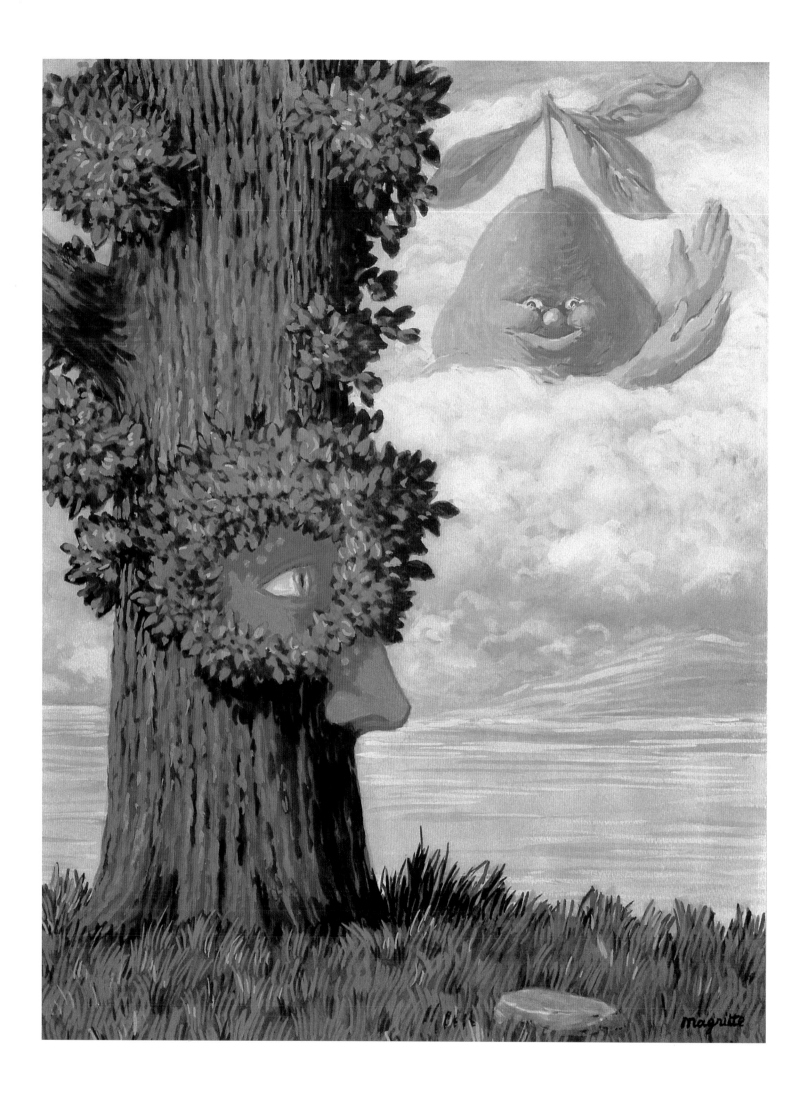

Entertainment, Irony and Derision – The "Renoir" and "Vache" Periods

It can be said, then, that Magritte's œuvre by and large forms a self-contained whole. From the moment that he broke with conventional art, around 1925, until the moment of his death in August 1967, the series of pictures which he painted were oriented about a single, unchanging concept. To summarize: everything is object, everything is "thing", whatever genre it may belong to; objects must be painted exclusively with their conspicuous details; if one combines objects among themselves in unexpected ways, the result will be a surprising image. From the pictorial point of view, this position can be interpreted as follows: there is no difference of type between the living and the rigid; things must be painted realistically, with their anonymity preserved; any surprise must result from unaccustomed juxtapositions, this anonymity and realism being the starting points. All of Magritte's work followed these principles; his art was based on the decisive and consistent rejection of emotive or simply sentimental painting. "Non-painting", as opposed to "pictography".

There are however two deviations from this path which the artist otherwise rigorously followed. Deviations of short duration, it is true, but close to each other in date: the so-called "Renoir Period" from 1943 to 1944, and the so-called "Vache Period" from 1947 to 1948. The former was the subject of a relatively intimate exhibition – there was a war on, after all – in a private apartment in Brussels in 1943. Twenty-three of these pictures are reproduced in a contemporary commentary by Mariën. The stencilled invitation, written by Magritte himself, read as follows: "René Magritte would like to arrange a meeting between his latest pictures and his friends, to be held on Saturday, 10 July, at 3 p.m., for example, on the first floor of no. 51a Rue de la Madeleine, behind the first door on the LEFT along the corridor." The gallery itself indicated that "René Magritte had broken with his usual technique".

As for the "Vache" paintings, they were first presented to public view at the very first one-man exhibition of the painter's works to be held in Paris, at the Galerie du Faubourg in 1948. It consisted of not quite thirty oils and gouaches, and it met with a generally negative reception. The exhibition was a failure. Louis Scutenaire wrote an introduction to which he gave a title leaving little room for doubt as to the artist's intentions: "Les pieds dans le plat" ("Putting One's Foot In It"). Not long after, he published a postscript entitled "Any carping at the Paris exhibition of the works of René Magritte is premature: so let's pay a visit!"

These phases were slip-ups along the route; but they were deliberate slip-ups, and in both cases justified. After all, if they marked a breach with the usual style – of applying the paint, of choosing the colour tones, of utilizing the materials, they did not constitute an obvious breach with the world of Ma-

The Crystal Bath, 1946
Le bain de cristal
Oil on canvas, 50 x 35 cm
Brussels, private collection

Alice in Wonderland, 1945
Alice au pays des merveilles
Oil on canvas, 145.5 x 113 cm
Private collection

gritte. On the other hand, between the two there are as many similarities as differences. The "Renoir" period was deliberately described as "Impressionist" or as "Neo-Impressionist", or as "Tachist"; The "Vache" period was sometimes described as "Fauvist". Indeed, the word "Vache" ("cow") was chosen by the painter himself as a parody on the word "Fauve" ("wild beast"). In any case, both periods represented "lyrical" interludes, the production of the resulting pictures being based on expressive methods and on free manipulation of pictorial elements. The lyricism to which the pictures of these periods bear witness did not exclude, however, a respect for form. The objects and human figures – there are many of the latter in these pictures – are always skilfully and accurately drawn. Only the colour – both the paints used and the hues – stand out against the earlier works with a vivacity that ranges from the joyous to the mocking. In the case of the imitation "à la Renoir", the prevailing effect is one of joyously colourful, impressionist or pointilliste delirium; as far as the "Vache" period is concerned, the delirium is one of extreme irony and anarchistic derision, in addition to unmistakable Expressionist touches. But whatever the phase, the subjects addressed are not so very different from those of the complete oeuvre seen in its entirety. The juxtaposition of motifs and their mutual relationships never fail to astonish; the mental associations called forth by the compositions always have something of the unexpected. And finally, during these years Magritte produced pictures which accord with the conventions he himself laid down at the start of his career. One such example is *The Voice of Blood* (illus. pp.62–63), which dates from the same year (1948) as most of his "Vache" canvases. It is also the case that the subjects of certain pictures from one or other of these periods have something in common; or rather, the subject can be identified with that of pictures from earlier periods. This is true of *The Sea of Flames* (1945 or 1946; illus. p.172), a picture à la Renoir, seen in relation to *The Lull* (1941; illus. pp.159), more typically Magritte. Another way of putting it would be to say that these years saw a mixture of various styles. This is the case with *Lola de Valence* or *The Pebble* (illus. p.175), both dating from 1948. The female figures depicted in these pictures are almost classical; they are in any case depicted in the same manner, with no conspicuous points of difference, as Magritte employed both on a previous occasion, in *Discovery* (1927; illus. p.51), and on a subsequent one, in *The Great War* (1964; illus. p.165). The lines of the figures – above all in *The Pebble* – are however drawn much more freely and with more lightness of touch. This interpretative freedom manifests itself still more clearly in other details: the movement of the ocean waves in *The Pebble;* the rose in the figure's hand in *Lola de Valence,* or the little round table on which her arm is resting.

In fact there is no less Surrealism in the "Renoir" and "Vache" periods than in any of the others. And while these periods might document a different Surrealism, in Magritte's case, from that practised by other artists associated with the movement, these individual moments of anarchism could only amplify its exemplary otherness and uniqueness. These two styles introduced into Magritte's "non-painting" an element of "painting with a capital 'P'" – an imprecise expression, perhaps, but what is meant is that the artist employed what were in effect "pictorial" techniques, as was said of those nineteenth-century photographers whose concern it was to imitate painting. In Magritte's case, these "pictorial" techniques consisted in using the brush with gusto and in playing crude games with colours and substances, all to a greater extent than he had done previously. A more entertaining kind of painting, perhaps.

"There is no need to fear the sunlight under the pretence that it has almost always served to illuminate a world of misery. With new and charming features, all these mermaids, doors, ghosts, gods, trees – all these objects will be restored to the full life of living light in isolation from the human universe."

Entertainment in the good sense of the word – that at least is confirmed by Scutenaire's commentaries, when he wrote: "Why not paint like Renoir, when his little quirks make you happy?" Or: "What an enterprising show of bitter-sweet humour . . . on the part of the artist, to impose his luminous pictures on spirits crushed by the miseries of the war" (Scutenaire, 1977). Indeed! The war, its atmosphere of alienation, its sadness, all played a role, without a doubt. On top of this came the personal dissatisfaction of the artist with a society turned in on itself, shutting itself into a necessarily absurd conflict, all its horizons blocked. It was an existential contradiction which led to the appeal for an indisputably restorative "full sunlight". This was the occasion for a revision of former achievments and certitudes, as attested by the writing of manifestos and the reflexions on an "amentalism" aimed at reforging the links between mental exercises oriented towards the tragic, and emotional exercises oriented towards optimism. In 1947 Magritte weighed in against a reactionary Surrealism, based in his opinion at the time on "ineffective magic", in the following terms: ". . . we have consciously chosen pleasure as the supreme goal

The Fire, 1943
L'incendie
Oil on canvas, 54 x 65 cm
Brussels, Musées Royaux des Beaux-Arts,
Gift of Mme Georgette Magritte

of life." And hence: "We must dream up objects full of charm which address themselves to what is left of the pleasure instinct within us." The 1947 "Amentalist Manifesto", incidentally, was sub-titled "Un nouveau sentiment". Sentiment? Sentimentality? By no means. It was a subtle attempt, rather, to clarify his personal position, at that moment, a time of political and social indecision, of cultural vacuum, of aesthetic dictates imposed by force. That year Magritte sent Scutenaire a letter (dated 25 March 1947), couched in half-joking, half-serious terms, which could provide an explanation. He also confirmed that his thinking had basically remained unchanged. "I have always depicted things, events, objects, people and animals clearly, even when these things and events were mysterious. From this standpoint, my desire to illuminate everything more brightly still was no bad decision on my part, or so it seems to me." He added: "... clearly, I do not mean that the resulting pictures were flat and lacking in mystery." And stressing once more the seditious intentions by which he was motivated: "I think too that with this painting in full sunlight, I am depriving corrupted souls of their last chance of withdrawing into a 'superficial' world." The "corrupted souls", however, were not to be moved. They went into a sulk. Magritte said of this period that it was "accursed", in view of the "uselessness of having shown the public" his sun-imbued pictures.

Later, in 1955, he struck the balance, aesthetic and moral, of this "Renoir"

The First Day, 1943
Le premier jour
Oil on canvas, 59 x 53 cm
Private collection

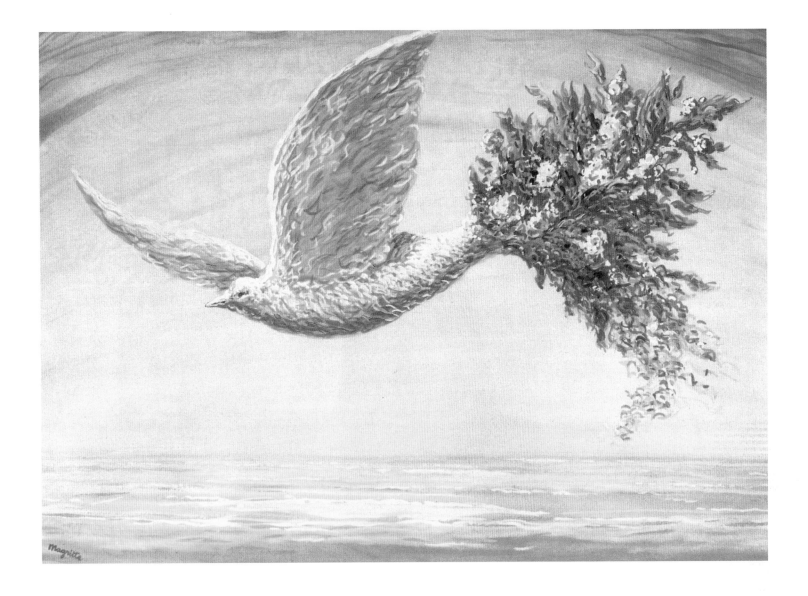

The Good Omens, 1944
Les heureux présages
Oil on canvas, 40 x 60 cm
Brussels, Berger-Hoyez Collection

period in a letter to Gaston Puel (dated 8 March 1955). He explained that for him, it was a matter of combining "two mutually incompatible things". The first consisted in a "feeling of lightness, intoxication, happiness" resulting from "a certain atmosphere and state of mind" which Impressionism "knew how to bring out in painting". The second was "the sense of the mysterious existence of things . . . which can only be perceived with a certain clairvoyance." And the reason he abandoned the style, he said, was by no means clear. "Perhaps because of a need for unity." Who knows? Perhaps because now the war was over, "just as peace has returned to the Earth, so the pyrotechnics can also disappear from painting" (Scutenaire 1977).

All the works of the "Renoir" period are worth mentioning as examples of Magritte's capacity to follow the recipes of his predessors when he had a use for them. As an example, too, of the personal advantage he drew from them on the level of his ethical demonstrations. Here we shall mention just a few, as being particularly illuminating.

The First Day (1943; illus. p.170) depicts a violinist in close-up against the background of a rich agricultural landscape. His hat and clothes are just like those worn by certain figures in Renoir's work. On his lap a ballerina is dancing. The canvas is painted in sunny golds and yellows. The brush technique with its contrasts and glissandi calls forth immaterial, impalpable impres-

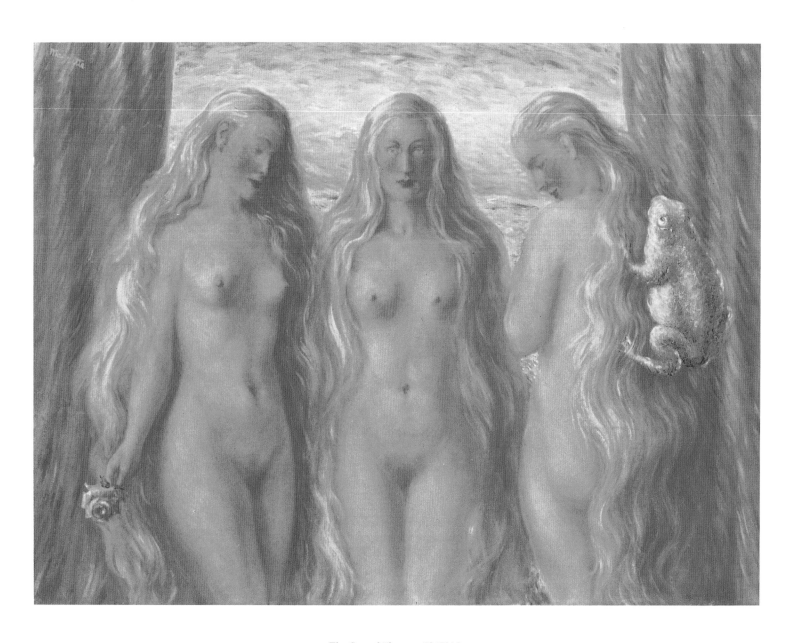

The Sea of Flames, 1945/46
Le brasier
Oil on canvas, 60 x 80 cm
Private collection

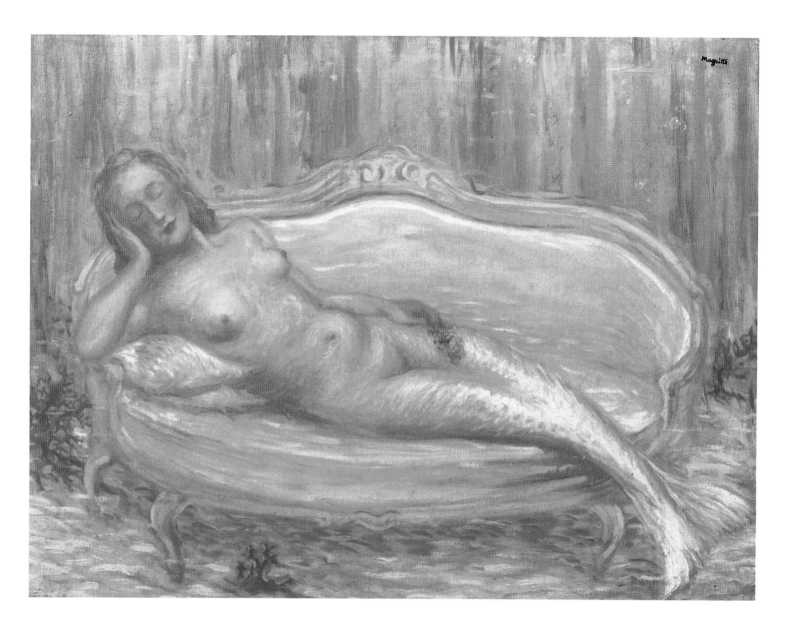

The Forbidden Universe, 1943
L'univers interdit
Oil on canvas, 81 x 65 cm
Liège, Musée d'Art Moderne,
Gift of Fernand Graindorge

sions. The paint has been applied with some vehemence, the oiliness of the medium is clearly apparent, but diminishes as one moves from the foreground to the background. The scene has a certain undeniable bucolic charm. But what is the dancer doing so close to the musician's sexual regions? Or is she supposed to be his sexual organ, in fact?

There is indeed an erotic expectation mingled with the cheerful gaiety of these impressionistic pictures. *The Forbidden Universe* (1943; illus. p.173) is another good example of this idealistic fusion of the pleasures of the flesh with the charms of nature. On the sea-bed, or so it would appear, a mermaid is asleep on a pink couch, with flowers in one hand, one arm resting on a cushion in the form of a tropical shell, while red corals are scattered about the floor. Notwithstanding the tranquil appearance of the model, nor the innocent pinks of the painting, the whole scene is bathed in a muted eroticism. The atmosphere could be that of some high-class brothel. One might compare this picture with an earlier one, *Collective Invention* (illus. p.37), dating from 1934. This depicts a mermaid in reverse, with the head and trunk of a fish and the legs and pelvic regions of a woman, washed up on a sandy beach. Here too there is an element of licentiousness, if anything, rather more obviously: could it be, perhaps, that here there are no charming fairy tale elements? A comparison of the two canvases clearly demonstrates the yawning chasm between the two styles: the less the charm, the greater the impact. Examples of an occasionally somewhat gratuitous picturesque charm are provided by *The Good Omens* (1944; illus. p.171): a dove, from whose tail emerges a bunch of flowers as from a Christmas cracker or some carnival "novelty" of the kind that Magritte must have known as a child. A wicked picture. But not a striking one. The "severity" which Magritte claimed for his "Surrealism in full sunlight", as for Surrealism *tout court* was here taken "a step further", in this case, a step too far. By contrast, we have *The Fire* (1943; illus. p.169), which takes up the theme of leaf-shaped trees so often treated by the artist in his more typical periods. Likewise by contrast, *Alice in Wonderland* (1945; illus. p.166), a picture combining Surrealist mockery and Impressionist technique with great perspicacity. Inserted in the trunk of a luxuriantly-leaved tree, there appear the features of a face of which only the nose and one eye are visible. In a sky covered in light clouds there is a swollen head shaped like a pear, similar to the one visible in the foreground of *Lyricism* (1947). Looking at these pictures, one can discern an unexpected relationship between the "Renoir" and "Vache" periods, of which the artist himself was probably unaware. Indeed, with *Alice in Wonderland* – as also with *Raminagrobis* (1946), incidentally – Renoir-style Impressionism took on a decisive force comparable to that of the great Surrealist pictures, while at the same time confirming its iconoclastic humour. As usual, in the half-open skies of ecstatic painting, it is not this same irreverent face that we see.

From today's point of view, the "Renoir" and "Vache" periods, in which Magritte attempted to express himself by different means from those he ususally employed, must be judged quite separately. The "Vache" period has acquired a retrospective importance which it did not have at the time, an importance not acquired by the "Renoir" pictures. And yet the "Vache" pictures derived from an intention which was, to start with, much less thoroughly thought out than the para-Impressionist series. The intention behind this latter was to open up, during a time of war, new perspectives for Surrealism: perspectives that were charming rather than tragic. Magritte

The Pebble, 1948
Le galet
Oil on canvas, 100 x 81 cm
Brussels, Musées Royaux des Beaux-Arts

174

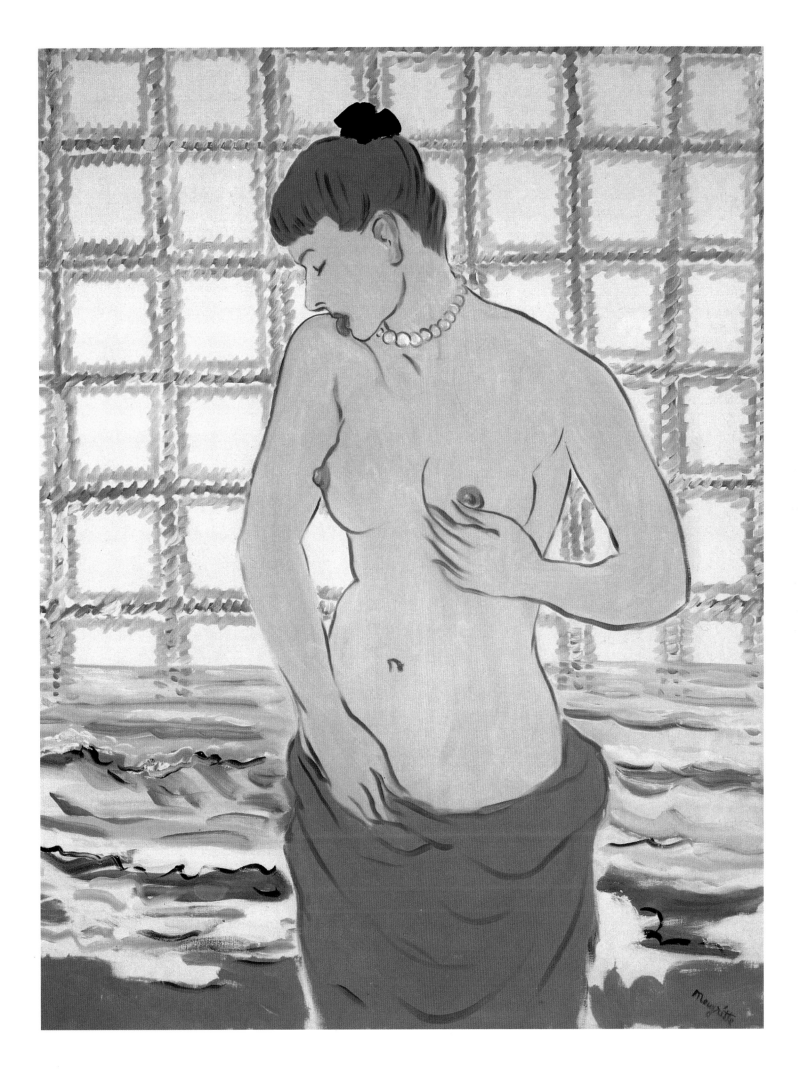

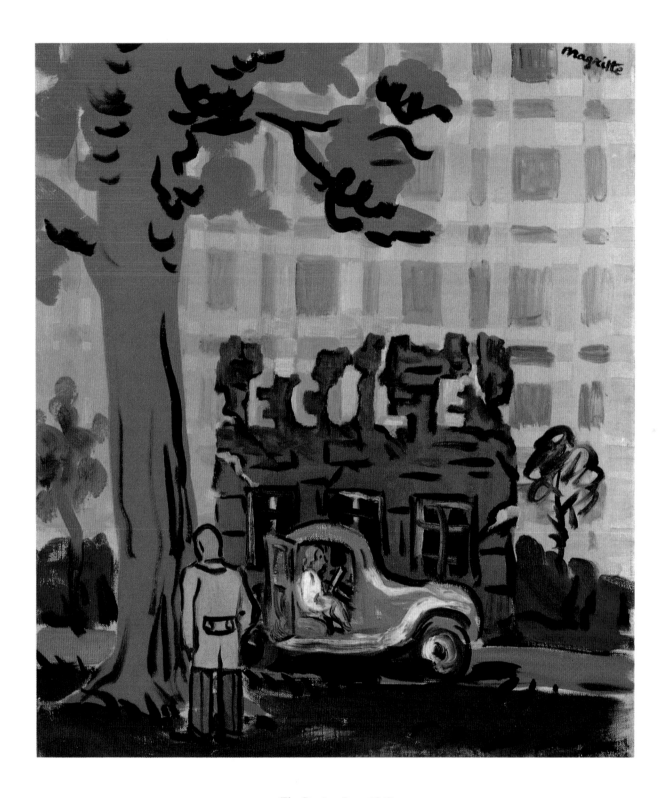

The Staging-Post, 1948
L'Etape
Oil on canvas, 54 x 46 cm
Private collection

Jean-Marie, 1948
Oil on canvas, 55 x 46 cm
Courtesy Galerie Isy Brachot, Brussels–Paris

wanted to use the techniques of the Impressionists without thereby abandoning "the science of objects and feelings to which Surrealism has given birth". By contrast, the "Vache" period was the result of a joke. In painting the "Vache" pictures, Magritte merely wanted to poke fun, in a fairly raucous fashion, at the Parisian patrons of the arts who, hitherto, had given but scanty attention to his work, even though he had lived in Paris from 1927 to 1931, many of his pictures having since been displayed at major international exhibitions.

So, of these two periods it was the less apparently serious one, the one less justified by Magritte's own ethic, which finally claimed the greater interest, even to the point of coming to be considered as one of the moving forces behind some of the youthful movements of the 70s and 80s, akin to the "Nouvelles Images", the "Transavantgardia", the "Neue Wilde" and the "Neo-Expressionists"! Important testimony to the success of the "Vache" period, long after it was conceived, was provided in curious fashion by the "Westkunst" exhibition in Cologne in 1981, the aim of which was to draw up a balance sheet of the state of post-1939 international art. Magritte was represented solely by pictures from the "Vache" period, which was considered by the organizers to be the sign of a "sudden and provocative change of style". It was contrasted more or less explicitly with the career of Chirico, of whom it was noted that he had "returned to a traditional form of painting". If nothing else, this was a recognition of Magritte's originality by comparison, his sense of movement, and his ability to be constantly at the forefront of his own time.

Undeniably, though, the "Vache" period represented no more than a fleeting, transitory phase in Magritte's development. In his work, however, there is one distant echo of it, and one which has never received much attention. We need to go back to the first pictures which took a pipe as their subject, in partiuclar to the one which immediately preceded his celebrated *The Treason of the Pictures (This is not a Pipe)* (1928/29; illus. p.120). The picture in question is a small canvas which does, indeed, depict a pipe (illus. p.122). It was found in the painter's studio following the death of his widow, and sold by auction in London when his estate was disposed of. It is a dark picture, in brown – dark for the background, verging on beige for the subject. The style it represents is a strangely modern Expressionism, even somewhat akin to the "Bad Painting" of recent times. It is as if the painter had wanted for the first time to attempt to construct an underlying alliance between the depiction of an insignificant object and an aggressive method of painting. Heavily crumbled, thickly applied, the paint is coarse and appears to have been put on with a trowel like plaster of Paris. It is reminiscent of Jean Dubuffet. Untitled, the picture shows, on the right, a shape resembling that of a pipe, badly drawn and seen from the side, while on the left there is a shape which could just about be that of a pipe seen head-on and foreshortened by perspective. In the bottom right hand corner are the words "La pipe". This little painting stands in total contrast to the various pictures in the series *The Treason of the Pictures*. Not only did Magritte here *not* play on the ambiguity of "This is not . . ." – he actually wrote that it was "the pipe" – but in addition he painted it in a grainy fashion not unlike that characteristic of his 1919 period, as attested by a *Nude* dating from that far-off year (illus. p.13). The date of the picture in question is uncertain, but Sotheby's experts assign it "almost certainly" to 1928, the year in which the first version of *The Treason of the Pictures* appeared. It could thus have been a preparatory study. There are however reasons for believing that

The Ellipse, 1948
L'ellipse
Oil on canvas, 50 x 73 cm
Courtesy Galerie Isy Brachot, Brussels–Paris

the picture might be earlier, dating perhaps from 1926, although nothing is certain. What is striking, though, is that the manner of painting which it attests to is at the very least just as "wild" as were the "Vache" jokes some twenty years later.

This joke was dreamt up by Magritte at the time when the Galerie du Faubourg invited him to exhibit in May 1948. It was to be his first one-man show in the French capital, which was way behind New York in according him recognition. There is no doubt that the he readily accepted. But he intended from the outset that this exhibition would be a kind of slap in the face for those Parisian connoisseurs who had shown little enthusiasm for him hitherto. As Louis Scutenaire recalls, this was "the opportunity to strike a heavy blow. There was never for one moment any intention of compiling a selection of pictures, painted in one style or another, which had already made a name for their painter ... The idea was not to please the Parisians, but to scandalize them" (Scutenaire 1977). The idea was to "put one's foot in it" – the title of the introduction written by Scutenaire for the exhibition "in an uncompromising argot". And that is just what happened. Only Paul Eluard did not fall into the trap. He wrote in his book devoted to the reflexions of the visitors: "He laughs loudest who laughs last." In order to shock, to scandalize, to strike a heavy blow, to "put his foot in it", Magritte, having certainly forgotten "the pipe" of 1926 or 1928, invented a new genre and dealt with subjects as yet untouched. His imagination was fired by pre-1914 caricatures shown to him by his friend

Paul Colinet. These consisted of drawings by "one Deladoes" recently published in various children's magazines which "treated the human race with a quasi-delirious expressionistic virulence, making use of horrific distortions and atrocious colours". If Magritte had not attached a particular significance to these horrific distortions and atrocious colours, one might think he had placed himself on a level with his models.

The fifteen oils and ten gouaches exhibited in Paris – virtually the entire output of the "Vache" period – are certainly marvellous documents of "our total lack of confidence in foundation and form", Magritte wrote in a letter to Scutenaire dated 17 May 1948. They are also a nice demonstration of an acerbic, vindictive, para-Dadaist humour, which incidentally manifested itself on a number of other occasions, for example the 1946 tracts entitled *The Imbecile, The Arsehole, The Bugger*. Finally, they bear witness to the eclectic indifference with which Magritte regarded his sources. Here, low caricatures; there, adventure stories; elsewhere, popular science or tragi-comic episodes taken from films. Perhaps this is why younger generations have rediscovered him – his "Vache" period and others. "We have eyes to see with. On this occasion among thousands, we do not ask ourselves the question. We simply ask it." Or: "What Magritte is showing you is for your refreshment but, above all, for your amusement." (Preface and postscript by Scutenaire to the Paris exhibition: "René Magritte, Peintures et Gouaches", Galerie du Faubourg, 1948.) The response of the public, according to Magritte, verged on almost total incomprehension: "The usual tripe: 'not so profound as he used to be', 'Belgian humour', 'you can see he's not from Paris'." In any case, none of the pictures was sold.

The Galerie du Faubourg's catalogue forms an almost complete inventory of the "Vache" period as it intruded upon the painter's normal development, for while this "fauviste" interlude occurred in 1947 and 1948, it did not mean that Magritte was not at the same time producing other pictures which remained entirely faithful to his basic outlook.

Among these were new versions of *The Rape* (illus. p.38), and *The Voice of Blood* (two versions, illus. pp.62, 63). But however that may be, here is the list of pictures exhibited in Paris from 7th to 29th May 1948:

Oils: *The Life of the Insects, The Pebble* (illus. p.175), *The Mountain-Dweller, The Pictorial Contents* (illus. p.183), *The Fuse* (illus. p.186), *The Ellipse* (illus. p.179), *Seasickness* (illus. p.184), *The Involvement of the Fire, The Suspect, The Psychologist* (illus. p.187), *The Triumphal March* (illus. p.182), *The Staging-Post* (illus. p.176), *Jean-Marie* (illus. p.177), *The Famine* (illus. p.189).

Gouaches: *Flute!, The Pope's Crime, Lola de Valence, The Rainbow* (illus. p.191), *Pom' po pom' po pom po pom pon* (illus. p.188), *The Night of Love, Black Magic* (same title as for a work dating from 1933–34), *The Depths of Pleasure, Prince Charming* (illus. p.185), *Longings*.

What most of the pictures show is a person or persons in incongruous situations, rigged out in clothes or other accessories less unexpected than usual, in accumulations such as the eight pipes being smoked simultaneously by *The Cripple* (1947; illus. p.180), five in his mouth, one each in his beard, his forehead and an eye. Or single objects like a watch on a chain wrapped around the same bearded figure, who is depicted wearing glasses, a red cap and a check pullover, against a coarsely painted background, while protuding from his right cuff is a mass of black hair. Then there is the rose being clutched in the fist

Undated drawing
Brussels, private collection

The Cripple, 1947
Le Stropiat
Oil on canvas, 60 x 50 cm
Courtesy Galerie Isy Brachot, Brussels–Paris

181

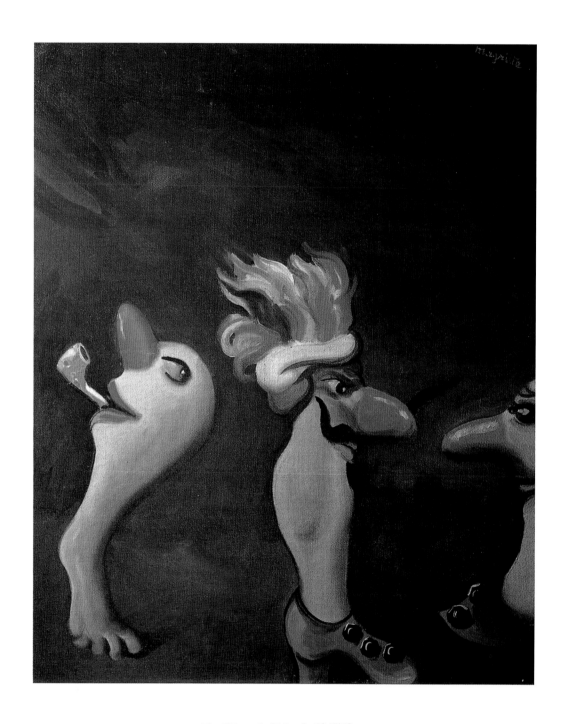

The Triumphal March, 1947/48
La marche triomphale
Oil on canvas, 63 x 54 cm
Courtesy Galerie Isy Brachot, Brussels–Paris

ILLUSTRATION OPPOSITE:
The Pictorial Contents, 1947
Le contenu pictural
Oil on canvas, 73 x 50 cm
Courtesy Galerie Isy Brachot, Brussels–Paris

Seasickness, 1947
Le mal de mer
Oil on canvas, 53.5 x 65 cm
Brussels, private collection

of the naked individual depicted in *The Psychologist* (1947; illus. p.187), the whole decor being reminiscent of those well-known pictures depicting similarly unclad women also posing with flowers in their hands. Then again, there is the riflebarrel replacing the nose of the subject of *The Ellipse* (1948; illus. p.179), a figure with a metallic green face and eyes like ping-pong balls, the only human feature being the single eye in the middle of the bowler hat on the figure's head; while on its right hand there rests another hand apparently attached to nothing. In the case of *Jean-Marie* (1948; illus. p.177), the sky above the landscape is painted as though it was a chequered tea-towel. The human figure, a one-legged peasant with a big nose, has all the appearance of a poacher. *The Pictorial Contents* (1947; illus. p.183) could well be an amalgam of everything else. It depicts a clown, a grotesque tightrope walker in clothes too large, in colours too bright, gesticulating too wildly. He holds a banana in one hand, a revolver in the other, while from his skull there emerge heads with running noses. His left trouser-leg is disfigured by a similar fantastic, frothy face. He is drawn and painted in a formless, runny fashion. The paint is at it were pissing from top to bottom, trickling in thick bubbles to come crashing down to the ground where it revives all its screaming colours. This *Pictorial Contents,* by its title and by the contempt for technique which it displays, is representative of practically all the aims which the artist had set himself for the time being. It testifies to the fact that we are dealing with subjects whose presentation, whose explicitly derisive intention, whose automatic production and the choice of whose colours all flew in the face of the "good taste" attributed to the patrons. There should have been a sequel, which in fact never materialized. Magritte and Scutenaire planned to "compose an Epinal print collection in colour on waxpaper", the illustrations to be provided by Magritte and the text by Scutenaire. The title was to be "The Life and Works of René Magritte of Yesteryear, Universal and Parisian Painter". Suzi Gablik was the first to

publish Scutenaire's proposed text – lively, satirical, and "unmistakably anti-French".

Alongside the thematic relationships mentioned, there are also technical parallels between the "Renoir" and "Vache" periods, although not apparent from the considerations which Magritte and his friend and accomplice issued on the subject of these excursions. In fact, with both styles, the method employed requires particularly vivid colours and a signature in which animistic feelings are given priority over intellectual calculations. Having had practical experience of Impressionism, Magritte must surely have been encouraged to move on to Fauvism; at least, the "Renoir" episode must have facilitated the "Vache" approach. In both periods, then, we clearly see how enchanting intentions, whirling moods and devastating, sarcastic intentions were fused together by the technique into an atmosphere full of brilliance and verve. *The Harvest* of 1944 – in the Renoir style – is no less mocking than *The Psychologist* of 1947 (illus. p.187) *à la fauve*. In one and the same period moreover, we can observe a real fusion between tight structures and lyrical de-structuring. There are successive passages across a single drawing in which a concern to depict things as they actually appear ends up in their inorganic dissolution. One only needs to look, in this context, at *The Pebble* (illus. p.175) and *Jean-Marie* (illus. p.177). The backgrounds are virtually identical; but between the two, the brush has assumed ever greater freedom. At the level of technique, it is precisely the manner of applying the paint and the degree of visibility of the applied medium that make all the difference between the "Renoir" and the "Vache" periods. As we have already pointed out, between the one style and the other, the brush strokes move from an apparently uncertain lightness to an apparently spontaneous decisiveness while, contrariwise, the forms change from exemplary accuracy to relative imprecision. Magritte had made the passage from Neo-Impressionism to Neo-Expressionism; from realistic figurative articulation to instinctive articulation; the passage from a fictitious painting created by painting, to a fictitious world created by the artist; a passage which leads to the total destruction of the usual notion of "great art".

However, alongside the similarities of technical execution evident in these two different periods, there is no mistaking the fact that there are certain contrasts in the respective messages. While Magritte attempted to claim, with some plausibility, that his "full sunlight" and his Neo-Impressionsm were subject to the same constraints as his usual style, it is rather difficult to make the same claim for the "Vache" period unless, that is, this latter is regarded as a fleeting interlude – which indeed it was, and which would justify its total neglect. Did Magritte give up this style against his will? Suzi Gablik has published (in English translation) a passage from a letter, the original of which is untraceable; in it, Magritte says that he would like "to pursue even more firmly the 'approach' represented by my Paris experiments – that would be my tendency anyway: slow suicide. But there is Georgette to take into account and the distaste I feel for being 'sincere'. Georgette prefers the well-painted pictures of 'former times'; alas, just to please Georgette, I shall no longer, from now on, exhibit any but my former kind of pictures. And I shall certainly find some way of sliding into a great big incongruity from time to time . . ." Was it a return to former times out of economic necessity? Or because it was the easy way out? Not long afterwards, the market intervened – along with fame – in the person of the proprietor of the Galerie Alexandre Iolas, who signed a contract with Magritte which made him his sole agent from 1956 until his death.

Prince Charming, 1948
Le prince charmant
Gouache, 45 x 32 cm
Brussels, private collection

The Fuse, 1947
L'Etoupillon
Oil on canvas, 72 x 75 cm
Courtesy Galerie Isy Brachot, Brussels–Paris

The fact is that once Magritte had left these sunlit and Fauvist periods behind him, periods during which painting in his eyes had become enchantment on the one hand, and acerbic but innocent entertainment on the other, once this period was over when his work departed from concrete "non-painting" for generous pictoriality, Magritte found his way back to precisely that style which did most justice to the intentions he had expressed and which made him known throughout the world. He left the pictorialist territory charaterized by his "Renoir" and "Vache" periods in 1948, after the Paris exhibition, and signalled his return to orthodoxy in singular fashion with *The Taste of Tears* (1948; illus. p.118). In this picture he developed an idea that had appeared as long ago as 1942, in *Treasure Island* (illus. p.117) and *The Companions of Fear* (illus. p.116): the leaf-bird or bird-leaf, a fusion of flora and fauna, the resurgence of verist presentations intermingled with romanticism. Perhaps this kind of romanticism was a reaction, in its turn, to the enchanting or caustic accents immediately preceding. Indeed, in a letter to the poet Marcel Lecomte on the subject of conventional romanticism, Magritte declared, somewhat over-has-

The Psychologist, 1947
Le psychologue
Oil on canvas, 65 x 44 cm
Private collection

tily, that as far as he was concerned, romanticism was accompanied by a "melancholic rather than by a joyous atmosphere". However, both the "Surrealism in full sunlight" à la Renoir in time of war, and the Fauvism "à la Vache" which he took up shortly after the cessation of hostilities, were certainly characterized by a certain joyousness. So was there a return to melancholy at the end of 1948? Or was it recourse to a toned-down melancholy, as documented by certain pictures painted during the 1950s, such as *The Empire of Light* (1954; illus. p.101), or *The Seducer* (1953; illus. p.139), or, above all, the portraits *The Likeness* (1954; illus. p.92) and *Anne-Marie Crowet* (1956), whose face we encounter once again in *The Ignorant Fairy* (illus. p.93) dating from the same years. Is this the melancholy of a post-war period which brought little satisfaction, everything having returned to how it was before 1939? In 1945, Magritte rejoined the Belgian Communist Party, only to leave it once and for all at the beginning of 1947. He and his friends had hoped to be able to start up an artists' cell within the party, which might be able to promote a revision of the party line on aesthetic matters. The party would have none of it, however. As Magritte admitted to Patrick Walberg, these were moments of failure and disappointment vis-à-vis a social system which continued to allow "restrictions, wars and inequalitites of fortune".

By contrast, beyond these waves of disillusionment which perhaps explain this para-romantic melancholy, Magritte was setting off once more on his own proud road. From now until his death, Neo-Impressionism and Neo-Fauvism having been abandoned, there followed one series of magnificient pictures after another. This is not the place to pronounce with certainty that these styles had disappeared without the slightest trace, but if there were traces, they are imperceptible. One vestige might be his preference for more frequent generous use of colour than before, though this is still by no means general. On the other hand, the basic ideas, the inventory of favourite objects, the original vocabulary – all are there in these later paintings, and their presence grows stronger as time progresses. These ideas, this inventory, this language – they

Pom' po pom' po pom po pom pon, 1947/48
Gouache, 32 x 45 cm
Private collection

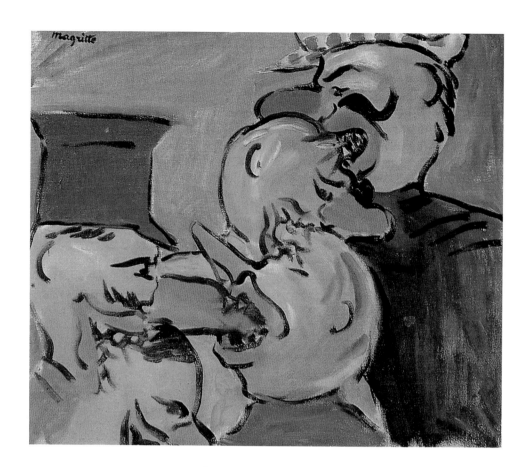

The Famine, 1948
La famine
Oil on canvas, 46.2 x 55.2 cm
Private collection

were summed up by the painter in a series of letters to Michel Foucault in 1966, one year before he left us. It was a simple proposition, but by no means a simplistic one: to take the reality of things as one's starting point, to confront objects with similitudes, and to suggest mystery by connecting them; to convey thought, to convey an image. Or, in other words: "Likeness resides only in thought. It is 'like' in being what it sees, hears and knows, and becomes what the world offers it" (letter to Michel Foucault dated 23 May, 1966).

It is in this ordering of permanent ideas that we can place the majoritiy of sequences which saw the light between 1948 and 1967, as well as most of the individual pictures. Thus the canvases entitled *Memory* (illus. pp.155 and 157), depicting the plaster head of a girl, blood flowing from its temple. The first of these pictures, dating from 1945, still shows traces of Neo-Impressionism (illus. p.157); the later ones, from 1948 (illus. p.155) and 1954, are wavering between serenity and drama. Thus also the figures with bomb-shaped heads and lathed table-leg bodies in *Natural Encounters* (1945; illus. p.58), *The Cicerone* (1947; illus. p.59), *Elementary Cosmogony* (1949), and the subjects of *Perspectives I, II* and *III* (illus. pp.68 and 71), which are based on well-known pictures such as David's *Madame Récamier* (illus. p.69) and Manet's *The Balcony* (illus. p.70). No charm here; the pictures have been taken over by an insistently iconoclastic dramatism: the original (personal) subjects have been replaced by coffins. Akin to these pictures – still half-romantic and half-allusory – is *The Ready-Made Bouquet*, in which Botticelli's *Primavera* is depicted on the back of a man in overcoat and bowler hat (the painter himself). Then there is *The Spirit of Adventure* (1962; illus. p.105), which is related, but in this case the back of the central figure is invested with two other figures likewise dressed in overcoats and bowler hats. *The Blank Cheque* (1965; illus. p.65) shows certain similarities of composition. Then we have the rocks and

clouds suspended in mid-air: *The Battle of the Argonne* (1959), *The Castle in the Pyrenees* (1961; illus. p.146) and *Zeno's Arrow* (1964; illus. p.147) among others.

Then we have the pictures in which the stones and rocks are so prominent as to form the beings and objects themselves: the whole series known as *Souvenir of a Journey* (illus. pp.148, 152 and 153), dating from 1951 to 1955, the imposing *The Legend of the Centuries* (1948; illus. p.151), *The Big Table* (1962; illus. p.149), the subtle but significant picture *The Art of Conversation* (1950; illus. p.150). In this last, words crop up in surprising situations, their literal associations reminiscent of the manipulations of Lewis Carroll: a scaffolding formed of blocks of stone is constructed in such a way that some of the blocks form the word "REVE" ("dream"); or looking again, one sees the word "TREVE" ("truce"), or else "CREVE" ("kicked the bucket").

We must not forget either the memorable picture *Personal Values* (1951–52; illus. p.98), noteworthy because it unites within itself a number of the disconcerting objectives by which the artist was haunted. The scene is set in a room open on all sides, its walls consisting of blue sky with well-broken white clouds. Apart from the bed and a wardrobe with mirrored doors, everything in the room is disproportionately large: everyday objects in monstrous dimensions. This illusionary effect was intended no doubt to impose on the eye of the viewer the objective evidence of the subjects treated thus "realistically" by Magritte. The same intention can be seen in *The Listening Room* (1958; illus. p.99) and *The Wrestlers' Tomb* (1961; illus. p.98).

There is also the series featuring curtains and wall-hangings: *Le beau monde* (1962; illus. p.200); *La Gioconda* (1964; illus. p.201); and that peaceful sequence of doves in flight: *The Big Family* (1963; illus. p.138) or *Spring* (1965; illus. p.141), a luminous *reprise* of the sombre *The Return* of 1940. *The White Elephant* of 1962 (illus. p.134) might be compared in this connexion with *Time Stabbed* of 1939 (illus. p.89): the comparison throws considerable light on the way Magritte's imagination worked, with stops and starts, and *reprises* of his own motifs, on how his inventory developed in recursive loops, and how his message is expressed between experiments with the natural and the supernatural, with the received and the plausible.

All that was left for this œuvre was to topple over into its destiny in 1967.

The Rainbow, 1948
L'arc-en-ciel
Gouache and gilt, 47 x 33 cm
Private collection

EXCITING PERFUMES BY MEM
So Fresh - so young - so wholly piquant

Point Doré Point Vert Point Rouge
Romantic Sophistiqué Exotic

From Advertising to Art –
From Art to Concepts

Magritte was imbued with the conviction that the art which he practised was the only possible one if he was to demand of his public that they share in the discovery of the enigmas lying concealed behind generally recognized phenomena. As a result, he hardly concerned himself at all with the work of other artists, nor of other movements, who might have been proceeding along more or less parallel tracks or invoking the teachings which his work and his statements might have provided in abundance. Many of his commentaries bear witness to this, whether they are concerned with his opinion of other Surrealist painters of his own generation, or of younger artists who eventually in one way or another acknowledged their debt to him. This egocentricity, a sign of his proud independence, is confirmed by the facts as they stand, for indeed, his work, which following his death can now be seen as a whole, is without parallel in the history of twentieth-century art. Without doubt it was, and remains, influential.

This influence has many layers, and it is not always possible to disentangle the various threads. Its presence can in any case be discerned in four principal directions, sometimes overt, sometimes covert, sometimes acknowledged, sometimes not. An exception must be made for the post-Surrealist fibrillations of painters more endowed with talent for technical prowess than blessed with any original imagination. These are the "false Surrealists", imitators encouraged by the – recent – popularity of the movement. But to return to Magritte and his influence: the first area in which it is evident is that of advertising. A second is that of Pop Art and all that goes with it, up to and including Hyperrealism. A third line of descent leads to the ethical pretensions of Concept Art while a fourth, indirect it must be said, links the "Renoir" and "Vache" periods to certain aspects of so-called "Neo-Fauvist" or "Transavant-garde" art. It is interesting to note that – apart from the field of advertising – the movements in painting which, in one way or another, acknowledge more or less overt links with Magritte, are all grouped between the 50s and the 70s, in other words in the context of highly contemporary, and wide-ranging, developments in the visual arts.

As far as advertising is concerned, it is clear that the numerous plagiarisms, successful or abortive, of which the world of advertising has been guilty, owe less to Magritte's own pot-boiling activities in this area than to the disconcerting verism of his pictures. If, while working in this area during periods of material insecurity (sporadically from the 20s right up to the 50s), Magritte was never short on communicational inventivity, nor of a sense of commercial "pull", what has retained the attention of marketing specialists was clearly his sound knowledge of how to present objects in a manner both suggestive and

The Voice of Blood (Study), 1948
La voix du sang
Gouache
Brussels, private collection

Exciting perfumes by Mem, 1946
Gouache on paper, 34 x 24 cm
Brussels, private collection

FESTIVAL MONDIAL
DU FILM ET DES BEAUX-ARTS
BRUXELLES
DU 1 AU 30 JUIN 1947

René Magritte in front of an
advertising poster, c. 1955
Courtesy Galerie Isy Brachot, Brussels–Paris

Poster for the *Festival Mondial du
Film et des Beaux-Arts, 1947*
Lithograph, 35 x 29 cm
Brussels, private collection

questioning. The proof of this is the fact that not only are many advertisements conceived "à la Magritte" – often to the point of being virtual copies – but also that his pictures – any of them – are used to decorate posters, brochures and informational material. They are also used to illustrate book covers, whether novels or essays of whatever kind, convincing evidence of the universality of Magritte's message. Nor is it a matter of indifference – in view of Magritte's interest in the use of language – that in addition to the advertising pictures he created himself, he also designed typefaces in the spirit of the age, thus confirming the links he maintained at that time with the fringes of Futurism, in other words, abstraction. Examples of this amalgam of words and pictures are: the catalogues he designed for the furrier S. Samuel between 1926 and 1928; the political and cultural posters dating from before and after the Second World War, for example for the *Festival Mondial du Film et des Beaux-Arts* held in Brussels in 1947 (illus. p.194), or *Hommage à Eric von Stroheim* (1957; illus. p.197); his cigarette advertisements (c.1935; illus. p.196). There was a more specific case still of the collusion between bread-and-butter work and his artistic œuvre: namely his perfume advertisements. The motif of the planned advertisement for the campaign *Exciting Perfumes by Mem* (1946; illus. p.192) – the product itself never got as far as the market – was taken up again in 1948 for the gouache and the oil painting entitled *The Voice of Blood* (illus. pp.62, 63 and 193).

Design for an advertising poster
for the *Belga* cigarette brand, c. 1935

"Commercial" art thus enjoyed good relations – perhaps helped along by necessity – with "Surrealist" art. All the more so, in fact, because in his Surrealist painting Magritte often employed similar techniques to those used by graphic artists in advertising. The strictly two-dimensional pictures demanded most particularly a flat and even – not to say anonymous – application of colour, with no effects resulting from the medium itself. These were precisely the techniques rediscovered in a more sophisticated form and on a larger scale by the New York Pop Art painters, several of whom, incidentally, started out as commercial graphic artists. Some of these "New York Five" (Warhol, Lichtenstein, Wesselmann, Rosenquist and Oldenburg), like Rauschenberg and Segal too, have laid some stress on the importance which, in their opinion, Magritte had for their art. For them, this importance lay undeniably in the principle of objective representation which Magritte introduced into modern art; it also lay in the links he forged between authentic verism and ulterior meaning; indisputably, too, in his attitude of curiosity towards all the processes

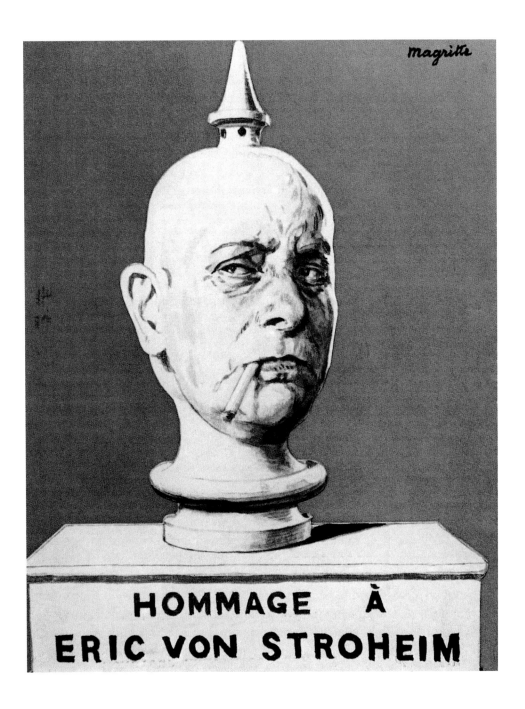

Hommage à Eric von Stroheim, 1957
Design for "L'Ecran du Séminaire
des Arts" in Brussels

available for the attainment of a given objective, be they in accord with hallowed aesthetic principles or not, such as photography, film, utilitarian graphic art, the world of the serial-story hero or the comic strip; finally, too, in the attraction exercised by the banality of things on a creator of otherwise mystifying pictures.

It must be said, though, that Magritte for his part always denied any claim to paternity of, or influence on, Pop Art, whose chief aims were indeed far removed from his own. For him, this school was a "well-meaning" resurgence of Dada, a decorative, shop-window art. All the same, he said that "one day, perhaps, unexpected pictures of the unknown" might emanate from "the Pop Art people". However "their error" was to want "to express the world as it is", a world which was merely "a transitory state", a "fashion", while poetry was "the feeling for the real, insofar as it is permanent". He also wondered whether Pop Art might not perhaps have acknowledged a debt to him because "my works do not form part of artistic production". This impression is not without

foundation. Even though it is not clear whether the American Pop artists were aiming to re-create a poetics of whatever kind, there is no doubt that their concern to practise figurative painting in a new way – by recourse to pictures of mass-produced goods – encouraged them to think in terms of "non-artistic" production, in terms of an "instant art history" (Lucy R. Lippard). Along with their acknowledgement of Magritte, the Pop artists also invoked the name of Marcel Duchamp: for both of them, the ideas one can form if anything spring from the way in which these things are perceived. In this sense, the "Marilyn" series of Andy Warhol, considered as a typology of the latter's intentions, might have echoes, other things being equal, in certain series of objects which occur in Magritte's inventory, and utilized by the latter in a recursive fashion. But while Warhol only wanted to be a copying "machine", Magritte saw himself as a poet creating "another world".

Thus it is not easy to find pictures by Magritte which are sufficiently significant of any relationship between him and Pop Art. If one sticks closely to the figurative characteristics and the technical qualities more or less common to both, the following examples, in addition to the "*Treason*"-Pictures of the pipe (illus. pp. 120, 122, 123), might be adduced for the pre-1930 period: *The Barbarian* (illus. p.45), *The Threatened Murderer* (illus. pp.46–47), *The Man with the Newspaper* (illus. p.49), *Discovery* (illus. p.51), *The Tree of Knowledge* (illus. p.133) and *The Key to Dreams* (illus. pp.128–29). The following period might perhaps be represented by *The Great Wall* (1934), insofar as it represents a faithfully realistic depiction of the female body, as is to be found in all pictures depicting women. The following might also be cited: *The False Mirror* (1935) and *Eternity* (1935; illus. p.202); *The White Race* (1937; illus. p.205) and *Time Stabbed* (1939; illus. p.89). Finally, a number of collages deserve mention, a technique the painter employed with enthusiasm throughout his life (cf. illus. p.199) and, in addition, certain sculptures of a para-Dadaist sort, or à la Marcel Duchamp, among them: *This is a Piece of Cheese* (1936/37; illus. p.206), *The Cork of Terror* (1966; illus. p.207) and the *Bottles* (1937, 1950, 1963; illus. p.208). In each case, the comparisons are only very incomplete, and at best only partial.

To Pop Art one might add the Hyperrealism that succeeded it in the calendar of movements which proliferated during the 1950s and 1960s. Quite clearly the link with Magritte is to be found – here, as in the case of advertising too – primarily on the level of objective reproduction. The Hyperrealists, or photo realists as they were also called, saw themselves, as Magritte did, as neutral and anonymous in relation to the reality which everyone can see. Richard Estes declared that "if you want to appreciate art, you simply have to appreciate objects and approach them with an open mind". Duane Hanson noted that "Realism is what is best suited to convey the fearful idiosyncrasies of our age." As for Magritte, he for his part delcared that "objects are to be painted with their visible details". And "The real identifies with its possibilities", which, "depending upon our preferences and desires, are "friendly, horrific, fantastical, banal, well-known, unknown etc." The North American Hyperrealists, like the Belgian Surrealists, thus bear witness to the explosive character of objective reality once it is transferred to a picture, all the more so if this picture does not seek to interpret anything. What separates them are the moods (or the ideas, or the prejudices) on the basis of which they embark on a visual registration of the reality of things. Thus the commentary-free observations of the photorealists necessarily fly in the face of the well-commented-upon obser-

Collage, c. 1966
Brussels, private collection

vations of the Surrealists, and are swallowed up therein. To paint the real, for the Hyperrealists as for Magritte, encourages "a new manner of comprehending the world". There is nothing real, no reality, without significance. And no significance without mystery.

Less directly apparent are the relationship which might possibly exist between Magritte's general objectives and conceptual art. This movement arose in the mid-60s and acquired a theoretical foundation in 1969 with the publication of Joseph Kosuth's "Art after Philosophy". While the relationships between Pop Art and Hyperrealism on the one hand, and between Pop Art and Surrealism à la Magritte on the other hand, are to be sought on the level of pictorial representation, any links between Magritte and the exponents of conceptual art are on the level of the ideas which both parties had developed concerning art and its function, and not so much in the works themselves, though here an exception must be made for those pictures in which Magritte plays with words, that is to say the series whose prototypes are *The Key to Dreams* (1927; illus. pp.128–129), *The Living Mirror* (1928/29; illus. p.131) and *The Treason of the Pictures* (1928/29; illus. p.120). The ideas underlying them are indeed very close to those purveyed by the staff of "Art and Language", a British journal sub-titled "A Journal of Conceptual Art". This

Le beau monde, 1962
Oil on canvas, 100 x 81 cm
Private collection

La Gioconda, 1964
La Joconde
Gouache on paper, 32.2 x 26.5 cm
Patrimoine culturel de la Communauté française
de Belgique

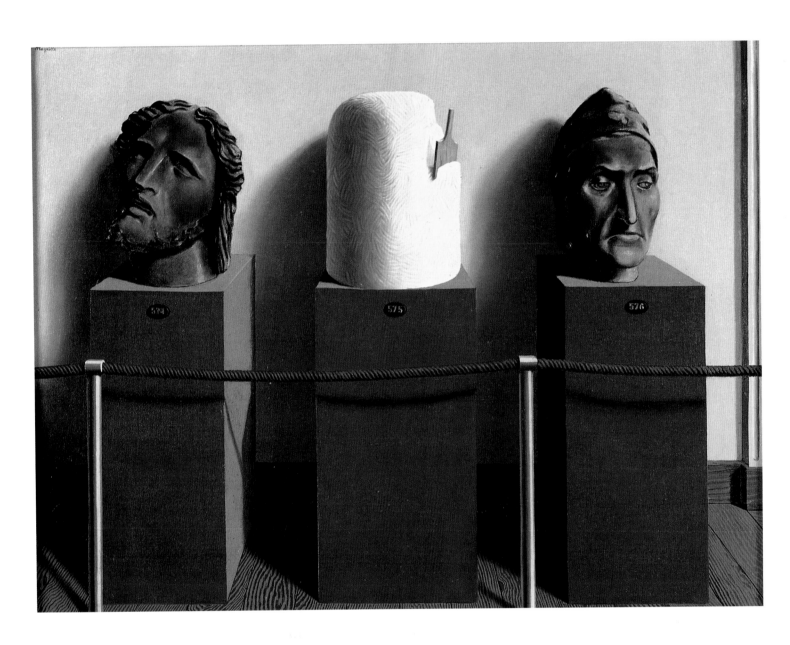

Eternity, 1935
Eternité
Oil on canvas, 65 x 81 cm
New York, The Museum of Modern Art,
Gift of Harry Torczyner

The Works of Alexander, 1967
Les travaux d'Alexandre
Bronze, 61 x 150 x 110 cm
Courtesy Galerie Isy Brachot, Brussels–Paris

The Well of Truth, 1962/63
Le puits de vérité
Pen and ink drawing, 29 x 21 cm
Brussels, private collection

The Well of Truth, 1967
Le puits de vérité
Bronze, 81 x 42 x 25.5 cm
Courtesy Galerie Isy Brachot, Brussels–Paris

accord in the field of ideas can be summarized as a common approach to the phenomenon of art, as understood by Kosuth when he wrote: "Art has similarities with logic, with mathematics and also with science." With logic, certainly, as far as Magritte is concerned. So much has been shown in some detail in the present work.

For the conceptual artists as for Magritte the idea preceded the work. Thought is dominant, always a "precondition of function", as observed by Wittgenstein or Segerstedt, whom Kosuth likes to quote. Thought is in fact the fundamental theme of the picture. But while for the conceptual artists the work – in marginal cases – is without significance for the idea from which it sprang, this is not true of Magritte. For him, the existence of the work was an absolute necessity, if the idea was to be made visible. Nor would we have shared the opinion of the conceptualists that aesthetics as such was to be rejected in favour of functional notions. The aims of art, if you like, depend more strongly on the

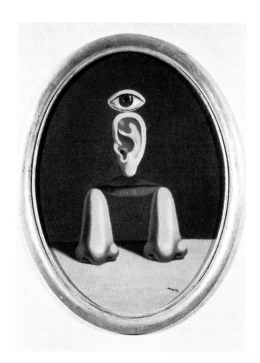

The White Race, 1937
La race blanche
Oil on canvas, 39 x 29.5 cm
Courtesy Galerie Isy Brachot, Brussels–Paris

The White Race, 1967
La race blanche
Bronze, height: 58 cm
Patrimoine culturel de la Communauté
française de Belgique

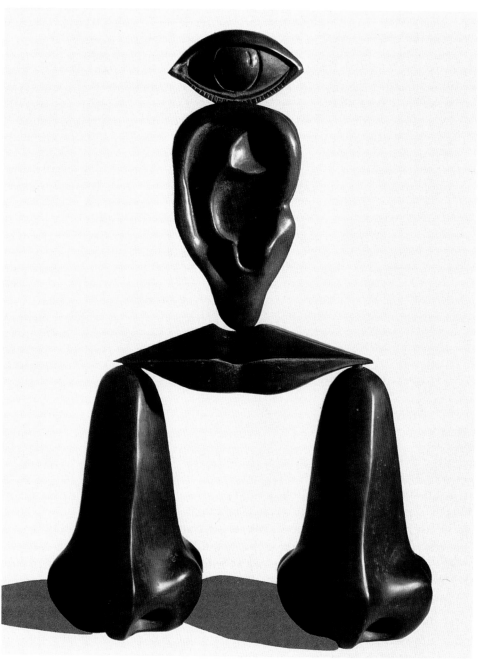

use one makes of it than on the manner of its production. Like Kosuth and his colleagues, Magritte did believe that aesthetics was alien to the raison d'être of objects, unless these are being considered from the point of view of decoration. He expressed this most particularly in the statement that the "how-to-paint" is dependent on "a science of painting which allows an exact description of the aspects of the world included in the likeness." Or else: "Art has no social justification except in the social role that it plays." Or again: "Do you pay more regard to the external appearance I give to my pictures than to their meaning?" ("Propos")

The exponents of conceptual art strove for a permanent enquiry into the nature of art, by separating what its practitioners called "formalist" art from an art which could find a proper definition only within itself. "If someone says this is art, then it is art" (Donald Judd). This reflexion illuminates a good part of the tendencies expressed in Europe, for example, by Beuys and Broodthaers,

This is a Piece of Cheese, 1936/37
Ceci est un morceau de fromage
Object, 30 x 34 cm
Houston (Texas), courtesy of
The Menil Collection

although their conceptualism was largely coloured by a less categorical influence. Magritte on the other hand wished to emphasize that "the quality of the personal acitvity" of an artist allows a judgement of the art of which he is a practitioner. The difference between the two positions is minimal, but present all the same. Conceptual art saw an opposition between Formalism and Nominalism, in other words between an art which is art by nature and an art which is art because it is called that. Magritte for his part rejected "sterile values" and at the same time demanded "new contents", which "integrate into the notion of art the search for less reducible feelings than the feeling of beauty or the self-styled refined feelings of the artists".

In fact the problem boils down to knowing what the art lover is buying when he acquires a work of art, in other words why one appreciates this work or the other. By acquiring a conceptual work, one is supporting an ideological trend rather than simply buying a picture or a sculpture. To buy a Magritte, though, is to buy a poetic picture, whose aim is to strip reality of its banal features. With regard to both sides, though, in the final analysis we are dealing with matters that cannot be expressed in words.

Finally, the question arises as to the so-called wild, Transavantgarde, Neo-Expressionist and Neo-Fauvist painting of the 70s and 80s. One should be clear in one's mind that Magritte had nothing to do with these, particularly as these chaotic movments brought to the art market aesthetic motivations in categorical opposition to his usual practice and to his deeply-rooted ideas. These new trends represented a return to paintings characterized by extreme sensibility, a return to a painting marked by primal sensations, using materials manipulated to produce pasty effects on slipshod drawing, a return to a destructured statement and a distorted reality, a return to everything that Magritte rejected. And yet an attempt has been made to subpoena him in their defence, by pointing to his "Renoir" and "Vache" periods, ephemeral as they were. This

The Cork of Terror, 1966
Le bouchon d'épouvante
Object, 24.3 x 33 x 39 cm
Courtesy Galerie Isy Brachot, Brussels–Paris

was the reason, probably dictated by the whims of the market, for the presence of "Vache" period paintings at the "Westkunst" exhibition in Cologne in 1981, as mentioned above. "Magritte steigt aus . . ." as the catalogue put it, "Magritte drops out." The catalogue goes on, rightly, to describe this period as a provocation. But how – unless by chance, which can bring about all manner of things – how can any links be forged with the Cobra group or the informal artists of whatever school, whatever their quality, and whatever interest they might have? Between Magritte's derisiveness and what they had to offer, there is in any case no decent comparison.

By contrast, it is clear that by recalling with such panache Magritte's own sudden irruption into a totally satirical form of painting, this brief period was replaced in a context from which other novel movements in contemporary art have appeared, "barbarian" trends from Baj to Basquiat, and from Kienholtz or Grooms to Cragg or Dokoupil. At a stroke, interest was redirected away from new forms of expression of derision or irony, of mordant humour or cheerful fantasy, away from forms of art with their roots in graffiti, and towards those based on the weaknesses of society and those which take an interest in the accidents occasioned by everyday existence. Here, too, any comparison with Magritte must be coincidental and ad hoc. It is by no means presumptuous, however, to note that Magritte – in contrast to his development otherwise – in the course of his sunny Neo-Impressionism and his "Vache" Neo-Fauvism envisaged an advance into a new art, non-formalist, primitive, innocent in other words, to convey the most inward agitations of an uneasy civilization, exposed not only to its angels but also to its demons.

Reality is viewed differently by the latest trends in art, but stripped of its banality here as with Magritte. Or rather, they are the expression of a reality whose banalities are raised to the level of works of art underlain by a contingent perception of the world destructive of all convention. A "non-aesthetic",

ILLUSTRATION LEFT:
Bottle Labelled "Bière de Porc", 1937
Height: 31 cm
Courtesy Galerie Isy Brachot, Brussels–Paris

ILLUSTRATION CENTRE:
Painted Bottle, 1963
Height: 35 cm
Private collection

ILLUSTRATION RIGHT:
Painted Bottle, 1950
Height: 29.8 cm
Private collection

all in all, if one regards these artists – from Pop Art right up to the practitioners of "Nouvelles Images" – as witnesses and translators of the age rather than as interpreters who can transfigure it. They translate reality without comment; they reproduce it without adornment. But is there no trace of mystery left? Would we take any notice of these post-Magritte works if, as a result of their mediation, the mystery had disappeared? Do they contradict the idea which – according to Magritte – "by becoming inspired, resembles the world because it shows similarities with what the world has to offer it, invoking the mystery of what it receives from the world?"

Magritte's work and thought are univeral; in the end they act more like catalysts than as sources of individual influence. Painted pictures and expressed ideas are so to speak like chemical substances which speed up the processes of action and reaction to which we submit – against habit and convention – the perception of our environment.

René Magritte, c. 1960

208

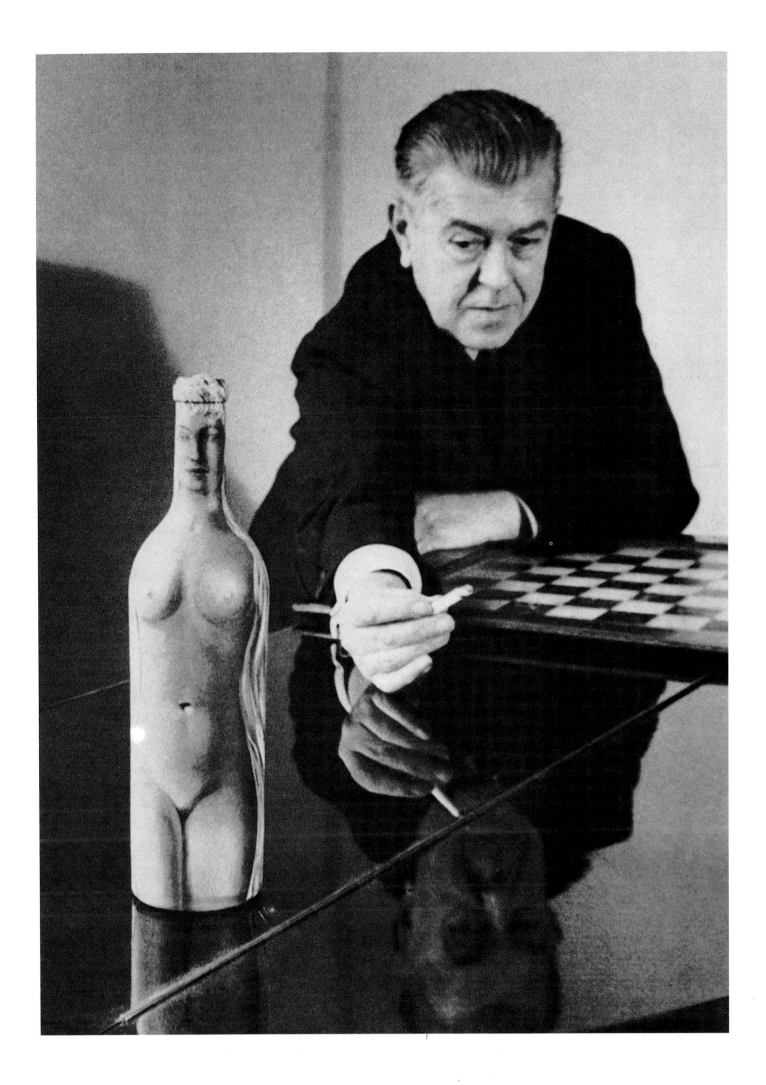

René Magritte 1898–1967
Life and Works

1898 René François-Ghislain Magritte born in Lessines in the Belgian province of Hainault on 21 November, the son of Léopold Magritte, a tailor and textile merchant, and his wife Adeline, née Bertinchamps, a milliner.

1900 The family moves to Gilly, where Magritte's brother Raymond is born on 29 June.

1902 Magritte's second brother Paul born on 24 October.

1902–1910 The Magritte family move house several times, first to Châtelet, then to Charleroi.

1910 René Magritte attends drawing lessons for children for the first time; he learns poker-work.

1912 His mother commits suicide at the age of 41. For reasons which remain unknown, she drowns herself in the River Sambre.

René Magritte's parents
Courtesy Galerie Isy Brachot, Brussels–Paris

1913 The family return to Charleroi, where Magritte attends grammar school. The children are brought up by a governess and by their grandmother. Magritte makes the acquaintance of his future wife Georgette Berger (born on 22 February 1901).

1916 Magritte enrols for two years at the Académie des Beaux Arts in Brussels. He attends courses given by Van Damme, Ghisbert, Combaz and the Symbolist painter Montald. He makes the acquaintance of Victor Servranckx.

1918 The Magritte family finally settle in Brussels.

1919 He meets various members of the contemporary avant-garde: the poet Pierre Bourgeois and his brother, the architect Victor Bourgeois; the abstract painter Pierre-Louis Flouquet, with whom he shares a studio for a short time. Together they publish a few issues of the periodical "Au Volant". He becomes increasingly interested in Futurism.

1920 He meets Edouard L. T. Mesens, his brother Paul's piano teacher, and Théo van Doesburg, who came to Brussels to hear a lecture on the Dutch group "De Stijl" and their "purist" theories. He becomes engaged to Georgette Berger, who is working with her sister in an artists' co-operative in Brussels. He has a short stay in Paris.

1921 Military service in an infantry regiment, at barracks in Beverloo (Bourg-Léopold) and Antwerp. Here he paints three portraits of his commanding officer.

1922 In June, marriage to Georgette Berger in the church of Saint-Josse-ten-Noode in Brussels. On the recommendation of Victor Servranckx, he is employed as a designer at the Peeters-Lacroix carpet factory in a Brussels suburb. Together with Servranckx he is the co-author of "Pure Art: A Defence of the Aesthetic". He is influenced by Orphism and Analytic Cubism. He designs the cover for a volume of poetry by Pierre Bourgeois.

Adeline Magritte with her son René, 1899
Courtesy Galerie Isy Brachot, Brussels–Paris

René, Raymond and Paul Magritte, 1907
Courtesy Galerie Isy Brachot, Brussels–Paris

1923 He resigns his position as carpet designer and concentrates on the design of advertising posters and exhibition stands.

1924 He sells his first picture, the portrait of the singer Evelyne Brélia. His "Aphorisms" are published in No. 19 of the periodical "391" edited by Francis Picabia. He makes the acquaintance of Camille Goemans and Marcel Lecomte.

1925 Together with Mesens he publishes the periodical "Œsophage" (only a single issue appears), a publication inspired by Dadaism. Through Lecomte he gets to know Chirico's picture *The Song of Love* (1914), which fills him with enthusiasm. He contributes two drawings to Marcel Lecomte's volume of prose "Applications" and designs the covers for the scores of two pieces by Edouard L. T. Mesens. He makes the acquaintance of Paul Nougé and the musician André Souris.

1926 He paints his first successful "Surrealist" picture: *The Lost Jockey*. He gives up advertising work, after concluding a contract with Paul Gustave van Hecke. He joins the Galerie Sélection, and its successor the Galerie L'Epoque, directed by Mesens.
　　Together with other Belgian Surrealists Magritte signs two leaflets: "Deux turpitudes" ("Two Disgraces") and "Les mariés de la Tour Eiffel" ("The Married Couple of the Eiffel Tower"). He designs covers for scores.

1927 In August René and Georgette Magritte leave Brussels and settle in Perreux-sur-Marne near Paris, where they stay for three years interrupted by short, but frequent, visits to Brussels. In Paris they meet Goemans once more, who has opened a gallery there. Magritte joins the group of French Surrealists and makes friends with André Breton, Paul Éluard, Hans Arp, Miró and Dalí. Van Hecke publishes an article on his work with 16 illustrations, entitled "René Magritte, peintre de la pensée abstraite" (in "Sélection", March 1927). He makes the acquaintance in Brussels of Louis Scutenaire, with whom he becomes lifelong friends.

1928 In August Magritte's father dies at the age of 58. Together with Nougé, Magritte publishes the periodical "Distances", which runs to three issues, in which there appear illustrations by him. The Musée des Beaux-Arts in Grenoble becomes the first public institution to acquire a painting by Magritte: *Les épaves de l'ombre (Left Behind by the Shadow)*, dating from 1926.

1929 Visit to Dalí in Cadaqués together with Paul and Gala Eluard (the latter later to become Gala Dalí). Decisive contributions to the periodical "La révolution surréaliste"; the cover of the last issue to appear (15 December) shows a well-known photomontage: *La femme cachée (Je ne vois pas la femme) (The Hidden Woman [I Can't See the Woman])*. It shows a woman surrounded by photos of the Parisian Surrealist group, with closed eyes. The final issue of December 15 includes Magritte's essay "Words and Pictures". At the end of the year the Galerie Le Centaure, to which Magritte had been under contract since 1926, closes down.

René and Georgette Magritte, 1920
Courtesy Galerie Isy Brachot, Brussels–Paris

1930 In view of the indifference with which he is regarded by the Parisian art scene, Magritte returns to Brussels in the middle of the year, this time definitively. Without any secure source of income, he sells his library. He resumes advertising work as a pot-boiler, and founds the "Dongo" studio. In his flat in the Rue Esseghem, the dining-room has to double up as a studio. His brother Paul takes on the administrative work.

1932 He joins the Communist Party, which he subsequently leaves on a number of occasions owing to differences of opinion. He writes several articles for left-wing journals, mostly under the pseudonym of Florent Berger. He makes the acquaintance of Paul Colinet.

1933 Contributions to the periodical "Violette Nozièrers" published by the French Surrealists.

1934 In Paris, Breton's "Qu'est-ce que le surréalisme?" appears, with Magritte's drawing *The Rape* on the cover. Magritte publishes his essay "Le fil d'Ariane" ("Ariadne's Thread") in the June issue of "Documents 34", an issue devoted to the "Intervention surréaliste".

1935 Paul Eluard publishes his poem "René Magritte" in the magazine "Cahiers d'art" (Nos. 5/6). A gouache done by Magritte appears on the front cover of the August (No. 3) issue of the "Bulletin international du surréalisme", which was published by the Belgian group.

1936 Magritte rejoins the Belgian Communist Party. He designs covers for the scores of popular works.

René Magritte, Georgette Magritte and Camille Goemans, 1928
Courtesy Galerie Isy Brachot, Brussels–Paris

René Magritte, 1930
Courtesy Galerie Isy Brachot, Brussels–Paris

1937 Visit to the banker Edward James in London. Magritte paints three large portraits of him. He gives a lecture in the London Gallery, which was under Mesens' direction, in which an exhibition of works by "Young Belgian Artists" is being shown. He designs the cover page for the periodical "Minotaure" (No. 10, Paris 1937). Makes the acquaintance of Marcel Mariën.

1938 Magritte gives the lecture entitled "La ligne de vie" ("Lifeline") at the Musée Royal des Beaux-Arts in Antwerp.

1939 Magritte designs the cover and end motif for "Frappez au miroir", a volume of poetry by Louis Scutenaire, and also provides the illustrations (Brussels, 1939).

1940 Magritte leaves Belgium following its invasion by enemy troops. Lengthy stay in Carcassonne together with Louis Scutenaire and Irène Hamoir. He paints portraits on commission, and meets Joe Bousquet, Raoul Ubac and Paul Eluard once again. Returning to Brussels, he makes a start on works which are to lead to his so-called "Renoir Period".

The first issue of the periodical "L'invention collective" appears under Ubac as editor, with Magritte as an active contributor. He designs advertisements and provides watercolours for the first five copies of "La chaise de sable" by Mariën (Brussels 1940).

1941 Eluard's volume of poetry "Moralité du sommeil" appears with drawings and a frontispiece by Magritte (Antwerp 1941).

1943 The first pictures of the "Renoir Period" (which is to last until 1944) appear.

During this period, Mariën's monograph also appears, with 23 reproductions from the "Renoir Period", as does also Nougé's Magritte monograph.

1945 Magritte rejoins the Belgian Communist Party for the last time. *The Red Model* appears on the cover of the new edition of Breton's "La surréalisme et la peinture".

1946 The first manifesto of "Surrealism in Full Sunlight" appears, under the title "Experience goes on" (L'expérience continue"), signed by Bousquet, Mariën, Michel, Nougé, Scutenaire, Wergifosse and Magritte. It is the period of "Amentalism" and "Extramentalism": Magritte proposes an "optimistic" Surrealism. He and his friends distance themselves from the Parisian Surrealist group around Breton, after the latter reacts negatively to the manifestos published in Brussels. Magritte and Mariën anonymously compose "Scatological Tracts" ("The Imbecile", "The Arsehole", "The Bugger"). Mariën edits the December issue of the New York periodical "View", devoted to the theme of "Surrealism in Belgium", which appears with a cover by Magritte.

1947 He leaves the Belgian Communist Party for the last time.

1948 Eluard composes a new poem on Magritte ("A René Magritte"). Gomez Correa publishes "El espectro de René Magritte" with reproductions of 13 works, accompanied by poems. The texts to the pictures are pro-

René and Georgette Magritte in the 1940s
Courtesy Galerie Isy Brachot, Brussels–Paris

vided by Wergifosse. Magritte illustrates "Les chants de Maldoror" by Lautréamont with about 80 drawings, and designs the cover. He also does the drawings, including one original drawing for the first 25 copies, for Mariën's "Les corrections naturelles".

1951 First mural for the ceiling of the *Théâtre Royal des Galeries Saint Hubert,* Brussels.

1952 Magritte edits the first number of "Carte postale d'après nature", of which ten issues – mostly in post card form – appear up to and including April 1956.

Left to right: Mesens, Magritte, Scutenaire, Souris, Nougé, Irène Hamoir, Marthe Nougé and Georgette Magritte, 1934

year. Magritte completes ten drawings for "Poèmes 1923–1958" by E. L. T. Mesens (Paris 1959).

1960 Magritte visits Breton. Suzi Gablik spends considerable time with Magritte in Brussels, researching an essay about him.

1961 Fourth mural: *The Mysterious Barricades,* Palais des Congrès, Brussels.

1963 Magritte plans a new house; on health grounds, he is unable to carry it out.

1965 Magritte's health takes a turn for the worse; visits to Ischia and Rome. He undergoes a surgical examination. In December he travels to the USA for the first and only time, the occasion being a retrospective of his work at the Museum of Modern Art, New York. The Magrittes also visit Houston, Texas.

1966 Visit to Cannes, Montecatini and Milan in the company of Louis Scutenaire and Irène Hamoir. Visit to Israel.

1967 Death of Magritte at the age of 69 on 15 August, in his own apartment at 97 Rue des Mimosas in Brussels, after a previous short stay in hospital. Earlier he had, during a visit to Italy, completed and signed the wax models for his eight sculptures at the Verona forgeworks. He never lived to see the bronze castings.

René Magritte, Marcel Duchamp, Max Ernst and Man Ray in Paris, 1960

René Magritte at work, 1963
Courtesy Galerie Isy Brachot, Brussels–Paris

1953 Second mural, unveiled in July: *The Enchanted Realm* in the gaming room of the casino in Knokke-Heist/Le Zoute. Magritte uses colour transparencies to project the pictures (eight in all) on to the walls, and has interior decorators do the actual painting.

1955 Magritte meets Maurice Rapin, who publishes extracts from Magritte's correspondence with commentaries.

1956 Magritte signs an exclusive contract (portraits excepted) with Alexandre Iolas, who from now on is solely responsible for the sale of all his pictures and the organization of one-man exhibitions. Magritte makes a series of short films, occasionally with scripts which he himself has written with friends. He is awarded the Guggenheim Prize for Belgium.

1957 Third mural: *The Ignorant Fairy,* Palais des Beaux-Arts, Charleroi, executed in the same fashion as that of 1953. Magritte makes the acquaintance of Harry Torczyner, a Belgian-American lawyer, who becomes his legal adviser. After a number of changes of address, he finally moves to 97 Rue des Mimosas, in the Schaerbeek district of Brussels, which remains his home until his death.

1958 Meeting with André Bosmans, the publisher of the periodical "Rhétorique". Magritte subsequently contributes intensively to the magazine and carries on a voluminous correspondence with Bosmans.

1959 Luc de Heusch films "René Magritte ou la leçon des choses" in Magritte's apartment. It receives its premiere the following

Bibliography

Selected monographs and writings consulted by the author

(Quotations in this book from René Magritte himself are taken from André Blavier, ed.: René Magritte, Ecrits complets, Paris, 1979, and translated by the present translator.)

Blavier, André: Bibliographie générale de René Magritte, jusqu'en 1965, in: Patrick Waldberg: René Magritte, Brussels, 1965

Blavier, André: Ceci n'est pas une pipe, contribution furtive à l'étude d'un tableau de Magritte, Verviers, 1973

Blavier, André, ed.: René Magritte, Ecrits complets, Paris, 1979

Breton, André: Le surréalisme et la peinture, Paris, 1928

Bruaene, Gérard von: Le Magritte de Léonce Rigot, Brussels, 1954

Colinet, Paul; Paul Nougé and Marcel Mariën: Dix tableaux de Magritte précédés de descriptions, Brussels, 1946

Demarne, Pierre: René Magritte, in: Rhétorique No. 3, September 1961

Dopagne, Jacques: Magritte, Paris, 1977

Foucault, Michel: Ceci n'est pas une pipe, Montpellier, 1973

Gablik, Suzi: Magritte, London, 1970

Glozer, Laszlo: Westkunst, Zeitgenössische Kunst seit 1939 (exhibition catalogue), Cologne, 1981

Gomez Correa, Enrique: El espectro de René Magritte, Santiago (Chile), 1948

Hammacher, Abraham M.: René Magritte, New York, 1974

Hamoir, Irène: Boulevard Jacqmain (novel), Brussels, 1953

Hofstadter, Douglas: Gödel, Escher, Bach, Stuttgart, 1986

Kosuth, Joseph: Art after Philosophy, 1969

Lautréamont, Comte de: Les chants de Maldoror, with 77 drawings by René Magritte, Brussels, 1948

Lebel, Robert: Magritte, Peintures, Paris, 1969

Mariën, Marcel: Magritte, les poids et les mesures, Brussels, 1943

Meuris, Jacques: Magritte, Paris, 1989

Michaux, Henri: En rêvant à partir de peintures énigmatiques, Montpellier, 1972

Noël, Bernard: Magritte, Munich, 1977

Nougé, Paul: René Magritte ou les images défendues, Brussels, 1943

Nougé, Paul: Histoire de ne pas rire, Brussels, 1956

Paquet, Marcel: Magritte ou l'éclipse de l'être, Paris, 1982

Passeron, René: René Magritte 1898–1967, Die Gesetze des Absurden, Cologne, 1986

Pierre, José: Magritte, Paris, 1984

Robbe-Grillet, Alain: René Magritte, La belle captive (novel), Brussels, 1975

Roberts-Jones, Philippe: Magritte, poète du visible, Brussels, 1972

Roque, Georges: Ceci n'est pas un Magritte, Essai sur Magritte et la publicité, Paris, 1983

Schiebler, Ralf: Die Kunsttheorie René Magrittes, Munich, 1981

Schmied, Wieland: René Magritte, Zurich, 1982

Schneede, Uwe M.: René Magritte, Leben und Werk, Cologne, 1973

Schreier, Christoph: René Magritte, Sprachbilder 1917–1930, Hildesheim, 1985

Scutenaire, Louis: René Magritte, Brussels, 1947

Scutenaire, Louis: René Magritte, Antwerp, 1948

Scutenaire, Louis: René Magritte, Brussels, 1964

Scutenaire, Louis: La fidélité des images. René Magritte, le cinématographe et la photographie, Brussels, 1976

Scutenaire, Louis: Avec Magritte, Brussels, 1977

Sojcher, Jacques: La pipe, son peintre, son philosophe, Brussels, 1975

Sylvester, David: René Magritte, New York/Washington, 1969 and 1970

Torczyner, Harry: René Magritte, Zeichen und Bilder, Cologne, 1977

Waldberg, Patrick: René Magritte, Brussels, 1965

Waldberg, Patrick: Magritte, Peintures, Paris, 1983

Recent exhibition catalogues (selection), in chronological order

Scutenaire, Louis; Jean Clair and David Sylvester: Rétrospective Magritte, Brussels 1978, Palais des Beaux-Arts; Paris 1979, Musée National d'Art Moderne

Goemans, Camille; Marcel Mariën; E. L. T. Mesens et al.: René Magritte, Lausanne 1987, Fondation de l'Hermitage

Colinet, Paul: René Magritte: Le domaine enchanté, Basle 1988, Art 88; Paris 1988, Galerie Isy Brachot

Schmied, Wieland; Camille Goemans; Marcel Mariën; E. L. T. Mesens; Sabine D. Lehner and Martine Jacquet: René Magritte, Munich 1988, Kunsthalle der Hypo-Kulturstiftung

Scutenaire, Louis; André Bosmans and Evelyne Deknop-Kornelis: René Magritte, Brussels 1988, Musées Royaux des Beaux-Arts

Torczyner, Harry; Louis Scutenaire; René Magritte; E. L. T. Mesens et al.: Rétrospective René Magritte 1898–1967, Brussels 1988, Galerie Isy Brachot

Goemans, Camille; Martine Jacquet; Catherine de Croes et al.: Magritte, Madrid 1989, Fundación Juan March

Scutenaire, Louis: Dessins, croquis et esquisses de l'atelier René Magritte, Paris 1989, Galerie Isy Brachot

Sterckx, Pierre: René Magritte – Photographs, New York 1990, Pace/Macgill Gallery

Exhibitions

1919 First exhibition appearance with *Three Women*; takes part in a joint exhibition of posters at the Centre d'Art in Brussels.

1920 Centre d'Art, Brussels, with Flouquet and others; "Internationale Ausstellung moderner Kunst", Bâtiment Electoral, Geneva (5 pictures).

1923 Exhibition by the group "Cercle royal artistique d'Anvers", Antwerp (7 pictures); also represented are El Lissitzky, Moholy-Nagy, Feininger and de Joostens.

1927 Galerie Le Centaure, Brussels: first one-man exhibition (61 works); Musée des Beaux-Arts, Grenoble.

1928 Galerie L'Epoque, Brussels (23 works); Galerie Goemans, Paris: "Exposition surréaliste".

1930 Galerie Goemans, Paris: "La peinture au défi" (one collage).

1931 Salle Giso, Brussels (16 pictures), texts by Nougé; Palais des Beaux-Arts, Brussels (30 pictures); also represented are René Guiette and Olivier Picard.

1933 Palais des Beaux-Arts, Brussels, catalogue with texts by Paul Nougé.

1934 Palais des Beaux-Arts, Brussels: "Exposition Minotaure".

1935 "Socialistische Studiekring", Ghent.

1936 Julien Levy Gallery, New York: first one-man exhibition in the USA; Palais des Beaux-Arts, Brussels; Esher Surrey Art Gallery, The Hague; Galerie Charles Ratton, Paris: "Exposition surréaliste d'objets"; New Burlington Gallery, London: "The international surrealist exhibition"; "Fantastic Art, Dada and Surrealism" in the USA (New York, Philadelphia, Springfield, Minneapolis, San Francisco, Milwaukee, Boston).

1937 Julien Levy Gallery, New York; Surrealism exhibition in Japan (Tokyo, Kyoto, Osaka, Nagoya), catalogue cover shows *L'épouvantail (The Spectre)*; exhibition of Belgian art in Moscow and Leningrad; Palais des Beaux-Arts, Brussels: "Trois peintres surréalistes" (Magritte, Man Ray, Yves Tanguy).

1938 Julien Levy Gallery, New York; London Gallery, London; catalogue preface by Herbert Read and Humphrey Jennings; "Exposition internationale du surréalisme" in Paris und Amsterdam.

1939 Palais des Beaux-Arts, Brussels.

1941 Galerie Dietrich, Brussels.

1943 Galerie Lou Cosyn, Brussels; private exhibition in an apartment in the Rue Madeleine, Brussels.

1944 Galerie Dietrich, Brussels.

1945 Galerie of the Edition La Boétie, Brussels: "Surréalisme. Exposition de tableaux, dessins, collages, objets, photos et textes."

1946 Galerie Dietrich, Brussels.

1947 Hugo Gallery, New York (one of the proprietors is Alexandre Iolas, who in 1956 signs an exclusive contract with Magritte); Société Royale des Beaux-Arts, Verviers (whose chairman is Oscar Merlot, whose portrait Magritte painted); Galerie Lou Cosyn, Brussels.

1948 Galerie du Faubourg, Paris: first one-man exhibition in Paris, showing exclusively "Vache" period pictures, catalogue text by Scutenaire: "Les pieds dans le plat"; Hugo Gallery, New York; Galerie Dietrich, Brussels; Copley Galleries, Hollywood; Biennale, Venice.

1949 Galerie Lou Cosyn, Brussels; Galerie Calligrammes, Paris.

1950 Galerie Le Parc, Charleroi.

1951 Hugo Gallery, New York; Galerie Dietrich and Galerie Lou Cosyn, Brussels.

1952 Casino in Knokke-Heist/Le Zoute: René Magritte – Paul Delvaux.

1953 Galleria dell'Obelisco, Rome; Alexandre Iolas Gallery, New York; Temps mêlés, Verviers; Galerie Le Carré, Liège; Galerie La Sirène, Brussels; Lefevre Gallery, London.

1954 Palais des Beaux-Arts, Brussels: first Magritte retrospective, compiled by Mesens; Maisons des Loisirs, La Louvière; Sidney Janis Gallery, New York (21 old pictures with words added); Biennale, Venice (20 pictures).

1955 Galerie Cahiers d'Art, Paris, organized by Iolas.

1956 Salle de la Bourse, Charleroi: retrospective on the occasion of the 30th exhibition of the "Cercle royal artistique et litteraire de Charleroi".

1957 Alexandre Iolas Gallery, New York.

1958 Galerie Cahiers d'Art, Paris; Alexandre Iolas Gallery and Bodley Gallery, New York.

1959 Musée communal d'Ixelles, Brussels: retrospective; Alexandre Iolas Gallery and Bodley Gallery, New York.

1960 Musée des Beaux-Arts, Liège: retrospective (the catalogue includes the text "La ressemblance" ["The Likeness"]); Museum for Contemporary Art, Dallas, and Museum of Fine Arts, Boston: retrospectives; Galerie Rive droite, Paris.

1961 Grosvenor Gallery and Obelisk Gallery, London: small concurrent retrospectives, catalogue text by Breton; Brook Street Gallery, London; Albert Landry Gallery, New York.

1962 Casino in Knokke-Heist/Le Zoute and Walker Art Center, Minneapolis: retrospectives; Alexandre Iolas Gallery and Bodley Gallery, New York; Galleria Galatea, Turin; Galleria Schwarz, Milan.

1963 Galerie Iolas, Geneva; Galleria l'Attico, Rome.

1964 Arkansas Art Center, Little Rock: retrospective; Galerie Alexandre Iolas, Paris: "Le sens propre", afterwards in New York; Renaissance Art Society at the University, Chicago; Hanover Gallery, London.

1965 Alexandre Iolas Gallery, New York; Galerie Rudolf Zwirner, Cologne; Galleria del Naviglio, Milan; Galleria Notizie, Turin; Galleria La Medusa, Rome; Castello Spagnolo, L'Aquila.

1966 Zwemmer Gallery, London.

1967 Museum Boymans-van Beuningen, Rotterdam and Moderna Museet, Stockholm: retrospectives; Galerie Alexandre Iolas, Paris.

1968 Galerie Isy Brachot, Brussels; Hanover Gallery, London; Byron Gallery, New York.

1969 Tate Gallery, London; Kestner Gesellschaft, Hanover; Galerie Alexandre Iolas, Paris; Kunsthaus, Zurich; L'Ap_ prodo, Turin.

1970 Galleria Alberto Schubert, Milan; New Smith Gallery, Brussels; Galerie Isy Brachot, Brussels.

1971 National Museum of Modern Art, Tokyo; The National Museum Of Modern Art, Kyoto; Galerie Isy Brachot, Knokke-Heist/Le Zoute; Galerie Alexandre Iolas, Athens.

1972 Gimpel & Hanover Gallery, Zurich.

1973 Marlborough Gallery, London; Hôtel de ville, Lessines.

1975 Dalvyn Gallery, New York; Galerie Isy Brachot, Knokke-Heist/Le Zoute.

1976 Neue Galerie, Aix-la-Chapelle; Musée d'Art Moderne, Brussels: "La fidélité des images", photographs, later in Baden-Baden, Paris, Vienna, Munich, Hanover, Angers, Nottingham; Galerie Isy Brachot, Art 7', Basle; Institute of the Arts, Rice University, Houston.

1977 Galerie Baukunst, Cologne; CAPC, Bordeaux; Galerie Isy Brachot, Paris; Sidney Janis Gallery, New York.

1978 Palais des Beaux-Arts, Brussels; Musée d'Art Moderne, Liège: "Magritte: Publicités 1918–1936".

1979 Musée National d'Art Moderne, Paris; The Parrish Art Museum, Southampton, New York; Galerie Isy Brachot, Brussels and Paris.

1981 Cologne: "Westkunst" (Magritte is represented exclusively by "Vache" period works).

1982 Kunstverein und Kunsthaus, Hamburg: "René Magritte und der Surrealismus in Belgien"; one-man exhibitions in various Japanese cities.

1983 Louisiana Museum, Humlebaeck.

1984 Fondation Sonja Henie, Oslo; Galerie Isy Brachot, Paris; Centre Wallonie-Bruxelles, Paris.

1986 Arnold Herstand, New York.

1987 Fondation de l'Hermitage, Lausanne; Kunsthalle der Hypo-Kulturstiftung, Munich.

1988 Galerie Isy Brachot, Brussels: retrospective "Magritte dans les collections privées"; Basle, Art 19'88; Galerie Isy Brachot, Paris: "Le domaine enchanté"; one-man exhibitions in various Japanese cities.

1989 Fundación Juan March, Madrid; Basle, Art 20'89; Galerie Isy Brachot, Paris.

1990 Pace/MacGill Gallery, New York: "René Magritte: Photographs".

Acknowledgements

The publishers would like to thank the Photothèque Succession René Magritte, Brussels, and the Galerie Isy Brachot, Brussels and Paris, for their support of this project and for providing the material for the reproductions. Thanks are also due to the following museums and institutions for permission to reproduce pictures:

A. C. Cooper Colour Library, London: p. 87
A. C. L., Brussels: pp. 160, 161
Author's archive: pp. 7, 108, 196, 197
Artothek, Peissenberg (G. Westermann): pp. 25, 51, 110/111,
Galerie Christine and Isy Brachot, Brussels: pp. 2, 8, 9, 10, 13–15, 18, 29, 31, 38, 39, 41 l., 41 r., 58, 59, 61, 63, 66, 70 r., 72, 75, 77, 83, 84 85, 89, 92, 96, 100 r., 105, 109 l., 112, 121, 123, 125, 126, 133, 134, 135, 137, 139, 149, 150, 153 below, 156, 157, 158 below, 159, 177, 179, 180, 182, 183, 186, 195, 203, 204 l., 205 l,. 208 l., 210, 211, 212 above l., 213 b., book cover, front and back endpapers
The Bridgeman Art Library, London: pp. 11, 35, 60, 70 l., 140
© Hickey-Robertson, Houston: pp. 69 below, 81, 144/145, 206
Shunk Kender, Paris: pp. 83, 213 below
Kunstfoto Speltdoorn, Brussels: pp. 162/163 below
Duane Michals, New York: p. 109 r.
Musée de la Photographie, Charleroi: p. 164
© Réunion des Musées Nationaux, Paris: p. 69 above
Photothèque Succession René Magritte, Brussels (agents: VG Bild-Kunst, Bonn): pp. 6, 12, 17, 22–24, 26–28, 30, 32, 33, 37, 38 above, 40 l., 40 r., 43–45, 49, 52, 53, 55, 62, 65, 67, 68, 71, 73, 74, 82, 88, 93, 97, 99, 102, 104, 106/107, 114–120, 130, 131, 138, 141, 143, 146, 147, 148, 151, 152, 155, 162/163 above and centre, 158 above, 165–167, 169–173, 175, 176, 181, 184, 185, 187–189 191–194, 199–202, 204 r., 205 r., 207, 208 centre, 208 r., 209
Courtesy of Wasmuth Verlag, Tübingen: p. 95
The illustrations on the following pages are from the publisher's own archives: pp. 16, 19, 21, 46/47, 57, 78/79, 86 r., 91, 98 above and below, 101, 103, 124, 125, 153, 212 below, 213 above